Mary Miller earned her doctorate in 1981 from Yale University, and
she has been a member of its faculty sin
numerous awards and honors, she is th
Symbols of Ancient Mexico and the Ma
Mesoamerican Religion (with Karl Taub
(also in the World of Art), *The Murals of*
Schele, *The Blood of Kings*. Mary Miller
to document and reconstruct the Maya
Mexico. In 1998 she was named Vincen
History of Art at Yale. She is also Master of Saybrook College.

D0446533

DISCARD

World of Art

This famous series provides the widest available range of
illustrated books on art in all its aspects. If you would like
to receive a complete list of titles in print please write to:

THAMES & HUDSON
181A High Holborn
London WC1V 7QX

In the United States please write to:

THAMES & HUDSON INC.
500 Fifth Avenue
New York, New York 10110

Printed in Singapore

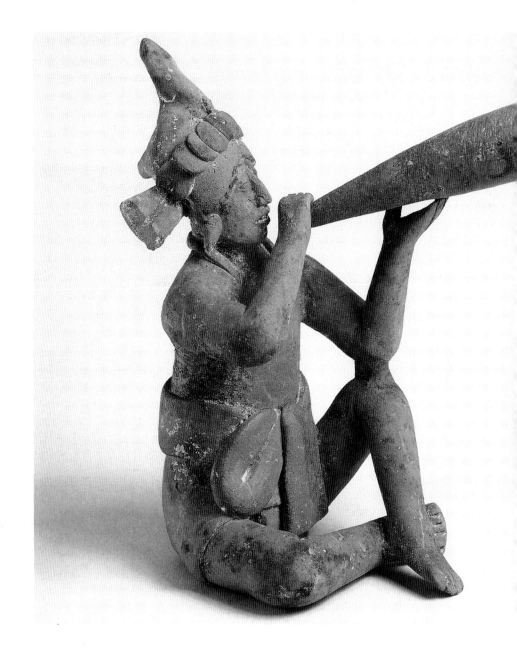

A Late Classic trumpeter from
Jaina Island lifts a horn to his lips
and prepares to sound a blast.

Mary Ellen Miller

Maya Art and Architecture

207 illustrations, 57 in color

THAMES & HUDSON

To the memory of Linda Schele, 1942–1998

© 1999 Thames & Hudson Ltd, London

First published in paperback in the United States of America in 1999 by
Thames & Hudson Inc., 500 Fifth Avenue, New York, New York 10110

Library of Congress Catalog Card Number 99-70938
ISBN 0-500-20327-X

Printed and bound in Singapore

Contents

Preface

1. A loving couple from Jaina Island (Late Classic) form an elaborate whistle. A similar figurine (ill. 139) may have had a body made from the same mold and then finished with different heads.

I visited Tatiana Proskouriakoff in Cambridge, Massachusetts over twenty years ago. I had wanted to talk with her about my dissertation topic, the Bonampak murals, since she had been an author of their initial study back in 1955. But what she wanted to talk about that November day was not Bonampak. "Oh," she said to me, waving a cigarette off to her side, "that subject has already been written about. What this field needs is a book about Maya art. What *is* Maya art? Why is it a great art style? And what is its range?" Coming from the woman who had written the only comprehensive book on Maya art—*Classic Maya Sculpture* (1950)—her words made a great impression on me. But I thought at the time that she was not talking about what I should do, for I was a complete stranger: it seemed to me that she was describing what she wished *she* were working on, rather than the project on Maya history that was laid out on a table that day and that became her last book.

A decade later Linda Schele and I spent months working together on *The Blood of Kings*. We were keen to pose and answer such questions as "What is Maya art?" but we were limited by the constraints of the exhibition at the Kimbell Art Museum in terms of the range of Maya art. And we found ourselves thinking and writing thematically: what we sought was to take the fruits of twenty-five years of Maya hieroglyphic decipherment and use them to decode the fundamental meaning of Maya art. Our book refocused Maya studies and brought Maya art to public attention in a way that it had not previously been known.

But I had long wanted to write my way through the larger corpus of Maya art, to look at so many fundamental questions that had not been answered in any overview. What is the nature of Maya sculptural development? How do the regional schools of sculpture and painting emerge, and what can be made of them? How did the Maya artist exploit the materials at hand? How did Maya art come to focus on the human figure?

So at last I found myself writing a book that has often seemed to me little more than a preliminary road map through barely charted territory. The result is not Tatiana's book, for it is less

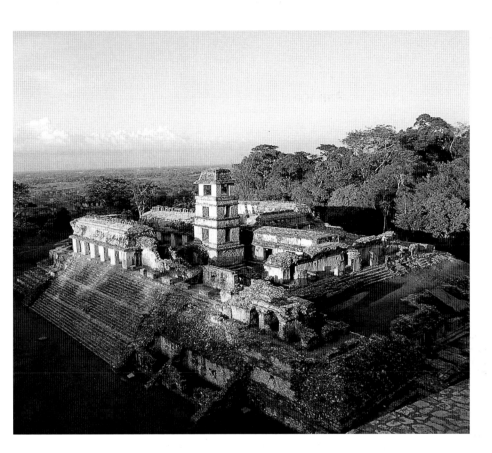

2. From the Temple of Inscriptions at Palenque, the observer gains an expansive view of the Palace, where buildings were added for over a century. Its signature tower may have been the final construction.

about the *whys* of Maya art and more about the *whats* than any book she would have written. Nor is it Linda's book: Linda went on to co-author three books on Maya history and ideology after our project. This book seeks to organize Maya art afresh and to do so in a way that will benefit students and those with a general interest in the Maya everywhere.

Over the years I have learned constantly from my colleagues. Simon Martin has been an excellent sounding board during the writing of this book, and I'm grateful for his thoughtful comments throughout the process. Steve Houston, Karl Taube, David Stuart, Michael Coe, Justin Kerr, Adam Herring, Regan Huff, and Diana Magaloni have all shared their ideas generously. Dorie Reents-Budet's exhibition, *Painting the Maya Universe*, came to the Yale University Art Gallery in spring 1995, making it possible for me to see and think about Maya vases every day for three months. I am also grateful for the intelligence and insight of my Yale students, with whom I am always seeing works of art for the first time.

Chapter 1: Introduction

In their texts, the ancient Maya gave names to the things they made. They identified the ceramic vessels they painted, distinguishing a low bowl, or *lak*, from a cylinder vessel, *uch'ib*. They named their buildings, calling, for example, the most sacred royal palace at Palenque the *sak nuk nah*, the "white big house," or the most important funerary pyramid at Piedras Negras the *muknal*, or "burial hill." They honored the day when they would set a new stone monument, a *lakamtun*, or banner stone, at Copán, and they called attention to the wealthy royal woman who commissioned a series of carved stone lintels at Yaxchilán. A painter at Naranjo signed his pots, adding for emphasis the names of his parents and revealing that he was indeed a painter of high status: his father was the king of the city, and the painter was apparently the younger son, one who would not normally take the throne. The Maya had names for these ancient artforms, and they knew who had commissioned a work of art and who in turn had made it. The Maya speak of writing and carving in the surviving texts, but like most ancient civilizations, they had no single encompassing word for *art* in their lexicon. And perhaps they had no need for such a word, for every surface—whether a textile or a thatched roof—could be transformed by paint and stucco and turned into a remarkable thing, ornamented with designs or figures that were characteristically Maya. These works were all around them, at dozens of Maya cities, and many were made to last. The ancient Maya world was a world of Maya art.

For most of the first millennium AD, the Maya built cities and sanctuaries in the tropical and subtropical rainforests of southern Mexico, Guatemala, Belize, and Honduras, all regions where the Maya had settled centuries before. The art of that era, generally from the Maya lowlands, is the main subject of this book, although both Preclassic and Postclassic materials will come to the fore from time to time, as will works from mountainous terrain. Nor even in regard to the period from AD 250 to 900, or what is called the "Classic" period, can this study be comprehensive, for at dozens of cities, large and small, Maya art and architecture

thrived, with local styles and traditions evolving over time. This book can be little more than a road map to the complexity of Maya art.

Maya art and civilization

The Maya of the first millennium were not the first civilization of Mesoamerica, the ancient cultural region that encompassed most of Mexico and northern Central America: that honor goes to the Olmecs of the Gulf Coast, who established ceremonial precincts and carved monumental heads and other sculptures in the first millennium BC. And by the time the Spanish arrived on Mesoamerica's shore early in the sixteenth century, the invaders quickly sized up the Aztecs as the most powerful civilization at hand. Even during their own apogee, the Maya may well have suffered political and military defeats at the hands of more powerful neighbors, especially the Teotihuacanos, who built their capital city near modern-day Mexico City. Cultures making complex art surrounded the Maya on all sides, and the Maya sometimes adopted the imagery and style of "foreign" forms.

The earliest works of Maya art were no doubt ephemeral, as are some works that the Maya make today. When the ancient Maya placed an unusual rock in a spring or cut flowers for an offering they may have perceived these acts to be as much art-making as the carving of a sculpture or the shaping of a ceramic vessel. From at least 500 BC, the Maya manipulated their environment, making of it monuments and buildings, and imbuing certain materials, particularly rare greenstones, and especially jade, with great value. During the Late Preclassic, Maya populations grew exponentially, and by the reign of Caesar Augustus in Rome, they had built one of their largest cities, El Mirador, in the northern Petén, but long before Rome's fall, by AD 250, it had fallen into disrepair and decline.

Millions of Maya inhabited the Maya lowlands, many of them living in or near substantial cities, some of them quite large, including Tikal, Copán, Calakmul, and Uaxactún, where settlement was ancient and where they set up monuments during the Early Classic (AD 250–550). Others, among them Palenque, Dos Pilas, and Xpuhil, flourished later, during the Late Classic (AD 550–900). Particular Maya practices took root almost everywhere during the Classic era, including the carving of tall stone shafts, or stelae, and their placement with low cylindrical stones called altars today. The cessation of this monument-making has served as one of the sharpest markers of the Classic Maya "collapse," often

posed as one of the great unsolved cultural declines of the past. But for resources, the Maya drew on the rainforest, and over the course of the first millennium, they may well have harvested most of it, so that by the eighth century, they probably inhabited a severely degraded environment, one unable to support the populations and offering little to exchange in trade with other regions. Yet despite the obvious collapse of civilization that follows this stressful eighth century, the era is also the richest source of Maya art, with large populations able to lay claim to elegant ceramics, and with kings eager to record their contentious relationships with neighbors and competing lineages prior to utter decline and abandonment.

Classic Maya civilization was not washed away in a single wave. During the ninth century, Classic Maya culture and art making continued apace in the north, first in the Puuc region, particularly at Uxmal and its neighbors, and then at Chichen Itzá, a place which in 900 was the most powerful city of Mesoamerica. Even with Chichen's decline after AD 1000, Maya culture did not falter altogether, and the finely painted books of the Maya that survive were painted within a hundred years or so of the Spanish arrival in Yucatán in 1511. But in large part, once Chichen Itzá had become only a place of pilgrimage, rather than a vibrant urban center, few materials that survive today—jade, bone, shell, fine-grained limestone—were being given a permanent form whose meaning and life as a work of art can still be retrieved.

Maya art is an art of the court and its retinue, in large part celebrating kings, nobles, and wealthy merchants, and the women, musicians, and artists who lived with them or served them. The Maya elites lived well, and their world was one of both perishable and permanent art: works of art could link them to the past by recalling the deeds or forms of ancestors or they could make room for innovation and imagination in somewhat new formulations. Living in the rainforest, the Maya struggled against rot and decay; new works and repaintings were constantly called for. Very little of what was once made survives, and yet it demonstrates a greater range of subject matter than any other New World tradition. Accordingly, no one can predict or even anticipate the next work of Maya art to be revealed from the ground: it could be a stone monument, or *stela*, that makes complete sense within some existing sequence, like the recently recovered Stela 40 at Tikal, or it might be a painted vessel that offers new insights into iconography and ritual, worked by a master hand—and not necessarily one previously known in the world of Maya art. In two such discoveries is revealed the tension between making a work

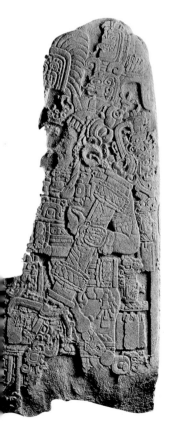

3. Discovered near Tikal's Temple I in the 1990s, Stela 40 depicts a late fifth-century king. For his monument, he recalled Stela 31, which celebrated his famous father, Siyah Chan K'awil (ill. 76).

3
4

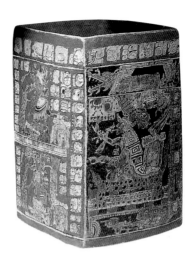

4. The so-called Box of Eleven Gods. The unmistakable image of the cigar-smoking God L commands a full side of this unusual box. On the other three sides, ten lesser gods pay him fealty. Closely related to a group of painted ceramics from the Naranjo region, this box may have come from the very same workshop.

according to a traditional recipe and making a work of imagination: in the world of Maya art, both were possible.

Additionally, much Maya art is site-specific, both in the current sense of being designed for a particular architectural space, but also in the sense of being made within a particular regional school. Thus the three-dimensional qualities of single-figure Copán sculptures last for generations; Palenque sculptors sorted out problems of two-dimensional group compositions, all the while designing works for interior rather than exterior display.

In its complexity and subtlety, in its sheer volume and innovation, Maya art is the greatest of New World art styles. No other tradition survived through so many generations or across such a geographical range, despite the tropical environment and mindless modern depredations. And no other works of art of the ancient New World bear texts that can tell their own stories. Although an Aztec date might indicate that a work had been made to commemorate a ruler's accession to office, only a Maya text can provide ancient narrative. The ancient Maya have left an incomparable wealth, and this book attempts to frame ways to see this remarkable trove.

Discovering Maya art
Modern viewers often claim that they know art when they see it, or, alternatively, that they know nothing of art but that they know what they like. From the beginning of the nineteenth century, explorers of the Mexican rainforest sensed both that they had seen ancient traces that they recognized as art and also that, contrary to experience with many other cultures of ancient Mexico,

they liked what they saw. When a colleague sent Alexander von Humboldt a sketch of a Palenque stucco, he immediately published it in his vast compendium of geological wonders of the New World. A German scholar who saw the sketch then republished it in the first comprehensive study of world art, and he marveled at the ability of its makers to render the human form proportionally, unlike the Aztecs. He crankily called the effort *ausartung*, however, or baroque—a deeply pejorative term in 1842—with a Neoclassical disdain for the detail he saw in the Maya sculpture.

With the voyages of John Lloyd Stephens and Frederick Catherwood to the tropical rainforests of Honduras, Guatemala, what is now called Belize, and the southern states of Mexico, the vast range of ancient Maya art and architecture suddenly came to the attention of the modern world. At Copán in 1839, Stephens' first encounter with ancient Maya ruins, he commented on the works around him with awe, and his infectious enthusiasm leaps off the page to charm one generation after another. A man of his era, a man before Marx, Stephens wasted no time worrying about whether he should be discussing "visual production" or "art," as might an art historian today. By analogy with the Old World,

5. Frederick Catherwood drew Stela F at Copán in 1839. Some years later he prepared a series of color lithographs in London from his sketches, often embellishing the luxuriant rainforest as he has done here, but without losing the detail of the monument that characterized his careful draftsmanship.

6. Remarkably, Frederick Catherwood was the first to have made records of the dress and habits of nineteenth-century Maya, even if he did so only to add focus to his renderings of Maya architecture, as he has done here for the Nunnery at Uxmal. Stephens and Catherwood were particularly engaged by Uxmal's elaborate facades and streamlined, low-slung forms.

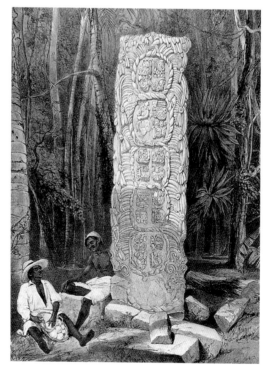

where he had traveled extensively and written an important study of Egypt, Palestine, and Petra, Stephens called monuments "sculptures" and recognized Maya writing for what it would ultimately prove to be, when deciphered 120 years later: a script that could replicate speech, a writing system that had been used extensively on public monuments to glorify subject and patron. Stephens called the architectural wonders that he saw "temples" and "palaces," terminology that has survived attempts at reclassification as "structures" or "range-type buildings," and in general he was right, spotting royal dwellings and shrines for worship of gods and ancestors long before archaeology could prove them to be so.

Furthermore, Stephens can be seen as the first serious student of Maya art. Now recognized as having regional traditions that can override time, political factions, or international trade, Maya art and architecture is more local than not—as were many aspects of ancient Maya life. Stephens called attention to regional differences, noting the rich, near three-dimensionality of Copán sculpture, distinct from all other Maya canons, and the near-absence of freestanding sculpture at Palenque. Where Stephens grasped the individuality and personality of individual subjects

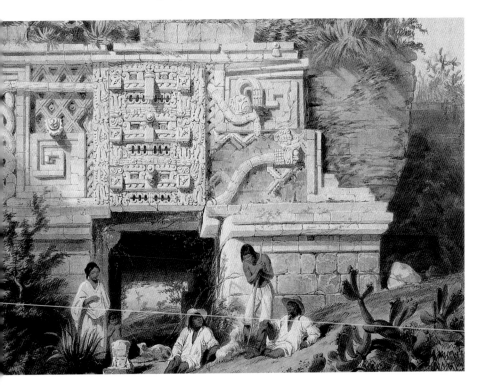

shaped into three dimensions at Copán, at Chichen Itzá he saw instead a grey militaristic uniformity that he likened to the Aztecs, a sculptural expression of his sense of decadent society. But while he identified such local characteristics, he also saw the unifying parameters of Maya art and writing. He linked the texts from the Dresden Codex, a Conquest-era Maya book published in 1810 by Lord Kingsborough, with the writings he had seen all across the Maya region, simultaneously distinguishing them from writings in Oaxaca or Central Mexico. By his identification as well of the ancient art with the living people, Stephens truly brought focus to ancient Maya art.

But there were things Stephens could not guess, including the age of Maya antiquities. In a world set topsy-turvy by the writings of Charles Darwin, the age of the planet or humans themselves seemed impossible to determine, let alone the age of Maya ruins. Not until the turn of the century would scholars figure out that the Maya ruins had preceded the Aztec, rather than co-existed. Stephens had concerned himself with Maya art and the questions that could be drawn from the works themselves, but he also thought he had put to rest speculations about Amerindian origins in asserting the veracity of the sixteenth-century Jesuit Acosta, who had proposed a land crossing from Asia as the explanation for human populations in the New World.

Soon nineteenth-century writers and explorers provoked by the ancient Maya made claims and investigations that ranged from the frivolous to the scholarly, with some at least straddling both camps. Despite being wild-eyed in his claims that the Maya civilization was the intellectual wreckage of the sunken continent Atlantis, Brasseur de Bourbourg rediscovered and published key documents that would lead to important decipherments of Maya art and writing. In rediscovering the first account of Yucatán written down by its suspicious bishop, Diego de Landa, Brasseur recognized that Landa's "alphabet" of Maya writing might some day hold a useful key. As an academic discipline of any sort, art history did not yet exist, but collectors of art abounded, along with collectors of rocks, gems, and the curious cultural remnant. Some of the greatest Maya treasures were swept off to foreign museums, where they fueled interest in deciphering the mysteries of this ancient civilization, an interest that in turn came to support archaeology both materially and intellectually. Some early anthropologists, in the belief that race constrained the potential for achievement, could not accept the very idea of civilization among indigenous Americans, and thought that at best, the Maya

were "barbarous" as opposed to "savage." Ironically, the addlepated Brasseur's contributions were to be of greater value than such sober inquiry into the nature of Amerindian humanity.

But even before such racist nonsense could fall by the wayside altogether, the nature of ancient Maya art proved its fallacy. When Alfred P. Maudslay began to study Maya art, he systematically retraced the steps of Stephens, ultimately (1898–1901) publishing the art and architecture roughly in the order Stephens had ordained, beginning with Copán and Quiriguá, and moving on to Palenque. Like Stephens, he looked for patterns, and he saw them in iconography and hieroglyphic inscriptions. Laying out the analogous inscriptions from the various sites, he set the stage for the pursuit of Maya hieroglyphic decipherment, and the quest Stephens had once prophesied for a Maya Rosetta Stone was on. The presence of such a complex writing system distinguished the Maya from all other New World peoples, and scholars came to place the Maya at the apex of New World cultural development.

Maudslay saw the relationships between art and writing, and he was one of the first observers of "full-figure" hieroglyphs, logographs—word pictures—and phonetic signs converted to animated figures, interacting with one another in the text. He also began to recognize repeated subject matter across generations in Maya art, particularly at individual sites, and he scrutinized the extraordinary lintels of Yaxchilán, seeing the richness of detail that is limited to a handful of Maya monuments.

With Maudslay's careful publication of Maya texts in hand, other scholars applied themselves to the decipherment of the published texts. But decipherment of the content languished while the

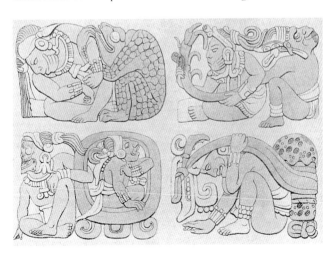

7. Alfred Maudslay hired Annie Hunter, a young London artist, to draw the Maya monuments that he had both photographed and made casts of in the field. Looking at her drawings, he discerned some key patterns of Maya writing and iconography, including what he called the "Initial Series," presented in his first volume. Here, the period glyphs for the uinal of twenty days and the day each bear a coefficient of zero, indicated by the hand on the cheek. The day sign and a glyph from the supplementary series follow.

rich calendrical framework, including the texts laid out by Maudslay, quickly came to be understood, providing evidence that the Classic Maya had thrived in the first millennium AD. Based on its different representation of the human figure, Chichen Itzá was assigned to a later period. Almost immediately the Maya were proclaimed the Greeks of the New World, the originators, the masters, with the Aztecs only recognized as their "Roman" followers!

As an antidote to studies of calendar and writing—and wisely sidestepping the bombast of "Greeks" and "Romans"—Herbert Spinden wrote *A Study of Maya Art* for his 1908 doctorate in anthropology at Harvard, a book almost continuously in print ever since, and a work that opened new ways of thinking about Maya art. Although Spinden was searching for a unifying religious principle—the serpent and its transformation—in all Maya art, the result was the first systematic study of Maya iconography, or what we might think of as the building blocks of religion. Using Paul Schellhas's study of Maya god representations in the same Dresden Codex that Stephens had pored over, Spinden dramatically introduced the names of Maya gods to their monumental counterparts and much of the common Schellhas nomenclature is still used today, including God A, a skeletal death god, or God K, a god with one leg that terminates in a serpent's head. Spinden drew on the collections of the Peabody Museum and recognized the value of studying Maya ceramics, even those without provenience. 8

And then Spinden did what no previous student of Maya art had done: he argued that both style and evolution were intrinsically present in Maya art, and that based on dated monuments, undated or unprovenanced monuments could be convincingly placed in sequence. Spinden wrote in the age of Bernard Berenson and Sigmund Freud: across the surfaces of carved stones he saw the traces of an unconscious to be recognized by outsiders, and in so doing, removed the Maya from consideration as a non-western people whose art would be timeless and unchanging, as Europeans and Anglo-Americans have often perceived artistic traditions they do not understand. In other words, Spinden's work made Maya chronology as inexorable and inescapable as Frank Lloyd Wright's Guggenheim Museum. Spinden's study drew the attention of art critics and the nascent field of art history. Roger Fry took notice, publishing Maya art in the pages of the prestigious *Burlington Magazine*, where no art outside the European tradition had ever appeared.

While World War I raged, Spinden tried to use his system to demonstrate that such monuments in sequence would have intrin-

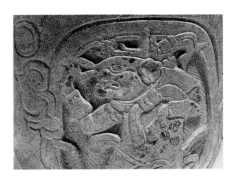

8. Herbert Spinden used the Maudslay drawings and the Teobert Maler corpus to analyze the iconography of Maya art, but he also studied objects in the Peabody Museum that he then used as evidence. His "Peto" pot can now be assigned to the Chocholá style.

sic content, and it is probably not coincidental that the content he thought would be present would be the questions of succession and warfare. Based on his earlier seriations, he proposed that the sculptural program at Piedras Negras presented first, an image of accession to the throne, followed, normally five years later, by that of a warrior. He noted the isolated groupings that these fell into around the site, and saw in them lineage and dynasty. Although Spinden never discussed his theory in relation to the politics of his time, he cannot but have thought about the European kings and princes who had donned the warrior's armor.

But Spinden's efforts to study art, and particularly its meaning, were not heard. One way or another, Maya studies have been driven by pursuit of ancient Maya writing, and Spinden, unlike any other member of his generation, let it simply be a tool, an indicator of date, rather than an engine. In general, whatever scholars have thought about the writing has determined how not only the art but indeed, the entire culture, was interpreted. When Stephens offered his belief that the writing probably provided the names of the kings and queens who had ruled Copán, the sculptures were accordingly thought to represent these kings and queens. But as time went on, attempts to decipher Maya writing yielded only dates and calculations: reading into the inscriptions the machinations of calendar priests, scholars decided that these calendar priests also were the subjects of the art. Unlike royalty, these calendar priests were thought to be anonymous, self-effacing, and uniformly male, even when wearing skirts. Dedicated to a life of stargazing, such priests eschewed war. Spinden's identification of warrior kings fell into disrepute, and for a generation, from World War I to World War II, scholars seem to have stopped looking carefully at Maya art, in order to convince themselves of the truth of their dogma. Studies of the Maya simply eliminated most considerations of Maya art.

Which is not to say that Maya art was not admired and collected, nor the world that had made it not extolled. Highland Guatemala, at Nebaj and Chamá, had previously yielded painted ceramics with elegant scenes at court; at Uaxactún, archaeologists pulled painted pots of a caliber previously unknown from the ground, and they puzzled over the imagery and texts before deducing that illiterate artisans had painted Maya pots, thus devaluing them for the intellectually elevated glyphic study and reducing them to little more than potsherds of chronology. Elegant figurines, some from highland Guatemala, and others from Jaina Island, in the Gulf of Mexico, introduced lively three-dimensional, hand-held works to the repertory, and quietly raised questions of manufacture, mass production, and the status of those who might own art.

When Sylvanus G. Morley, the dean of Maya studies between the wars, looked at Maya art, he knew that he recognized great art when he saw it. In his 1946 magnum opus, *The Ancient Maya*, one of the most interesting books ever to be written about the Maya, Morley unhesitatingly (and undoubtedly to the embarrassment of some of his more intellectual colleagues) named his "Fifty Maya Superlatives," enumerating (#27) the "most beautiful example of stone sculpture" (Wall Panel 3, Piedras Negras) and (#30) "most beautiful example of sculptured stone door lintel" (Lintel 24, Yaxchilán). Such enthusiasms irritated Tatiana Proskouriakoff, whose landmark book, *A Study of Classic Maya Sculpture* (1950), began with an assault on Morley's unscientific thinking. "In its crudest form [his] thesis maintains that the 'better' a monument is the later it is, until the development reaches a peak of perfection and a period of decadence sets in," she wrote. For the first time in several generations, a scholar once again began to look at Maya art carefully and ask the works what they could say to the modern viewer.

And of Maya art and its nature? Proskouriakoff introduced the term "Classic" to widespread usage, indicating the presence of what she termed the "Classic motif," referring to the "single human figure...at the center of the composition," a figure that might be a "deity, a priest, or ruler, or an abstract conception symbolically portrayed," and essentially falling within the chronological framework of the first millennium AD. Adopted for usage to delineate cultural periods throughout Mesoamerica, the Preclassic-Classic-Postclassic classification carries heavy freight today, in an era reluctant to privilege the cultural achievements of one era over another. But the terminology nevertheless persists and will be used here.

9

9. Lintel 24, Yaxchilán. Sylvanus G. Morley designated this lintel "the most beautiful example of sculptured stone door lintel" on his list of "Fifty Maya Superlatives," but he and other scholars of the first half of the twentieth century could only puzzle over its meaning. Blinded by their devotion to a belief that the Maya monuments depicted calendar priests, they did not recognize the troubling imagery for what it is: a woman running a rope studded with thorns through her tongue, on her knees before a king with a blazing torch.

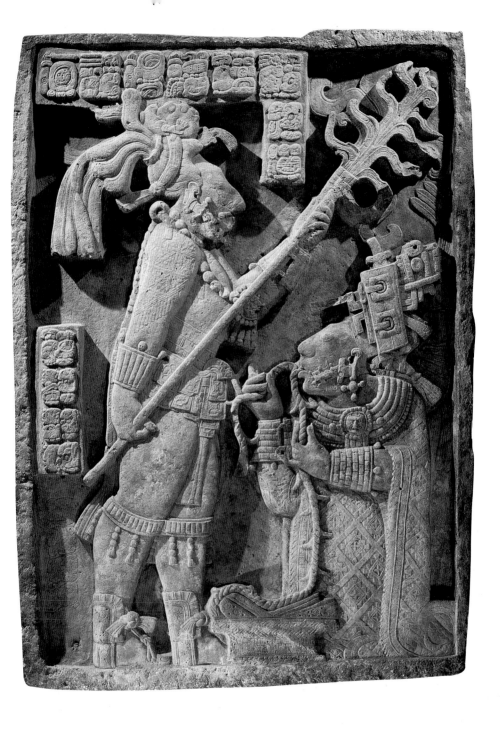

From 1940 to 1960, many American archaeologists turned away from the sort of center-city excavations that had yielded fabulous discoveries of sculpture and ceramics. Stung by criticism that the previous manner of work had been little more than intellectual stamp collecting, archaeology gave its attention to science, and to new techniques of scientific analysis. But this shift of inquiry created an opening for historians of art, both in Mexico and the United States, who began to look at the Maya corpus. Like their nineteenth-century predecessors, some were drawn to the naturalism and pictorial presentation, particularly on painted ceramics, and they saw humor, domestic life, and a lively engagement with the human form.

At the same time, widespread travel and amateur archaeology, as well as the tragedy of looting, allowed for more enthusiastic study of other Precolumbian arts of Mesoamerica, as the region encompassing northern Central America and most of Mexico came to be called, and Maya art could at last be recognized as only one of several pinnacles of artistic achievement, along with Olmec, Mixtec, and Aztec arts, among others. Miguel Covarrubias, a great student of Precolumbian art and a major figure in Mexican modern art himself, was in fact uncomfortable with the high estate in which Maya art was commonly held and preferred the seeming simplicity of Olmec art; in his writings he successfully deflated the cant that often surrounded the promotion of the "peaceful" Maya and their art.

Although the story of Maya hieroglyphic decipherment since 1960 has been told elsewhere, it is worth mentioning here that Tatiana Proskouriakoff played a key role in terms of both the decipherment and in transferring its implications to Maya art. Proskouriakoff recognized that the glyphs she deciphered as verbs indicating "ascension" to office and the "capture" of captives were associated with appropriate subject matter, sweeping away the veil of anonymity that had cloaked Maya art with the publication of her 1960 study of Piedras Negras inscriptions, its rulers and their sculptures. In one fell swoop, calendar priests became petty kings of warring states, promoting their cults for personal aggrandizement. Many of the personages Stephens had once supposed to be women were not robed priests, it turned out, but women indeed.

As the decipherment of the writing system transformed Maya studies and invigorated the study of Maya art, so did the personal energy and drive of Linda Schele. Her work in decipherment led her to frame new questions to be asked of ancient Maya art and society and to look into the very nature of ritual in ancient life. Her

work achieved a recognition unknown for Maya studies since the days of Morley, and she also bridged the disciplines of art history and archaeology, formulating a synthetic history of the ancient Maya. She reinvigorated interpretive work with the modern Maya, in whose thought, word, and deeds she found the imprint of the past. Her death in 1998 left Maya studies bereft.

One immediate result of the decipherment was that scholars began to scrutinize iconography carefully. When Michael Coe sat down to study the range of painted and carved pots in the early 1970s, he realized that they presented a world of supernatural, religious characters, accompanied by texts that were certainly not the scribbles of illiterate scribes. The role of ancient religion in art and its representation came to the fore: in both monumental and small-scale form, the Maya had taken note of their gods, rendering kings in their guise and illustrating ancient myths, some of which were recounted centuries later in the sixteenth-century holy book, The Popol Vuh.

Major exhibitions, *Die Welt der Maya* in Europe, *The Blood of Kings* and *Maya: Treasures of an Ancient Civilization* in the United States, brought public attention to Maya art, as did the flurry of quincentenary exhibitions in 1992–93 that included the Maya among their offerings. The featured subject of a traveling exhibition in 1993–95, *Painting the Maya Universe*, Maya vase painting has taken its place as one of the great ceramic painting traditions known to mankind. Clearly one of the world's great art traditions, Maya art has been receiving its due. The most casual student of art history opens most survey studies of world art and finds the Maya at hand for the first time since 1842.

Like other modern readers, I often pore over Stephens for his fresh insights, but perhaps his most important contribution was simply to recognize that the indigenous peoples of Chiapas, Yucatán, Guatemala, and Belize were all Maya and spoke Maya, and that they were the descendants of the ancients who had built cities, carved sculptures of their gods and kings, and written in a script that probably recorded their language. By the end of the nineteenth century, Maya art could be seen in London, or Paris, or Cambridge, Massachusetts. Driven by wars and mobilized by the world economy since the 1970s, the Maya now live in New Haven, Connecticut; Toronto, Canada; and Bonn, Germany. Like other peoples of the modern world, they are now in diaspora, as is the art of their ancestors. In this modern world, the ancient Maya need no longer be thought of as a parallel universe, those "Greeks of the New World," but simply as the makers of their own world of Maya art.

Chapter 2: Maya Architecture

General considerations

From the first millennium BC onwards, as the Maya began to build public buildings, they created vast facades against which to stage great spectacles and plazas in which to congregate. Sixteenth-century Europeans described the winding processions that had moved from city and town to shrine all across Mesoamerica, brightly adorned warriors and supplicants poised against the man-made marvels of roads and pyramids. We can today imagine that among the Maya, many travelers would have been en route to make offerings to the Sacred Cenote or great natural sinkhole of Chichen Itzá, one of the natural marvels that focused human attention in ways like architecture itself.

With its very emphasis on mass and the relatively small attention given to interior spaces, Maya architecture is composed of a few relatively simple elements: the house, the volume of platform or pyramid, and the path or steps that animated the first two. At heart lies the one-room Maya house, and the sort of house built today has been built since the beginning of Maya settlement. Ancient Maya builders replicated the forms in stone and then multiplied them to compose great rambling palaces or isolated them atop huge platforms to create temples. Most characteristic of the house is its hip roof; translated into stone the result is the corbel vault, in which courses of stone approach each other until they can be spanned by a single stone. Despite being inherently unstable, the vault's relationship to the hip roof gave it such value that it was never challenged by any other vaulting, although the Maya also used flat, trabiated roofs using wooden beams and stucco.

The mass of pyramids and platforms itself is an astounding feat, for the Maya builders assembled tons of recycled rubble or freshly quarried rough limestone to construct huge pyramidal structures or to extend natural land forms. Builders framed off sections to fill with rubble; workers carried the rubble up tier after tier, often scaling a steep, unfinished staircase that was then covered by a more finely finished one when the structure was complete.

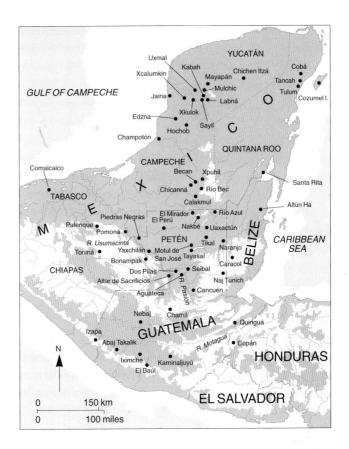

10. Map of the Maya region, showing sites mentioned in the text.

To us the mass always appears to be a solid, but the ancient Maya may well have understood the mass to be penetrated by the hidden voids of one sort or another—caches, tombs, and sealed rooms—that archaeologists uncover.

The counterweight to mass is void, and the Maya valued the plazas as much as the volumes. Larger buildings demand larger plazas, and so the largest constructions, whether at Late Preclassic El Mirador or Classic-period Tikal, received the grandest attendant spaces. A huge plaza like Quiriguá's often seems out of kilter with the modest volumetric mass. Like the massive constructions, plazas often overlie hidden efforts, usually drains in this case that kept the plazas from flooding. At Tikal, gently sloping plazas delivered water to reservoirs.

To connect these most important aspects—plaza, house, and platform—the Maya depended on two other essential forms, steps and pathways. Steps move humans vertically whereas pathways connect horizontally, and the Maya used both with careful

12

thought. Shallow, high, and steep staircases may have limited real movement, although providing visual access; deep and massive steps may have been most desirable for performances and rituals. At all periods of time, the Maya built elevated roads they called *sak behs* or "white ways," from the gleaming plaster finish of their surfaces. At a city like Uaxactún, the path became a ceremonial road to connect different clusters of temples and palaces to one another; in other cases, *sak behs* connected two cities, or city to town, as between Uxmal and Kabah.

From the earliest times, the Maya built a single axial architectural form, the ballcourt, for a game played with a solid rubber ball. In its simplest form merely two parallel mounds with sloping sides, the court also evolved more elaborate forms, with steps at one end or the other for seating or sacrificial display in one standard variation, or laid out in the shape of a capital letter I in another. Frequently found adjacent to palaces in their most elaborate forms, ballcourts also turn up at some distance from the hearts of ceremonial precincts, usually as simple stone-faced mounds. Sloping sides at southern lowland sites gave way to vertical walls at Uxmal and Chichen Itzá before the courts generally vanished from lowland Maya ceremonial precincts in the Postclassic, although Postclassic highland Iximche featured multiple courts. What modern scholars know of the play of the game derives both from Spanish descriptions and from the representations common in Classic art. Opposing sides fielded teams of three to five players to be on the court at once, and heavily padded players struck the ball to a goal—a ring, a marker, or the endzone—without touching the ball with their hands.

For modern observers, one of the difficulties in making sense of Maya architecture has been simply to see the architectural configurations through the sea of forest, whether the scrub jungle that grows with the 70 cm (28 in) of annual rainfall in northern

11

11. Tatiana Proskouriakoff developed this convincing reconstruction of Groups A and B at Uaxactún to demonstrate how the *sak behs* (elevated roads) connected the elegant clusters of buildings separated by ravines and swamps. She called it a city and noted that much of the area was "occupied by residential buildings and minor plazas and courts," but could not render it for lack of archaeological data. The resulting image probably helped foster the notion of the so-called "vacant ceremonial center."

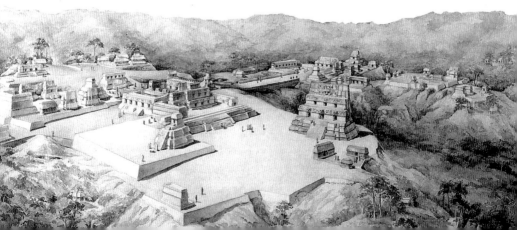

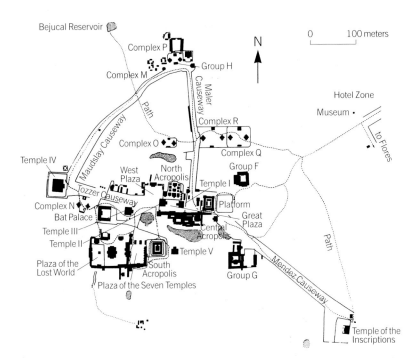

N

Bejucal Reservoir

Complex P

Complex M

Group H

Maler Causeway

Path

Complex R

Hotel Zone

Museum •

to Flores

Complex O

Complex Q

Temple IV

West Plaza

North Acropolis

Complex N

Bat Palace

Temple III

Temple II

Plaza of the Lost World

South Acropolis

Plaza of the Seven Temples

Maudslay Causeway

Tozzer Causeway

Group F

Temple I

Platform

Central Acropolis

Temple V

Great Plaza

Group G

Mendez Causeway

Path

Temple of the Inscriptions

0 100 meters

12. Simplified plan of the city of Tikal, Guatemala. The giant temple-pyramids and open plazas helped orientate the pedestrian on the ground.

Yucatán or the high canopy rainforest of Chiapas that results from 3 m (10 ft) of rain a year. Accordingly, viewers have often thought that there is no city plan nor even a city. Late twentieth-century depredations of the forest laid bare the Maya countryside, however, for the first time since the eighth century, making it possible to see the larger context of Maya settlement.

Unlike their counterparts at Teotihuacan in Central Mexico, the Maya found no attraction in rectilinear city streets or the city grid pattern. Rather, most Maya cities grew organically, from the core outward, and from the bottom up, with accretions that both expanded the city's radius and took its highest buildings ever upward. Maya architecture accommodated local topography and took advantage of its features: high, solid, limestone outcroppings served best for massive constructions; low, swampy areas could be turned into urban reservoirs. The Maya very rarely leveled a hill to rationalize topography, but they frequently hauled massive amounts of fill to expand and accentuate local features.

A city without streets has often seemed a confusing agglomeration of structures, but that point of view may be one informed by the modern plan or map reader. In fact, for a pedestrian at Tikal, finding one's way around the city might well have been quite straightforward, since the open plazas and huge pyramids created

12

both landmarks and vistas for on-the-ground orientation. Despite the ease its plan provides for the modern viewer, the meticulous grid of contemporary Teotihuacan in Central Mexico could have seemed labyrinthine, its narrow and congested streets (with the exception of its single great north–south axis) monotonous and confusing and preventing most long-distance views of its pyramids, the distinctive landmarks. Strikingly, those Central Mexican cities that were most closely allied with their Maya counterparts—Xochicalco, Tula—are most Maya-like in their city plan, whereas those that develop without regard to the Maya—Teotihuacan, Tenochtitlan—prefer the grid.

Were these great Maya centers "cities"? Not in any twentieth-century sense of the word, surely, but within the context of the premodern world and the ancient New World they were indeed. Interestingly enough, John Lloyd Stephens sized up Copán and Palenque as cities in 1839, and although he was not writing from the point of view of modern sociology or urban studies, the comparison he probably had in mind was his own New York City, where the population at that time was about 300,000. To him a city was a center of social extremes and a place of differentiated architecture: a cathedral and a palace could be distinguished just by their appearance; subtler differences separated city hall from the financial markets. Stephens himself did not hesitate to distinguish between a palace and temple, and he had reasonable expectations of what those terms meant.

Maya cities provided the greatest social differentiation of the ancient Maya world, for they were home to both the richest and the poorest of their times, with populations of 100,000 or so probably resident at Tikal or Calakmul or Caracol. Even a population of under 20,000 at Copán or Yaxchilán allowed for sharp separation of social classes. The rich were well off by any standards and the entire circle of king and court may have been as much as ten percent (and some scholars might hazard more) of the entire population. Over time, architectural forms differentiated themselves more and more, perhaps reaching a Maya apogee at Chichen Itzá, where the external forms of architecture are more distinct from one another than at any southern lowland site. Chichen Itzá may also have had the most heterogeneous population of any Maya city, and that mix may have enhanced architectural differentiation.

The earliest Maya cities of the central region established the pattern of fashioning highly elaborate exteriors of pliable stucco built over tenoned supports on their buildings. Usually—and the best-known examples today are those from Late Preclassic El

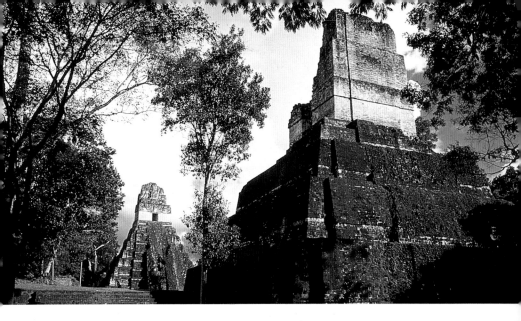

13. Temple I (left) at Tikal—shown here facing Temple II across the Great Plaza—once had an elaborately carved roofcomb.

Mirador and Uaxactún—the facades of the largest buildings feature huge heads of gods, and these may have functioned directly as idols for adoration and offering. By the Classic period, the scale of facade decoration diminished and may have been replaced by the use of portable braziers and urns, for example, that would have been set up on facades as called for. However, during the Late Classic massive decoration was set on the roofcombs or on upper facades. The roofcomb of Temple I at Tikal took on the appearance of a giant enthroned ruler, little more than the skeleton of which appears today. The upper facades at Uxmal bear elaborate iconography that offers clues to building function.

The rationale for building and rebuilding Maya cities was long linked by scholars to the calendar cycles of Mesoamerica. But were any buildings really constructed to celebrate the completion of 52-year cycles, when the solar calendars of 365 days and ritual calendars of 260 days intersected? Indeed, such a hypothesis now seems unlikely for any Mesoamerican city, for excavations throughout the region have demonstrated connections between building campaigns and the ambitions of individual rulers.

Because Maya society had no single central authority, individual rulers and different ruling families solved their architectural problems differently. Although cities of the Petén generally look more like one another than they look like the Usumacinta cities, no template explicates either regional variety and scholars have been stymied in their attempts to develop a formula that satisfies more

than a single center. Yet regional and temporal distinctions can be recognized: Early Classic Piedras Negras clearly resembles the Petén, whereas its eighth-century flowering follows the pattern established at Palenque in the seventh century. One might anticipate that the relatively similar physical environments of Piedras Negras and Yaxchilán, the former only a day's canoe trip downriver on the Usumacinta from the latter, would have resulted in similar architectural configurations, but they could hardly be more different in their architectural solutions.

Among the Maya the agendas of both ruling families and individual lords are sharply reflected in architectural programs. One of the most obvious concerns was to honor one's ancestors, to enshrine their tombs within huge architectural constructions and to make shrines at the top of those temples the site of veneration. At some cities these developed into huge ancestor complexes. At the same time, the city also served as the seat of visceral, mortal power. What may once have been fairly small and simple throne rooms became potent palace chambers, in some cases insulated from the view of the populace, and in others designed to command the public's attention.

Around the Petén: Uaxactún, Tikal, Calakmul, and Aguateca

The first cities of the Classic era arose in the region known today as the Petén, in northern Guatemala, where cities of the Late Preclassic had previously flourished, particularly at El Mirador. Most grew up around swampy areas, which may have been more favorable for agriculture than lakes and rivers. On most maps today, or even from the air, the Petén looks almost flat, but the broken terrain of karst limestone is in fact rolling and choppy, with underpinnings of solid stone serving best for supporting massive structures. The elevated roads called *sak behs* often span swampy areas to link complexes built on solid ground; for comparison, we need think only of New York City, where the rock under Midtown and Lower Manhattan supports massive buildings, connected by the "*sak behs*" of New York's avenues.

Early in the first millennium AD, the lords of Uaxactún constructed a large radial pyramid known today as EVII, with a staircase flowing down each side and directed toward one of the cardinal directions. Huge postholes atop the platform may have supported symbolic "world trees," rather than any sort of conventional structure. The lord or priest who stood at the center of the platform would then have stood at the earth's navel, the center, where the fifth direction of up-and-down would have come alive.

14

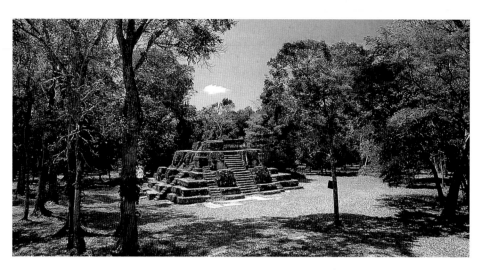

14. Archaeologists stripped away layer after layer of Structure EVII at Uaxactún during the 1920s, finally reaching an original construction ("sub") that was completed in the first 200 years of the first millennium. Although modest in comparison with contemporary efforts at El Mirador, EVII-sub was an important building in its day, a giant chronographic marker that confirmed the movements of the sun.

15. When observed from EVII, the three small structures facing the larger pyramid marked the equinoxes and solstices, so that the "E-Group" functioned as a giant chronographic marker.

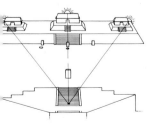

Massive plaster ornament featured giant heads of the Maize God borne by the upper halves of the heads of great serpents.

EVII-sub privileged the east facade, where in later phases a stela would be placed at the base of the stairs. On the east, the pyramid formed a particular arrangement with three smaller buildings, creating what has been nicknamed an "E-group," a configuration now widely recognized at sites with a strong Early Classic presence. Functionally, the Uaxactún E-group is a simple observatory. From a point on the eastern stairs, lines of sight can be drawn to the three small buildings which identify the sunrise on the days of the solstices and equinoxes. Rebuilt time and again throughout the first millennium, EVII's alignment remained intact.

Excavations in Group A revealed a very different sort of building program that flourished simultaneously. Before AD 250, Uaxactún lords had razed a perishable longhouse and built a three-temple complex, a triadic grouping even more widespread that the E-groups. As kings died, their successors buried them in fancy tombs topped by new temples in their honor. But in the seventh century, a new style of building took over the A-V complex: long, ranging palaces first blocked off the main stairs and then proceeded to turn the old cluster into a sequence of private courts. Royal burial moved to new sites along with their temple shrines, but lesser members of the court—women, children, along with retainers—continued to be buried simply under palace floors.

From Uaxactún's highest temples, an observer could have seen the roofcombs of Tikal some 24 km (15 miles) to the south.

15

17

Tikal shares many architectural characteristics with Early Classic Uaxactún, but on a much grander scale. The Lost World pyramid forms the focus of an E-group. An adjacent fourth-century structure features the talud-tablero exterior construction characteristic of distant Teotihuacan, architectural testimony to the political allegiances of the era. Interestingly enough, the workmanship must have been entirely local, for its proportions do not conform to Teotihuacan standards. But the interest in confronting the differences between the two cities' architectural program was reflected on the small scale as well, evidenced by the three temple facades carved onto the surface of a pot cached at Tikal.

At Tikal, the North Acropolis effectively became a vast ancestral shrine over the 600 years that rulers buried their predecessors within the complex. For example, early in the fifth century, when

16. (below) Teotihuacan-style building at Tikal (Structure 49). Despite the arrival of Teotihuacanos in the fourth century AD, few Maya buildings took on any visibly foreign characteristics. However, Structure 49, near the Lost World pyramid, featured balustrades virtually unknown in Maya architecture but characteristic at Teotihuacan, along with unusual proportions for a Maya building.

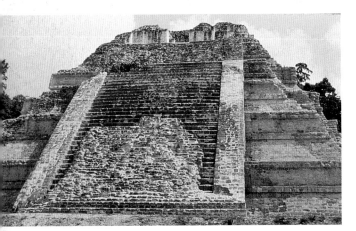

18. (right) Tikal's Temple I (foreground) faces Temple II across the Great Plaza, with Temple IV in the distance; the North Acropolis lies to the right.

17. (below) At Uaxactún, Group A buildings evolved in eight major stages over at least 500 years from a three-temple complex of the Early Classic to multi-chambered galleries in the Late Classic.

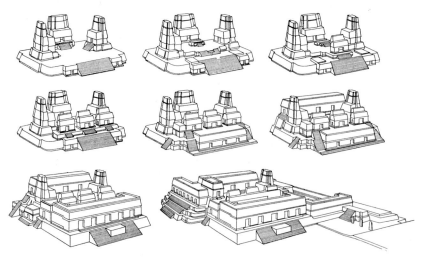

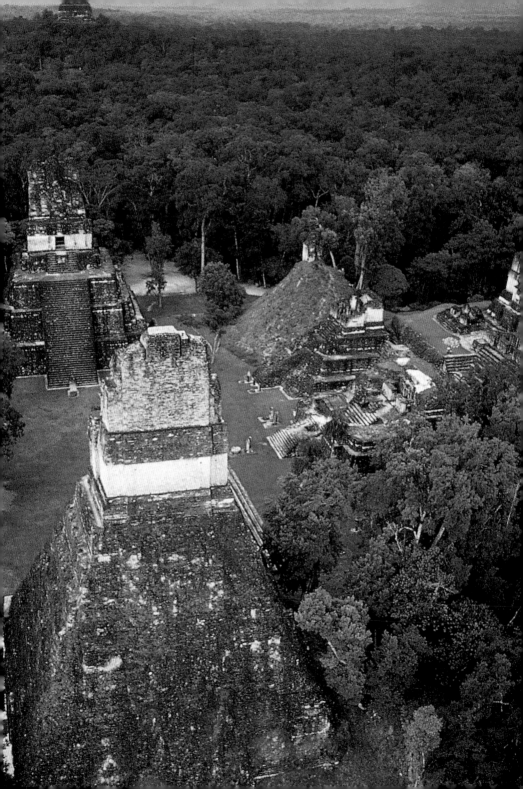

19. The pot from Problematic Deposit 52 at Tikal may show the arrival of Teotihuacanos at Tikal. Moving in a long column, the foreigners carry tripod cylinders and Central Mexican dartthrowers from a Teotihuacan-style structure, at far right, to a Maya one.

Siyah Chan K'awil oversaw the interment of his father, Nun Yax Ayin, he ordered a bedrock chamber be carved into the front of the North Acropolis; over the top workmen probably built a temporary structure so that the funerary rituals could proceed. Into the tomb went the abundance of Tikal—pots, foodstuffs, perhaps his namesake caiman, or "ayin"—alongside the dead king. Priests sacrificed nine young attendants to serve with him in the afterlife, and workmen constructed a corbel vault to seal the tomb. Then, over the next few months a pyramid known today as Structure 34 rose over the tomb, to be topped by a three-chamber shrine, the rooms linked together from front to back, railroad style. Siyah Chan K'awil had then completed the shrine to his father, and the building personified the late king. Eclipsed politically in the sixth century, Tikal simultaneously experienced sharp economic decline, and for nearly 150 years few buildings went up at the city.

Freestanding pyramids seem in general to have been shrines to powerful ancestors like Nun Yax Ayin, not only at Tikal but throughout the Maya realm. A king fulfilled his duty to his predecessor when he so honored him, but such constructions obviously reflected on the living as well. When Yik'in Chan K'awil had died, his heir and successor probably entombed him—although no excavations have ever pierced the structure—within the huge pyramid known today as Temple IV, the single most massive temple constructed anywhere during the eighth century. Was it all an act of filial piety, or did the heir also wish to demonstrate that Yik'in Chan K'awil had outshone Hasaw Chan K'awil, whose burial in Temple I had initiated the passion for such constructions in the eighth century? Or was the power of Yik'in Chan K'awil so great that his heir felt the need to wall him in as thoroughly as any living person could? Or, in building such a temple, did he also impress upon the neighboring cities his own absolute power, and did he force them to deliver some of the stone as tribute?

We may never know all the motivations of eighth-century Tikal kings that led them to build ever higher and grander, but the result, at the end of a century of construction, was a configuration of massive ancestral temples that all addressed Temples I and II, which stood in silent dialogue with one another across the Great Plaza. Temple I housed Hasaw Chan K'awil, whose death succeed-

ed that of his wife by just a few years, and who had been honored by, if not buried in Temple II (her portrait lintel spans the shrine doorway, but no tomb was found). Under Hasaw, Tikal had flourished once again, and his successors all paid homage to him in addressing his shrine with their own. Yik'in Chan K'awil's Temple IV was the greatest; Temple III may have sought to interpose itself between the father in Temple IV and the grandfather in Temple I as a member of the third generation since Hasaw. Visible from distant temple tops, the Tikal family pyramids stood like sentinels, ever on guard. These pyramids all face inward, perhaps to be likened to the way the triangle of Tikal causeways kept the populations moving only from one Tikal complex to another, without ever directing energy outward. Indeed, in its art, too, late Tikal turned inward, reflecting on its great achievements of the past.

During the eighth century the Tikal lords gathered up monuments from all over the city and installed them in front of the North Acropolis, effectively sealing the sector from further construction. The heavy rounded moldings of the Early Classic structures seemed framed by the clean lines of Temples I and II, as if in a triumph of Maya modernism. To the south of the Great Plaza the Tikal lords built a vast palace complex, known today as the Central Acropolis, with the structures of later generations directly on top of some others. Despite their inviting appearance, galleried structures that face the plaza prevent access to private courtyards within, and the only access was carefully limited by the large eastern palace. Beds and thrones provide evidence that the king and a large retinue lived there, with centralized food preparation facilities set on the south slope of the acropolis.

Starting in the seventh century, Tikal kings initiated along the causeways six unusual architectural configurations that are referred to today as Twin Pyramid Complexes. Unlike any other known Maya ceremonial architecture, these were dedicated to

20. Tikal's Twin Pyramid Complexes replicated aspects of the Great Plaza—pyramids at east and west ends, an ancestral shrine to the north, and a galleried building on the south—and were dedicated on katun (twenty-year period) endings.

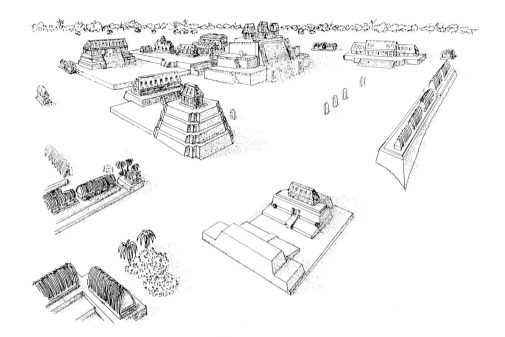

21, 22. Dos Pilas in its heyday (above) and in the eighth century (opposite), when its citizens ripped facings off buildings in order to throw up hastily made walls, presumably in a last-ditch defense of the city's core.

celebrate the katun, or twenty-year period of the Maya calendar, and the radial form of their platforms and the identical radial pyramids along the east–west axis may signal a calendrical orientation related to that of EVII. The north precinct houses a stela commemorating the king's performance of the katun ending, while nine plain stelae line up in front of the eastern pyramid; the western one never features stelae. The entire program may seek to miniaturize the Great Plaza, with an ancestor shrine on the north, matched pyramids east and west, and a simple palace on the south, and then to replicate the form along the causeways.

Tikal's greatest political rival, Calakmul, was also one of the most important of Classic Maya cities. Northwest of Tikal and in the modern Mexican state of Campeche, Calakmul probably suffered terrible depredations c. 700, when Tikal won a great clash between the two powers. Perhaps these wars explain why archaeologists found little standing architecture at Calakmul, but excavations in the 1990s uncovered acres of massive buildings, palaces, and shrines. Calakmul lords rebuilt a late Preclassic building into the largest structure at the site, Structure II. The Calakmul lords sometimes set their stelae several tiers up a massive structure, and their positions have been reconstructed in recent years. In the West Group, a ballcourt neighbors an unusual horizontal rock

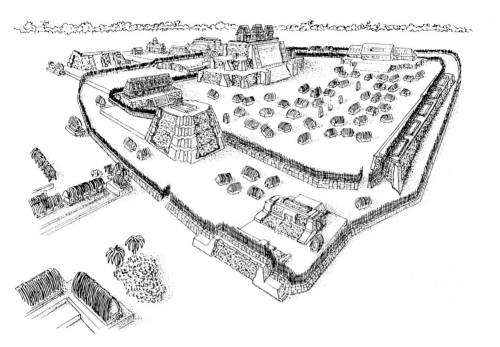

outcropping that features seven bound, naked captives, perhaps the site of sacrificial rituals to accompany the ballgame.

Probably during the sixth century a rogue branch—or its antithesis, the rightful heirs—of the Tikal family established rule of the Petexbatún region, with twin capitals at Dos Pilas and Aguateca. Much of the architecture was built hastily, but in desperate—and futile—eighth-century attempts to fight off battle and siege, residents ripped facings off structures in order to construct walls. Palisaded walls formed defensible, concentric patterns, without regard for pre-existing structures. Both cities fell to their attackers, but at Aguateca, attackers torched the roofs, setting off a fire storm that consumed the city. No one returned to sift through the ashes until Takeshi Inomata began to work through this Maya equivalent of Pompeii in the 1990s.

The Maya west: Palenque, Toniná, Yaxchilán, and Piedras Negras
During the Late Classic, the most dynamic architectural innovations took place in the western Maya realm, where dynasties grew quickly wealthy and used their wealth to promote their reigns with public works. Unlike the cities of the Petén, the western cities all feature obvious strategic siting. Yaxchilán and Piedras Negras both perch at key points along the Usumacinta River; set into

hillsides, Palenque and Toniná can observe the plains before them as far as the eye can see. Modest towns during the Early Classic—although some erected stone monuments and other works—they thrived just as Tikal faltered in the sixth century, as if they benefited economically from Tikal's weakness. Perhaps nowhere was this as clear as at Palenque, where an individual king (Hanab Pakal) and his two sons (K'an Balam and K'an Hok' Chitam) built most of what is visible today in about a hundred years, from AD 650 to 750.

At Palenque we know almost nothing of the previous program—except its very existence—but prior to Hanab Pakal, engi-

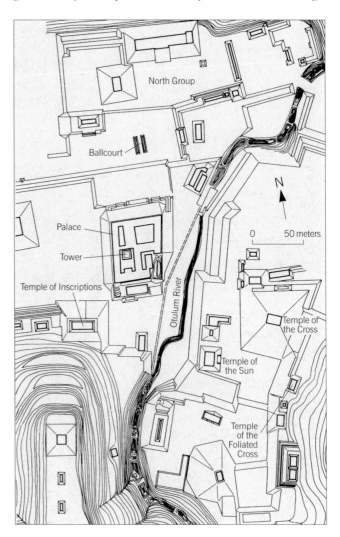

23. Plan of Palenque.

neers had canalized the Otulum River, bringing running water into the Palace. By the eighth century there were no fewer than three toilets in the Tower court, although the way they functioned is unknown today. Additionally, because of the steep slope down to the north, engineers had begun the construction of platforms on the north, in order to place galleries on roughly similar levels. 23

King Hanab Pakal first laid out his plan for the Palace with the construction of Houses E, B, and C, probably in that order, atop older structures that were converted into subterranean passages in this phase. The three buildings radiated like spokes from an imaginary point at the northern end of House E. House E became 24

24. Aerial view of Palenque's Palace complex, looking south. During the seventh century, Palenque architects constructed what are today the interior colonnades of the Palace, Houses E, B, and C, which radiate like spokes of a wheel.

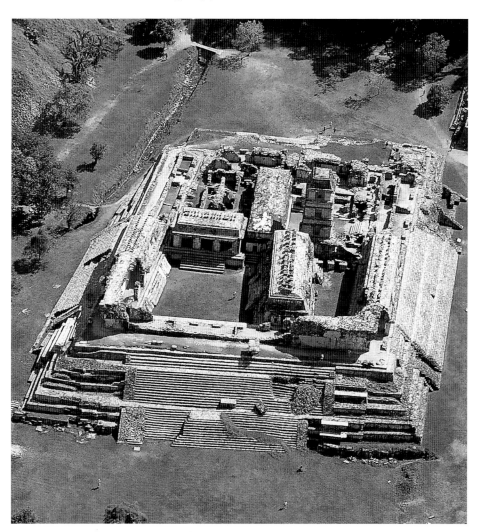

the center of the Palace, and its distinctive exterior drew attention to the significance of the building even when its principal function as a throne room was superseded within a generation, for unlike any other building in the Palace, it was painted white. Stylized flowers repeat with wallpaper-like regularity across the front facade, and text inside it notes that the building was called the "white great house," or *sak nuk nah*. As the first major building of Hanab Pakal's regime, House E anchored itself in the idiom of perishable architecture: its overhanging eaves are cut to resemble ordinary thatch, emphasizing its relationship to humble architecture. Hanab Pakal set his main throne here and other lords may have presided from portable thrones in House E.

With its open floor plan and the mat motif on its upper story, House B may have at one time been a *popol nah* or council house, where Hanab Pakal's lords would have gathered. From House B's south side, lords could have easily passed without notice through the back door of House E; they could also have witnessed the actions to the north from their front steps, in what eventually became the Northeast court. House C's inscribed steps relate the humiliating defeat Palenque suffered early in the seventh century; they remained *in situ* as Palenque built the evidence of its own war and tribute machine around the painful memory.

Perhaps because of the extremely heavy rainfall in the region, Palenque engineers solved the problem of creating interior space. By building side-by-side corbel vaults, the central wall was stabilized. Relatively light roofcombs rested over the central load-bearing wall, enhancing stability and allowing both the width and height of interior chambers to grow. The sloping mansard roof may have also been invented at Palenque, and its profile diminished the mass at cornice level and above, further enhancing stability. By the time Hanab Pakal died, his designers were cutting out keyhole niches on the interiors of corbel vaults, diminishing their mass; in House C, they added a staircase to the roof, where stargazers could gaze upwards at night and watchmen could study the plain for movements during the day.

K'an Hok' Chitam dramatically changed the old open, radial palace in the eighth century when he commissioned long galleries that created a rough rectangle around the central spokes. He set up his throne in House AD, commanding the view of the entire plain in front of him to the north. House AD probably became the main entrance to the Palace, but despite the open and engaging appearance of the long post-and-lintel arcade, the continuous interior wall meant that no further approach to interior chambers could be

25. Palenque architects both stabilized and enhanced the corbel vault by setting the heavy roofcomb along the central load-bearing wall, possible in the parallel corbel constructions of the Palace.

made from the north side. Rather, any visitor was channeled around to the east and west sides.

On the east side of the Palace, the visitor entered through the plain post-and-lintel entry only to find that the interior doorway to the Northeast court—and equally invisible from inside the courtyard—was an ogee-trefoil corbel vault elaborated with such curving finish that modern observers have been inclined to view it as "Moorish." Reaching to the top of the vault, such a cross-corbel construction began to achieve an interior space rare in ancient Mesoamerica.

But the visitor who entered the Northeast court unawares was 26 in for an additional shock: flanking the stairs leading down into the courtyard were nine huge, gross sculptures of captives similar to those chiseled onto the outcropping at Calakmul. One could literally walk along the front of the building, dancing along their foreheads to emphasize their humiliation. Across the way, along the lower story of House C, tribute-paying lords from Pomoná march toward its central stair. The message was clear: yield to Palenque and pay tribute, or end up a humiliated captive. The private courtyard may have been a place to impress neighboring lords with Palenque's prowess.

This kind of enclosed architecture became fortress-like without active aggression, guaranteeing privacy to those within its

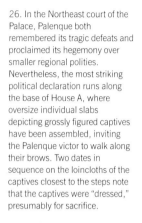

26. In the Northeast court of the Palace, Palenque both remembered its tragic defeats and proclaimed its hegemony over smaller regional polities. Nevertheless, the most striking political declaration runs along the base of House A, where oversize individual slabs depicting grossly figured captives have been assembled, inviting the Palenque victor to walk along their brows. Two dates in sequence on the loincloths of the captives closest to the steps note that the captives were "dressed," presumably for sacrifice.

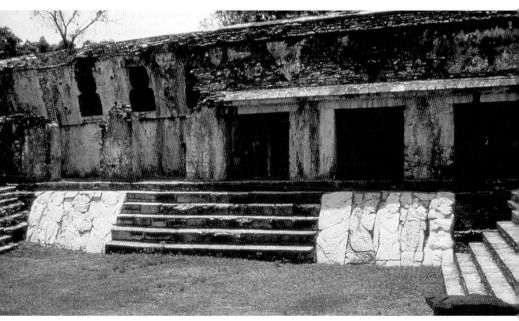

walls. Its iconography suggests that court business was devoted to war, taxation, and political machinations. The final building in the Palace was the three-story Tower, a unique survival in Mesoamerican architecture (one at Copán may have been washed away in the nineteenth century). Its construction made the old courtyard of House E nearly unusable, which may be how the court came to house toilets. Narrow staircases winding around a central core take the viewer to an ideal point for observation of the plain to the north, Palenque's vulnerable side. Meanwhile, elegant palace compounds were built to the northeast, where the Otulum River gave way to waterfalls and private pools. Probably the homes of wealthy nobles, as well as some members of the royal family, such palaces more effortlessly accommodated women and children, dogs and turkeys, and may well have been the sites of weaving, cooking, and an easy domesticity.

Hanab Pakal is the single king that we now know to have constructed his ancestral shrine during his own lifetime—perhaps as an extension of his conviction in his own divine kingship. Some years before his death in 683, his architects set the nine-level Temple of Inscriptions directly into the hill behind it, using the natural elevation for much of the pyramid's height. Until Mexican archaeologist Alberto Ruz lifted the floor slabs at the rear of the uppermost chambers, cleared the hidden interior staircase, and, in 1952, found the remarkable tomb that would later be identified as Hanab Pakal's at the base of the pyramid, no modern observer had had a clue as to the motivation that lay behind the building's construction.

27

The Temple of Inscriptions tomb chamber was designed for eternity, in ways different from any known Maya construction: instead of the usual wood, the cross-ties are stone (a material without the tensile strength wooden cross-ties provide) and a small stone tube, or "psychoduct," as archaeologists have called it, connects the tomb to the stuccoes at the top, following carefully along the staircase edge. Probably for generations after Palenque itself was abandoned, Maya memory may have retained the notion that Hanab Pakal was hidden within its secret compartment.

Like Tikal's Temple I, the Temple of Inscriptions rises in nine distinct levels. Both pyramids probably refer to the nine levels of the Mesoamerican underworld, where a king would descend to its nadir, only to rise up once again. Most Mesoamerican cosmic schemes feature thirteen levels of the heavens in which the surface of the earth is the first layer. Thirteen distinct corbels connect the tomb to the upper galleries, fulfilling both cosmic schemes in the

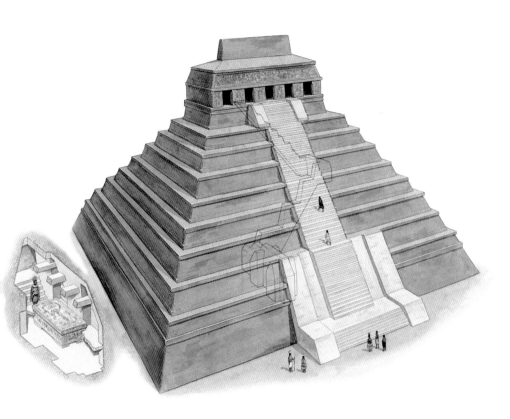

27. After archaeologist Alberto Ruz had located a hidden entry in the rear chamber at the top of the Temple of Inscriptions, he slowly emptied the rubble-filled staircase over several years, zigging and zagging until he discovered a great tomb at its base, on axis at the base of the exterior stairs. The detail (left) shows the interior of the tomb, with Hanab Pakal's magnificent sarcophagus at its center.

single structure. Despite Hanab Pakal's remarkable success in promulgating his own persona, his son K'an Balam apparently had the last word, for the stuccoes on the front facade show him to have been a god even as a child, his image united with that of K'awil.

Modern viewers have often found the Temple of Inscriptions, along with the Palace, to be among the most sympathetic of ancient Maya buildings. In large part, their attraction probably lies in the interior spaces, unusual even discounting their remarkable preservation. But another characteristic that makes these buildings so appealing is the proportional system, which promoted the square and rectangle in proportions Europeans call the golden section. When a rectangle with the proportions of the golden section has a square removed from one end of it, the result is a rectangle of the original proportions. Did Maya architects understand the system they were using, or are the results a happy accident? The piers and voids of the front facade of the Temple of

Inscriptions would suggest that at least at Palenque, they recognized the playful potential of such a system.

Located to the east of the Otulum River, the Group of the Cross set themselves apart from the rest of Palenque: in fact, from the top of the Temple of Inscriptions, the Temple of the Sun appears to have turned its back. Hanab Pakal's son K'an Balam dedicated the three-temple complex in 692, when he was a relatively old man, and perhaps he wished his own program to have little to do visually with the program of his father, since he also seems to have made little contribution to the Palace. In any case, the Cross Temples feature a design principle also present in House AD of the Palace, where a single high vault intersects parallel ones at a right angle, creating huge interior spaces. Here the mass of Maya architecture has been reduced to fabric that envelops void. A small shrine at the rear of each structure forms a symbolic

28

29

28. Hanab Pakal's oldest son, K'an Balam, dedicated the Cross Group in 692, nine years after the death of his father. Each building holds a rear shrine that functioned as a symbolic sweatbath for each of Palenque's patron deities.

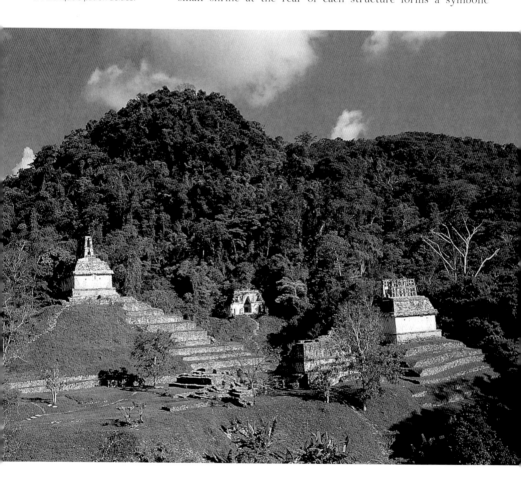

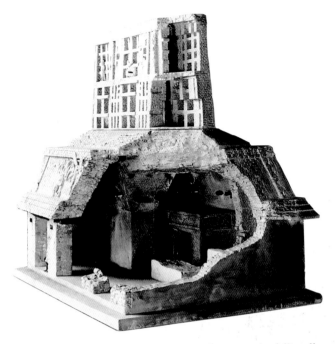

29. Cutaway model of the Temple of the Cross. In bisecting two parallel corbeled vaults with a single corbel, Palenque architects opened up interior space in a way not followed—or invented—at any other Maya site.

sweatbath, a *pib nah*, in the accompanying texts (and literally reading "undergound pit oven"!), and the iconography of each temple runs from the sculptured panel of the shrine to the facade and onto the roofcomb, constructed in each case as a lightweight stone assemblage, finished with stucco ornament.

Palenque sits on the first substantial rise to break the long plain from the Gulf of Mexico. Moving due south, the elevation climbs, going both uphill and downdale, until one arrives at Toniná, set at about 900 m (2,950 ft) above sea level, higher than any other major Classic "lowland" site. Seven distinct south-fac-30, 31 ing terraces rise up from the plaza level, and the public imagery of its architecture provides ample evidence of the intimidating way Toniná handled its enemies. A huge stucco facing rising from the fourth to fifth level features a terrifying death god who bears the decapitated head of a Palenque lord in his hand. Dozens of sculptural fragments found on the plaza probably once composed a fifth-level frieze of Toniná's most famous victims.

Toniná follows a more rigorous geometry than most Maya cities, with right-angle relationships between most buildings. This is especially evident on the plaza level, perhaps following the geometry of the two important ballcourts. The larger of these, H6, emphasizes the theatricality of the Maya ballgame and its role in public sacrifice as a post-war ritual. Protruding from the sloping

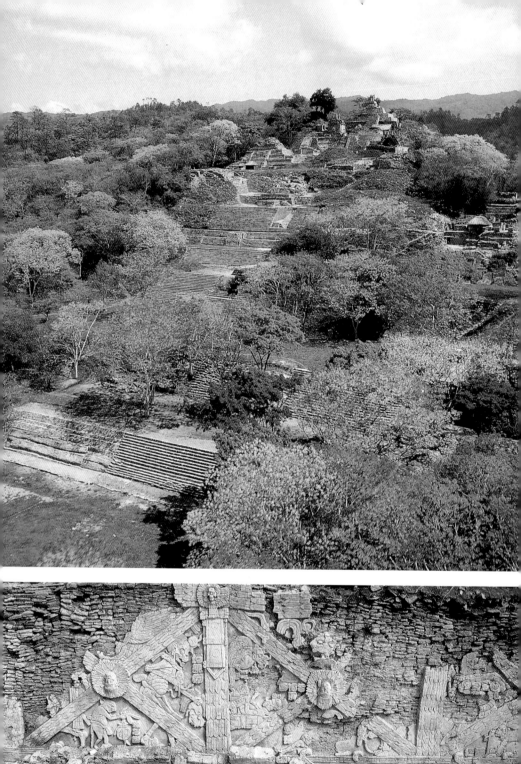

30. Toniná commands views to the south. The site rises up in seven distinct levels from the plaza, where two great ballcourts dominate. A stucco-finished retaining wall rises between the fourth and fifth level, featuring a hideous death god.

31. A death god at Toniná (a "turtle-footed" death god notes the text) gleefully holds out the decapitated head, whose closed eyes also signify death. The head's luxuriant tresses may liken him to the ear of harvested maize; his elegant profile may indicate that he is a captive from Palenque, a victim of Toniná's wars. A cheerful rodent follows behind. The geometric banding, punctuated by decapitated heads, is otherwise unknown in Maya art.

walls along its narrow alley are unusual markers, each composed of a trussed human body attached to a shield. At Toniná, the architecture served the mission of its warrior kings.

Today the boundary between Mexico and Guatemala for much of its length, the Usumacinta River was a great artery in Classic times. The river's traffic probably made some Maya towns and cities wealthy, but it also promoted discord and provided relatively easy access for uninvited warriors. Given their similar environments along the river and relative proximity, Yaxchilán and Piedras Negras might be expected to have developed along similar lines, but in fact the opposite is true. Their main relationship seems to have been antagonistic, and they inhabited different political orbits.

Yaxchilán planners capitalized on a steep hill perched on an omega-shaped spit of land that slowed the speed of the water right in front of their main plaza. Remnants of stone pilings remain in the river, vestiges of what was once a pier—or perhaps a tollgate that allowed Yaxchilán's lords to demand payment for safe passage. Small, independent structures creep up the hillside, so that all structures above the plaza level hold commanding views of the river to the northeast. Unlike most other Maya cities, few galleried buildings form palace quadrangles at Yaxchilán, nor are there obvious funerary pyramids.

The entire plaza-level construction may well have functioned as a grand palace. Buildings on the southwest side feature the portraits of female dynasts, and a sculpture in Structure 23 notes that Lady Xok commissioned the structure. Although rarely identifiable in Maya architecture, these buildings may well have been women's palaces, the special preserve of royal wives and female attendants.

While women were building plaza-level buildings, the Yaxchilán kings played king of the mountain, dominating the highest points of the hillside with buildings that announced their supremacy. Early in the eighth century, Itzamnah Balam II claimed the highest point with Structure 41; fifty years later, his son Yaxun Balam commanded control of the plaza from Structure 33. The latter apparently also leveled Early Classic buildings, whose sculptures he then incorporated into some of his own projects. Powerful and assuming, these structures tried no Palenque-style engineering innovations. Both are narrow, single-chamber structures; heavy roofcombs over their vault capstones would exacerbate the tendency of corbeled constructions to collapse. Apparently aware of this problem, Yaxchilán builders reinforced

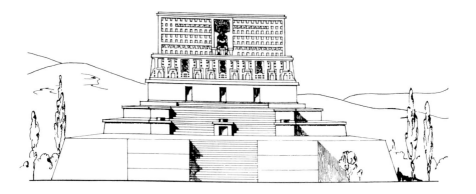

32. Elevation of Structure 33 at Yaxchilán. King Yaxun Balam demolished some earlier structures when he built Structure 33 to celebrate his reign. The building dominates the plaza.

their buildings with interior buttresses, leaving even less interior space. Yet capturing interior space may not have been the priority that capturing the mountain was: in front of Structure 33, Bird Jaguar also set up a carved stalactite within a pit, as if to create a symbolic cave and its attendant springs beneath his pyramid. In this way, he may have expressed the pan-Mesoamerican concept of *altepetl,* or "water-mountain," known to us best from Aztec practice, with its meaning of "civilized place."

Structure 33 also features an architectural element used widely at Yaxchilán, Dos Pilas, Copán, and a handful of other Maya cities: carved steps. Carved steps usually celebrate victory at the home site, although they may also have been erected at the defeated site, perhaps to force the movement of heavy stone—a practice known centuries later, among the Aztecs, who insisted that defeated towns deliver heavy rock to their capital. Yaxchilán's Structure 44 offers the single most dynamic record of carved steps, with defeated captives deployed on treads like doormats that must be repeatedly stepped upon. The risers, on the other hand, relate family genealogy, placed where no one can ever step.

Along with Yaxchilán, the other principal city on the Usumacinta is Piedras Negras, and the two were in keen competition with one another. Strategically located between dangerous rapids and the San José Canyon—the damming of which has been planned jointly by Mexico and Guatemala in recent years—Piedras Negras retains more Early Classic structures than most western cities, and may have been the unchallenged authority on the river until late in the seventh century, when Yaxchilán's fortunes rose.

Having started with complexes of palaces integrated with what are probably funerary pyramids toward the southern reach of the site—and marked by sequences of monuments—construc-

tion of later palaces and temples moved northward. Although many buildings were rebuilt time and again, in a fashion more like Tikal than Palenque, the eighth-century architectural push was at O-13, the largest single structure at Piedras Negras, and in the West Acropolis. The greatest of all Piedras Negras compounds, as well as the northernmost, the West Acropolis is a vast palace framed by two large pyramids whose levels number nine when counted from the plaza floor. In the construction of galleries, Piedras Negras architects adopted the engineering techniques pioneered by Palenque designers in the use of parallel corbels, although the cross-corbel concept does not appear ever to have been used.

A vast flight of stairs separates the palace from the plaza floor, and as at Palenque, what seems to be an inviting galleried building instead blocks easy entry to the courts behind and above it. In Tatiana Proskouriakoff's reconstruction drawing, the principal throne in a formal receiving room can just be glimpsed through the colonnade on the north side of the first court. Far more private rituals would have transpired in the court behind, almost entirely inaccessible from the first. From the structures at the top, a commanding panorama of the river came into view, but the buildings

33. The West Acropolis, Piedras Negras. By the end of the eighth century, the West Acropolis was completely built up, a complex of palaces and funerary pyramids that came to be the center of royal ritual. Within the first main courtyard of the galleried palace, kings set first one throne and then another shortly before the city was abandoned and the throne smashed on the palace steps. Sweatbaths to both left and right of the palace buildings may have serviced separate lineages or genders.

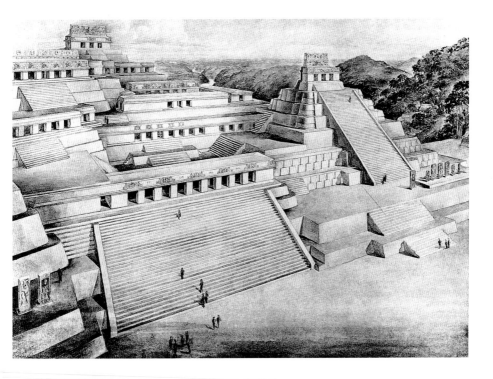

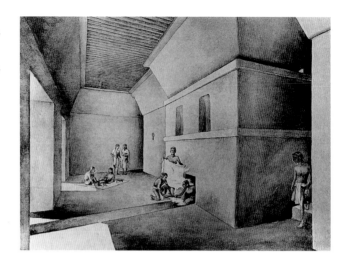

34. Tatiana Proskouriakoff reconstructed how the sweatbaths at Piedras Negras functioned, all under a roof of timbers. A spacious dressing room surrounds a small steam chamber, reached only by a narrow passageway.

themselves all face away from the water. Archaeologists found what was probably the tomb of Lady K'atun Ahaw, an early eighth-century queen, under the floors of a palace building, and like Yaxchilán, Piedras Negras may have had specialized women's structures.

Each side of the West Acropolis features a sweatbath, perhaps to accommodate separate lineages or to separate men from women. Although found from time to time at other Maya centers, these Piedras Negras sweatbaths were the grandest ever constructed, and no less than eight have been explored to date. To accommodate the special needs of a structure that had a vaulted steam room, complete with firebox, the builders sprung half a corbel vault from the steam chamber and then met the corbel with a huge span of timbers, creating a capacious interior space. The surrounding chamber, then, could serve a large population of bathers, for whom the baths probably met medicinal, ritual purification, and social needs.

In the southeast: Caracol, Copán, and Quiriguá

To the far east and south Maya settlements developed farther apart than in the heavily populated Petén and Usumacinta regions. Topography probably played a role, with the Maya Mountains of southwestern Belize providing both isolation and resources for Caracol, whose role has come to light only in recent years. Known primarily as the site that successfully made war on Tikal in the sixth century, Caracol was also adjacent to valuable wildlife and birds, minerals and materials of use to the Maya, all readily

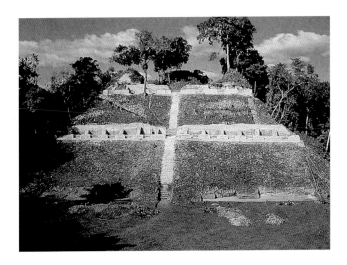

35. In an architectural innovation, designers at Caracol integrated palace and shrine function, enhancing the privacy of the nobility. In a building like Caana, courtly life took place completely away from public view, at the pyramid's top.

exploited in the nearby Maya Mountains. Caracol used its resulting wealth to build vast structures and to connect them with a web of *sak behs*.

At the center of the web lies a group known as Caana, and in its massive principal structures, palace and funerary structures were integrated in a program specific to Caracol. Palace buildings begin about halfway up the platform, as if to monitor movement along the central axis. Then, at the top, completely cut off from any public view, an entire complex opens up, so that members of the court could have remained separated from the rest of the population.

Almost 200 km (125 miles) due south of Caracol lies Quiriguá, Guatemala; a hard day's journey further south of some 50 km (30 miles) brings one to Copán, Honduras, the southernmost of all Maya cities. Somewhat isolated from the rest of the Maya world, these two southern cities shared history, sculptural styles, and architectural practice, and the Copán lineage may have originally founded both of them. The answers to some questions about Copán may lie under the modern town, which rests on a key section of the ancient settlement. Other answers were surely washed away when the Copán River edged close to the Acropolis and destroyed elegant palace structures that had remained *in situ* as recently as the nineteenth century.

The rolling terrain of the Copán Valley provided superb opportunities for the dramatic siting of architecture, and planners considered both views of and alignments with the peaks and the dramatic saddle in the hills to the north. As a result, the Principal

36. The so-called Principal Group at Copán. The long narrow plan of the site replicates the long narrow valley in which Copán lies.

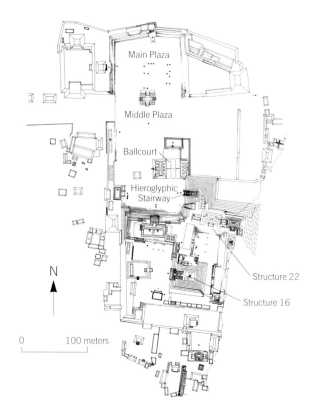

Main Plaza

Middle Plaza

Ballcourt

Hieroglyphic Stairway

N

Structure 22

Structure 16

0 100 meters

37. The Ballcourt, Copán. Rebuilt three times by Copán kings, the Ballcourt lies at both the center of the ritual precinct and at the center of Copán ritual life. Three markers down the court's central alley created metaphorical openings to the Underworld.

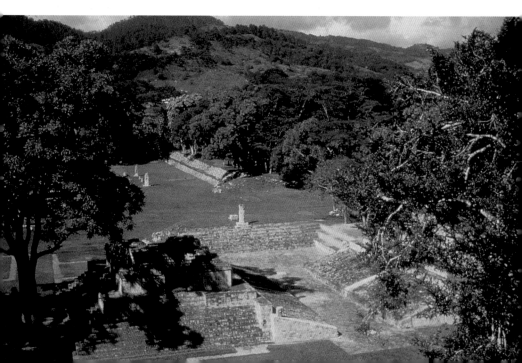

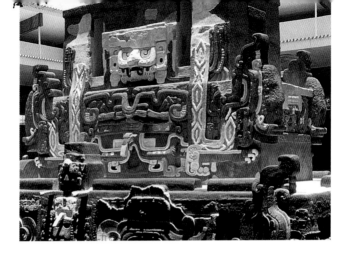

38. Deep within Copán's Structure 16 lies an Early Classic pyramid nicknamed Rosalila by its discoverers. Painted several times in shades of brilliant reds and greens, the building was the focus of Acropolis religious practice until it was carefully buried, probably at the beginning of the Late Classic. This view shows a replica constructed for the Copán museum.

Group has the quality of being a microcosm, with the surrounding landscape channeled and condensed into the man-made world. Within that man-made complex, the Ballcourt intensifies the reading of the landscape, as if the entire site could be reduced to its parallel structures and sculptures. One of the most beautiful of all Maya courts, the Copán Ballcourt lies at the heart of the Principal Group, placing the ballgame as well at the heart of royal ritual.

In recent years, archaeologists have tunneled deeper into the Copán Acropolis than has ever been attempted at a Maya site before. From far below Structure 16, a nine-level pyramid, has come evidence of what may be the Founder's tomb, interred in the early fifth century, when a new lineage began to direct Copán to great heights. Archaeologists have nicknamed the early buildings that overlie one another like onion skins deep underground Rosalila and Margarita, and they were carefully buried so as to retain much of their elaborate ornament. Subsequently, fueled by wealth and powerful leadership, Copán grew rapidly, and the Acropolis became a huge bureaucratic palace, at least in the Late Classic period—and the structure over the Founder's tomb remained an ancestral shrine at its heart in all the rebuildings.

Structure 22 may have been a principal royal receiving room in the eighth century. Its exterior was conceived to be a symbolic mountain, with the doorway its cave; maize gods flourished at its cornices, only to be scattered like chaff when the building collapsed years later. Huge Wits heads—indicating the symbolic mountain—display long noses at the structure's corners, much like the god heads of Puuc architecture in far-away northern Yucatán. Next door and obviously less important and less visible—it is set back from 22 and off the central axis of the court—is a

39. One of Copán's greatest builders, King Waxaklahun Ubah K'awil, constructed Structure 22 as a principal palace at the beginning of the eighth century. The Wits doorway configures the structure as a symbolic mountain; maize gods flourished at the cornices, as if to prove the abundance and fertility conferred by the king. A Popol Nah is recessed at left. In the foreground of the Jaguar Stairs is a symbolic ballcourt.

40. Whereas many hieroglyphic steps enunciate a particular victory, the Copán Hieroglyphic Stairway proclaims the victory of Copán throughout all time. An ascending supplicant goes back through time, following the texts, and must address five great Copán kings whose oversize representations sit in full relief on the stairs—including Waxaklahun Ubah K'awil, who died ignominiously at Quiriguá.

Popol Nah, or council house, indicated by the prominent mat motif on its frieze. Family emblems appear on the sides of the structure, perhaps indicating the prominent lineages of Copán: on the south is a fish, probably the same ruling Fish family who built a huge residential palace just to the south of the Acropolis. To the east, a now-lost graceful tower may have surveyed movements along the river.

Between the Ballcourt and the Acropolis stands the great Hieroglyphic Stairway, a large pyramid whose steps are inscribed with 2,200 glyphs that relate the history of the Copán dynasty. The text starts at the top and runs to the bottom, so that a supplicant beginning at the pyramid base would have the experience of walking back through time. Five three-dimensional rulers of Copán (some atop two-dimensional captives) sit on projections from the staircase, ancestors who accompany participants as they travel through time, at last entering a sacred antiquity at the summit. The Hieroglyphic Stairway was erected in the mid-eighth century, after the king of Copán fell captive to the king of Quiriguá. Usually hieroglyphic stairs proclaim victory or acknowledge defeat: in an unusual twist, the Hieroglyphic Stairway at Copán visually and textually demonstrates that it has always been a victor, as if to state that its particular historical circumstances were no more than a blip on its radar.

While the Acropolis went higher and higher over time, the Main Plaza retained its integrity as a huge open space, matched to the Acropolis very closely in terms of square meters of area and an effective visual counterweight to its mass. Although rebuilt periodically, the level was raised only slightly in the early eighth century, when older monuments were removed to the margins. A prominent king of the early eighth century deployed his own program of monuments across the northern end of the plaza, each manifesting a different deified aspect of his persona.

By the late eighth century, local lineages in the Copán Valley were vying for status and a role at court. Nowhere is this clearer than in the Sepulturas compound, where the House of the Bacabs was the central building of a palace compound that included adjacent homes of widely varying quality. Presumably the lineage in this compound had gained wealth and prestige through their practice and skill as extraordinary artists—to which they testify through some of the most artistically elaborated hieroglyphic texts known today.

Neighboring Quiriguá lies in the exceptionally flat Motagua River Valley, today little more than an island of forest amidst

40

banana plantations. The Quiriguá lords may have gained exclusive control of the trade in uncut jade, most of which was found in the middle Motagua Valley. After Quiriguá's surprise victory over Copán in 738, King Cauac Sky rebuilt the main group in Copán's image. Accordingly its acropolis and palace, as well as ballcourt, lie at the south end of the Great Plaza. With little previous permanent architecture in their way, builders conceived of a plaza far grander than Copán's. Without the counterweight of an equally large acropolis, and without Copán's defining plaza boundaries, the effect pales. The visitor is left to ponder the stelae set up on the Great Plaza, the tallest ones ever erected: they, too, seem out of proportion at the small site.

Río Bec and Chenes architecture

41. Great towers dominate the Xpuhil skyline, none with a functioning stairway but rather with stucco sculpture that only imitates a stairway and then forms a false chamber at the summit. Despite this remarkable deception, the pyramids probably hold tombs at their bases.

Short shrift is often given to the architecture of the Río Bec and Chenes sites, the best known among them Becán, Xpuhil, and Chicanná in the former region and Hochob in the latter, although any distinction between the two styles has depended on the presence of towers (Río Bec) and their absence (Chenes). In large part, these cities are often overlooked because their few monuments have yielded almost no legible texts. So while art historians can hang the architectural—and of course sculptural—developments

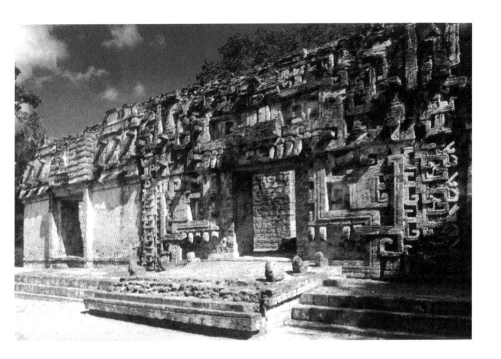

42. Both ranging and pyramidal structures at Chicanná all feature monster mouth doorways, turning most elite buildings at the site into symbolic mountains.

at Copán and Quiriguá on the armature of their known internecine warfare, no such narrative can be constructed for Río Bec and Chenes programs. Even though this book emphasizes art over architecture, there is good reason to look at these sites closely. For one thing, their buildings are among the most sculptural constructions of Maya architecture, particularly during the Late Classic. For another, from the tombs and caches of these cities have come exceptionally fine small-scale works. And the nearly complete absence of monumental sculpture is in itself a question worth asking of this region, for although the architectural tradition seems distinct from that of the region's nearest powerhouse, Calakmul, it may well be that Calakmul had dictated a prohibition on the stela, in which a king's very essence would be present.

Like Structure 22 at Copán, most Río Bec and Chenes structures feature great monster mouths as their central doorways. In their relatively flat landscape, these buildings all become symbolic mountains, or Wits, making architecture into topography. Chicanná's monster mouths deliver the visitor into single chambers, often with a second, dark chamber directly behind, in the sort of configuration for royal reception—and possibly for tribute storage at the back. At nearby Xpuhil and Becán, palace galleries are anchored by great solid towering masses—which are just false

42

41

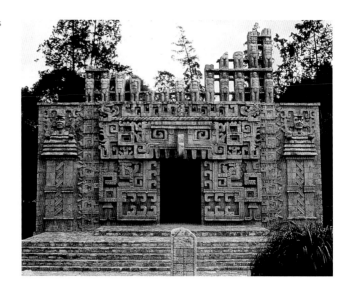

43. Captives stand atop the heads of one another, three tiers high, in the unusual roofcomb of the main building at Hochob.

pyramids, for despite the appearance of steps and shrine, both are created by simple stucco adornment, and the steps cannot be ascended. These towers may well be funerary monuments with tombs at their base, but perhaps the true pyramidal shrine was also prohibited in this region, along with the public monument.

Hochob, more than 100 km (60 miles) to the north, features the Wits doorways, but no towers, in characteristic Chenes fashion. What is most striking about Hochob is the roofcomb of its best-preserved building, for at least two courses of standing bound captives form its framework. The symbolic mountain, then, is capped by chains of human sacrificial victims, testimony both to the power and practice of the Maya in this region.

Puuc architecture

A band of hills known simply as the Puuc ("hills" in Maya) run in a large circumflex-shaped form in western Yucatán and northern Campeche. Although receiving little rainfall (less than 50 cm or 20 in annually) and with neither surface streams and lakes nor underground sinkholes, the Puuc was home to dozens of Maya sites, almost all of which flourished in the ninth century, supporting a far larger population than lives there today.

John Lloyd Stephens and Frederick Catherwood spent months documenting the architecture of the region (and fighting malaria; the disease would eventually kill Stephens); Uxmal, the largest and grandest of the cities, was the featured subject of the now-lost panorama they installed in New York City to great acclaim in

1843. But once the famous travelers had brought Puuc architecture to modern attention, these buildings' presence was insistent, and in the 1890s, casts of the facades were installed at the 1893 Worlds Columbian Exhibition in Chicago. The young Frank Lloyd Wright walked past these buildings every day, absorbing their formal qualities: later he would build Hollyhock House and other remarkable signature structures that made formal reference to Puuc architecture.

Like Piedras Negras or Palenque, Uxmal juxtaposes palace quadrangles with freestanding pyramids, some of which we may suppose were funerary in nature. Even the account told to Stephens about the Pyramid of the Magician would suggest that some pyramids went up quickly. According to the legend, an old hag nurtured an egg, from which then hatched a dwarf. Both of them held magical powers. She thought so much of the dwarf's abilities that she had him challenge the city's king to a series of contests. In one round, the king challenged the dwarf to see who could build the largest structure overnight; when the dwarf awoke at the top of the Pyramid of the Magician, he had won that contest.

With two distinctive profiles, the Magician must have been 44 built in at least two phases. On its west side, facing the quadrangles, a dangerously steep staircase leads to a monster-mouth Chenes-style shrine; a far gentler slope on the east leads to a typical Puuc chamber at the very top, with its characteristic mosaic ornament conforming to a compressed facade above the doorway.

The Magician looks out over the Nunnery Quadrangle, a palace that was conceived as a quadrangle from the first, as opposed to eventually ending up as a quadrangle, as at Palenque. The Nunnery, like many Puuc buildings, demonstrates some of the characteristics that makes Puuc architecture both visually satisfying and an engineering marvel. First, Puuc designers invented the "boot" stone, and they used it to stabilize the corbel vault. Literally 45 shaped like a high-topped shoe, the boot stone functioned as an internal tenon, anchoring the final course of stonework to the previous one. The greater stability meant that they could begin to use the corbel vault easily as a doorway, a practice that had only ever been used rarely, notably in the Twin Pyramid Complexes at Tikal. Additionally, they developed an efficient method of construction, in which thinly cut veneer stones overlaid a rubble core. In this way, much less volume of finished stone was required, and the fine workmanship of the veneer stones allowed them to be fitted together with almost seamless precision.

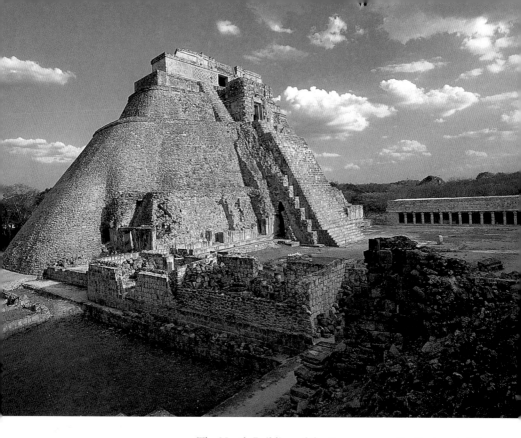

The North Building of the Nunnery was the first part of the compound to be completed, and its roofcomb runs over its front load-bearing wall, like a false storefront of nineteenth-century America. Although one might expect such constructions to be

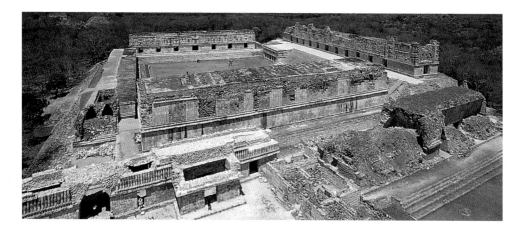

unstable, keeping the weight off the vault stones in fact anchored the structure, and the walls bearing these "flying facades" are sometimes the only ones left standing at some Puuc buildings. Later buildings of the Nunnery gave up this feature.

Finally, Puuc architects recognized the monotony of regularly spaced doorways of equal size. Each Nunnery building finds a different solution to spacing and size, culminating in the great South Building, whose central corbel doorway becomes the quadrangle's gateway.

The builders of the House of the Governor took all the lessons of the Nunnery and used them in a single structure, composing what may be the single most beautiful building of ancient America. The plan of the building suggests three individual structures, linked together by huge recessed corbel vaults. Vaults rarely exceed the height of the wall up to the springline, but these sloping vaults spring from the base of the overhanging facade and are thus unusually high, visually driving the building upward as if they were arrow points.

Only the central doorway of the Governor is a square, and each pair of the flanking rectangular entries stands yet another measure farther from its predecessor. This feature makes the building seem to flatten out. Simultaneously, however, the slight outward lean of the upper facade—or what is called "negative batter"—makes the building seem tall and light. Modern clothing, after all, yields the same effect with shoulder pads that visually whittle waists and make the wearer look taller! Furthermore, both effects are countered by the heavy, slightly overhanging upper facade, which presses down on the doorways and casts sharp shadows. As if to compress the full complement of ornament from a

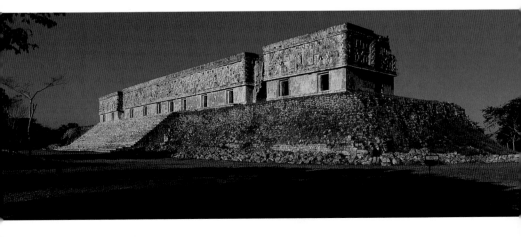

"flying facade," the elaboration of the upper facade is dense and rich, yet focused on the seated ruler over the central doorway who surveys his realm.

Given the huge platform of the Governor, there could have been a plan for a quadrangle, a project dropped at the beginning of the tenth century, when Uxmal was apparently abandoned. On the other hand, any additional construction would have eliminated the powerful view that the ruler would have had, particularly when seated on the double-headed jaguar throne still *in situ* in front of the building. Perhaps when the builders were completed, Uxmal's King Chan Chaak may simply have found the results so satisfying that not another stone was moved.

Sak behs connected the small Puuc cities to one another: just 18 km (11 miles) from Uxmal, Kabah marked arrival at its center by passage through the single greatest freestanding arch that the Maya ever built. At Labná, just 15 km (9 miles) farther south, a somewhat smaller arch defines entry and exit from its elaborate palace. The two sides of the arch present completely different mosaic adornments, with the far richer facade reserved for the interior. Small house forms flanking the arched opening probably held god images.

The mosaic ornament of Puuc buildings has long suggested the motifs of textiles, particularly given the sorts of repeating geometric patterning that covers facades like tapestries. Many buildings have dark, private rear chambers that cannot easily be seen from the front of the structure. The Puuc Maya may well have used these private chambers for the storage of tribute, particularly

48

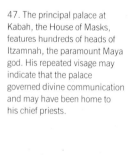

47. The principal palace at Kabah, the House of Masks, features hundreds of heads of Itzamnah, the paramount Maya god. His repeated visage may indicate that the palace governed divine communication and may have been home to his chief priests.

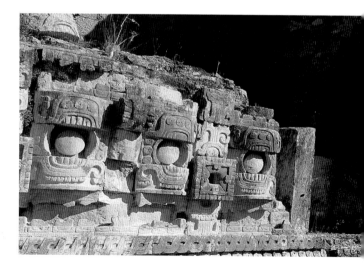

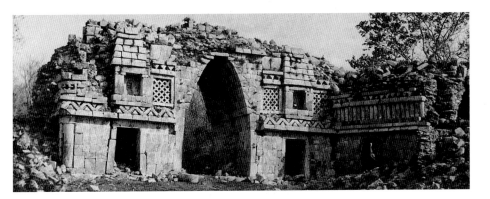

48. The Arch at Labná denotes entry and exit from the palace compound at the site.

textile wealth, and the very subject may have been publicly promulgated from building facades.

Most Puuc buildings also feature stacks of deity heads, sometimes at the corners of buildings, other times at cornices, and nowhere so overwhelmingly as at the House of Masks at Kabah, where these deity heads carpet the entire facade. Their great protruding snouts have long baffled Mesoamericanists: while early twentieth-century travelers wanted to read them as elephant trunks, scholars did not progress beyond calling them all Chaak, or rain-god masks. Recently Linda Schele and Peter Mathews have identified many of these heads as different aspects of Itzamnah, the principal creator god, who was often known in his powerful avian version. Buildings guarded by Itzamnah were places of divination and priestly power: the House of Masks once proclaimed its potency with its dazzling facade.

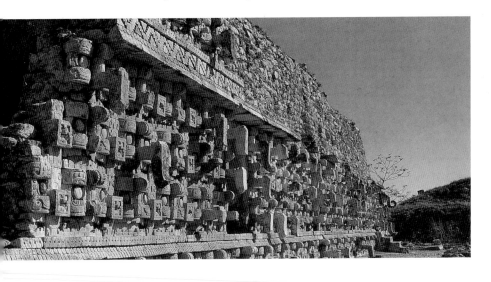

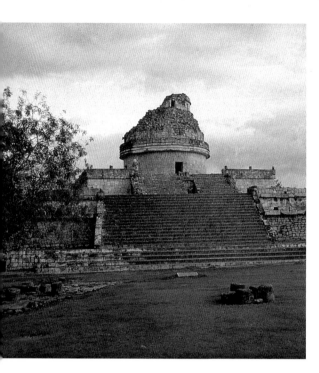

49. The Caracol at Chichen Itzá seems to be ever in motion, its doorways and windows off axis from its stairs, circling like the volute of a conch shell, from which it takes its modern name.

From Chichen Itzá to Tulum: northern lowland architecture after the collapse of Classic cities

For about 250 years, probably ending about AD 1000, the Itzá ruled from Chichen Itzá, making of it the single most powerful Maya city of all time, but with its power concentrated into a much shallower timespan than most southern lowland cities. Additionally, the rise of Chichen Itzá accompanied the decline of the south, and it seems likely that Chichen warriors broke up the old order as they constructed a new one in the north. But the result may well have been much more ethnically mixed than any previous Maya city, resulting in greater architectural diversity. Accordingly, although many buildings recapitulate types known elsewhere, there are also a number of new ones that seem to have taken root in Chichen's fertile mix. Several new elements were added to the architectural inventory, including the round building plan, clusters of piers and columns, and serpent columns, along with new built-in sculptural forms, chacmools and thrones supported by the raised arms of sculptured human forms ("atlanteans"), treated in Chapter 5.

The southern part of the city retained the most traditional forms of Maya architecture. The Red House, for example, features parallel corbel vaults and a roofcomb running over the central

52

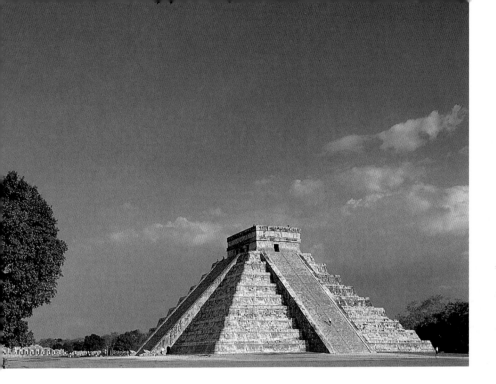

50, 51. On the two annual equinoxes, the nine distinct setbacks of the Castillo (as it has been nicknamed)—top—cast a seven-segment serpent of light against the north staircase. The visible Castillo contains a hidden pyramid within (above), whose royal furnishings—a throne and chacmool (ill. 126)—have remained *in situ* for a thousand years.

load-bearing wall, a lesson learned from either Piedras Negras or Palenque. The Temple of the Three Lintels is a Puuc-style building in its proportions, design, and ornament, but made without Puuc technology—boot stones and veneer masonry—or Puuc refinements.

Within this southern quadrant builders erected a structure with a remarkable plan: the Caracol, so-called for its conch-like plan of concentric circles which rest in turn on a small trapezoid atop a large trapezoidal platform. The central doorway of the Caracol does not align with the platform steps, so that the building visually seems to be ever circling in motion. Entering the interior, the ancient user of the building would have ascended to the second story by ladder, then taken tiny steps to the top. Much of the upper story has collapsed, but three small openings that seem to focus on the observation of the synodic periods of Venus survive. This round structure, then, would seem to be dedicated to the cult of Ehecatl/Quetzalcoatl, paired aspects of a Central Mexican deity associated with round buildings and whirlwinds, as well as Venus. Among the Maya he was known as Kukulcan, Feathered Serpent, and this building was his principal temple at Chichen.

The great Castillo lies at the center of the northern quadrant 50, 51 of the city as it is known today. Even in the sixteenth century this

49

52. Plan of Chichén Itzá, the
dominant city of the Postclassic
Maya.

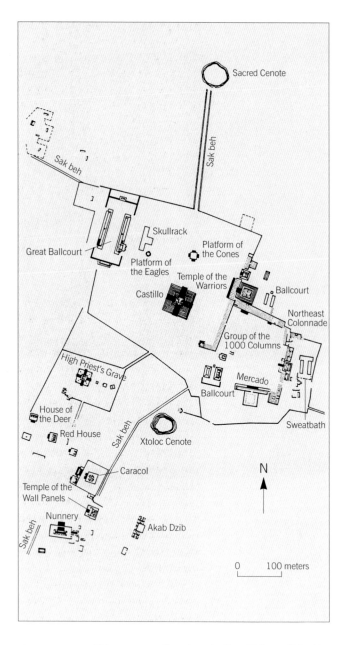

structure was still in some use, for when the first Bishop of Merida,
Diego de Landa, visited the site, he was able to count the 91 steps
on all sides, whereas Stephens found the structure an overgrown
ruin in 1840. Although Chichén Itzá had been abandoned for cen-
turies, the Maya of the region still visited its Sacred Cenote (the

Maya *dzonot* has become cenote in modern parlance), the great sinkhole connected by a *sak beh* to the plaza, to make offerings; the entire sector of the Castillo, plaza shrines, and the Cenote may all have been maintained for centuries after abandonment, much as certain buildings at Tikal may have been maintained for pilgrims.

Those 91 steps on each side of the radial Castillo total 364, and 365 if one counts the additional serpent heads on the north side as a step. Furthermore, at the time of the semi-annual equinoxes, a seven-segment serpent of light brilliantly appears against the northern face of the pyramid when viewed from the west. In other words, along with EVII-sub at Uaxactún or the Twin Pyramid Complexes at Tikal, the Castillo is a giant chronographic marker, both summing up the solar year in its numerology and marking its passage.

Additionally, the Castillo is a nine-level pyramid, which one might suppose is a funerary pyramid. Mexican archaeologists pierced the north staircase in 1936 and found a complete smaller version of the same building buried within, with the exception that it had only a northern stairway. It may well be that this earlier, unexcavated pyramid holds a tomb. Bishop Landa called the Castillo the "Kukulcan"; perhaps the bearer of the title Feathered Serpent still rests within.

Linda Schele and Peter Mathews have proposed that the Castillo may have been thought of as Snake Mountain, the Coatepec of Central Mexican legend, a place central to Mesoamerican creation beliefs. This may well explain the stone vessels with turquoise offerings interred in the north stairwell, and the assemblage of three jades laid out atop a turquoise mirror back in the "fossil" Castillo building, for both offerings are associated with foundations and creation beliefs. One of the oldest of the radial buildings, EVII-sub of Uaxactún, shares the iconography of Snake Mountain, a concept that may be more ancient than Maya culture itself.

To the west of the Castillo lies the Great Ballcourt, the largest in all of ancient Mesoamerica. The reliefs and paintings that articulate both the court itself and the associated buildings describe the sacred founding of the city and its supernatural charter. Furthermore, the Great Ballcourt was seen as the crevice from which the Maize Gods could be renewed and resurrected time after time. As large as a U.S. football field, the Great Ballcourt may not have been designed for mere mortal play: making contact with its rings, 8 m (26 ft) straight up from the playing field, would have

50, 51
15, 20

53

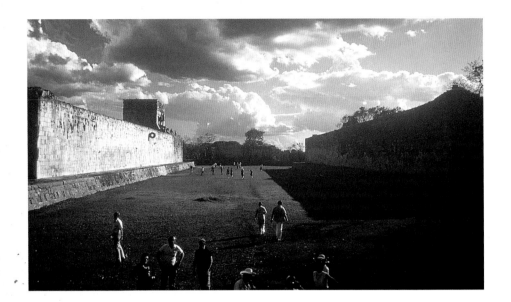

53. As large as an American football field, the Great Ballcourt at Chichen Itzá dwarfs human participants, for whom driving a ball through its high and small rings would have been nearly impossible. Three huge panels feature scenes of victory and sacrifice along each of the sloping walls at eye level.

54. Just to the northeast of the Great Ballcourt lies the Skullrack, of which a detail is shown here.

defied typical play. In fact, the use of the structure may well have been symbolic.

The adjacent Skullrack (Tzompantli), with its facade of repeating human crania, may well have been for the display of decapitated sacrificial victims from the Ballcourt. The Platform of the Eagles features alternating jaguars and eagles consuming human hearts. Such imagery is similar to that of the Toltec capital at distant Tula, Hidalgo, and may well refer to practices of human sacrifice and cannibalism common to both cities, in which human flesh was consumed during human transformation into their animal companions.

To the east stands the Temple of the Warriors, the largest of a series of colonnaded buildings that feature serpent columns, monolithic benches, and chacmools (altars in the form of reclining captives). In fact, as archaeologists discovered to their amazement, the Temple of the Warriors subsumes a nearly identical version of itself; the later building was simply enlarged and built over the earlier one, so that the front chamber of the Warriors rests directly over the corbel vaults of its predecessor. At the top, serpent columns frame the doorway, with a chacmool in between. The large throne in the rear chamber may have been for gatherings of powerful lords from distinct lineages, perhaps indicated by the individualized attire of the mini-atlanteans who support the throne.

The dozens of columns in front of the Temple of the Warriors feature both warriors and tribute bearers; some of the latter are

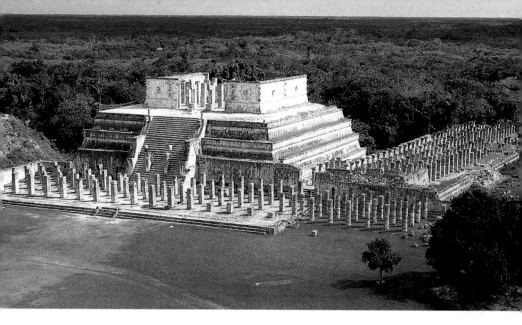

55. The Temple of the Warriors, Chichen Itzá. Dozens of columns populate the west (front) and south facades, probably once supporting a perishable roof over a chamber for careful screening of visitors to the temple's summit.

female. These columns supported a roof in antiquity; to enter the temple, one had to walk among this grove of guardians, and surely in the gloom one keenly felt their looming presence. By the time the visitor's eyes had adjusted to the darkness, he or she was suddenly plunged into the brilliant light of the staircase. The building, then, manipulated and controlled the observer, leaving little room for deviation from the practice spelled out by the iconography.

We can only wonder at the circumstances that led the lords of Chichen Itzá to make so many buildings in the template of the Temple of the Warriors. Some must have gone up simultaneously; others, as evidenced by the Warriors' own sequential construction, expanded an earlier version. Were these buildings council houses for the powerful lineages that came together at Chichen Itzá? Each lineage may have been responsible for garnering tribute and payments, all delivered and stored in these remarkable buildings: when the family of the Temple of the Warriors grew more wealthy, they built the largest of these structures, an architectural rival to the Castillo.

The Temple of the Warriors is very similar to Temple B at Tula, Hidalgo, in both the way columns frame the front of the building and also the way they formed contiguous plaza-level buildings. In fact, the entire plan of Tula relates closely to the main plaza at Chichen, not just reversed but rotated as well. Before the year AD 900, when the Toltecs were fully in power and reaping the

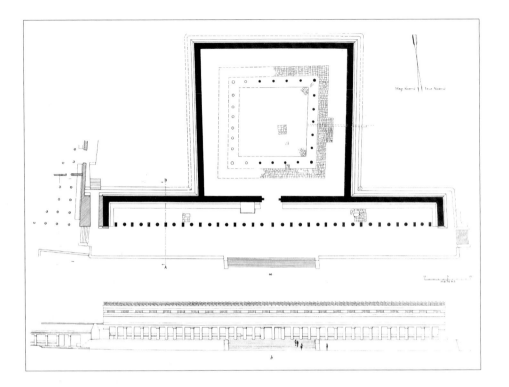

56. Spanish for market, the Mercado—seen here in plan and elevation—was probably no market at all but rather one of Chichen Itzá's most private palaces. Created rather hastily with recycled columns, the building also features uneven numbers of columns along a side.

benefits of the trade routes that brought American Southwest turquoise to Chichen Itzá, Tula and Chichen had established a special relationship. The nature of that relationship is unknown, but one can only imagine that when Chichen fell, Tula may have led the attack.

The large, somewhat enclosed space south of the Temple of the Warriors and behind the Group of the 1000 Columns could have functioned as a public market, as some have supposed. On the south side of this plaza there lies the so-called Mercado, or Market building. With a unique floor plan among Maya buildings, what sort of function did this structure really have? Like many Late Classic Maya palaces of the southern lowlands and the Puuc, the Mercado offered an appealing stoa-like facade—in this case, of columns with sloping benches carved with parading warriors behind—but like those palaces, in fact, entry beyond the facade is keenly limited, in this case, through a single door. What lies behind the facade is a single, grand atrium. Columns line the atrium, while the outer wall is solid, ensuring privacy for royal receptions or banquets. George Kubler long ago suggested that it might have been a tribunal, given the unusual floor plan. What tri-

56

bunals would have looked like, if indeed they existed, is not known, but the Mercado may well have been a building for a specialized function, one not represented at other sites. Vivid representations of autosacrifice might suggest that it was a building for ritual penitence. Whatever its function, the Mercado was built using recycled columns, and it seems to have been thrown together hastily, with uneven numbers of piers along east and west sides of the patio. Unlike most Maya public buildings at Chichen Itzá, the Mercado had a thatched roof, and at some point, attackers burned the building down, leaving the abandoned mess for modern archaeology.

Abandoned though it was, Chichen was not forgotten, not by pilgrims, nor by those who kept the records of how the past had been. Nowhere was the memory of Chichen Itzá kept more alive than at Mayapán, founded after the fall of Chichen. Unlike Chichen, Mayapán was a walled city, both perhaps to keep its population in, as well as to keep others out. At its center was a radial pyramid, a pale but important shadow of Chichen. Mayapán lords ordered pieces of Puuc facades dragged to their city, perhaps delivered punitively, perhaps brought as trophies. Dozens of small colonnaded buildings, mostly facing the pyramid, were sloppily made, using columns and stucco.

Finally, some of the last Maya architecture went up along the Caribbean coast, where Spanish invaders would spot the thriving Tulum in 1518, and where, once abandoned by the Maya, the pirates of the Caribbean found shrines and palaces to use as occasional bases of operation. The greatest of these coastal sites, Tulum was little more than a large town.

Protected by the coral reef offshore, Tulum was an ideal way station for the ocean-going canoes of Maya traders. Freshwater springs right at the edge of the sea provided water. Once beached at Tulum, traders with valuable cargo may well have felt some security as well, for Tulum was walled on its three land-facing sides, with watchtowers built into the corners, and the landing was protected and safe. Two Classic-era stelae found at the site were probably brought to Tulum as gifts or tribute by some of these traders. Many of the people who made a living associated with Tulum probably lived outside the walls, unlike Mayapán, but commerce took place within the walled precinct.

Although beautifully sited—and Structure 45 gazes out at the sea as if it might have been an ancient lighthouse—Tulum cared less for the sea, orienting its diminutive buildings inward, their backs to the water. The largest structure at the site, known as the

57

Castillo, was nevertheless exceptionally small by the standards of earlier Maya buildings, and its rooms were quite tiny. In general, Tulum's builders worked hastily and casually, depending on thick coats of stucco to even out shabby workmanship. The negative batter that made Uxmal's buildings light is so exaggerated at Tulum that buildings appear ready to keel over.

Far from Uxmal, in the highlands of Guatemala, rival Quiché and Cakchiquel Maya built independent cities in the last century before the Spanish conquest. Badly sacked by the invaders, Quiché Utatlan remains rubble today, but Cakchiquel Iximché became the first Spanish capital of Guatemala in 1524, and Bernal Diaz was later to recall its ample chambers. Founded between 1470 and 1485 on a plateau surrounded by defensive ravines, Iximché provided separate compounds for its ruling lineages, each with elegant living chambers, temples, dance platforms, and a ballcourt. Such programs were common among highland Maya towns.

57. The white towers of the Castillo at Tulum make the building visible from the Caribbean Sea, but the structure itself turns its back to the sea, addressing instead the other palaces and temples of the small walled city.

Shortly after the Spanish moved in and demanded heavy taxes, the Cakchiquels fled and fought a guerrilla war against their new overlords for several years.

Many Spaniards commented—unfortunately rarely more than in passing—on the extraordinary architecture and life of the people they fought doggedly against for a generation in Yucatán. When Francisco de Montejo at last subjugated Yucatán to Spanish rule in the 1540s, Maya lords were still carried in palanquins and Maya hieroglyphic writing was a commonplace. The one late and fine Maya city of which we know almost nothing is T'ho, which became the site of modern-day Mérida, founded in 1542. Some of its blocks can be found today in the Cathedral walls, or in Montejo's house, both along the main square of Mérida. Great recyclers of ancient buildings themselves, the Maya must have lamented the destruction yet nevertheless found it part of a familiar pattern.

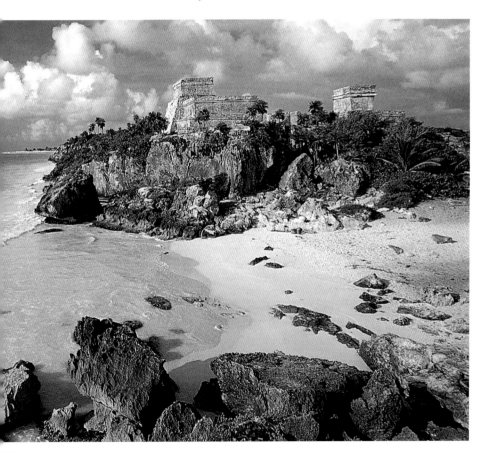

Chapter 3: The Materials of Maya Art

For most of the twentieth century, when archaeologists looked at the material basis for Maya civilization they despaired of its resources in every respect. Seeing in the jungle the potential only for shifting slash and burn agriculture, they even doubted it held the underpinnings of civilization. We know now that the rainforest—and even the term suggests bounty rather than the mass of tangle one might read into "jungle"—initially offered a world of abundance. From the sea to the forest canopy, wild out of the ground or grown and harvested by humans, the natural environment of the Maya offered a wealth of materials to fashion into permanent works of fine quality. Classic Maya cities clustered in the Maya lowlands, with the modern Guatemala department of Petén at the center, a region of stable, non-volcanic karst limestone foundation, cut by only a few large rivers, primarily the Usumacinta and its tributaries, the Pasión and Lacanhá, in the west, the Río Hondo, New River, and Belize River in the east, and the Motagua, which rises in the Guatemala highlands and courses east, not far from the Guatemala–Honduras border. In the north, the limestone yields to sinkholes, which open to reveal underground water. Many of these cenotes were holy places to the Maya, among them as we have seen the Sacred Cenote at Chichen Itzá, and valued objects were given to the water.

In other places, natural caves formed, particularly in eastern Petén and Belize, but elsewhere as well, in Yucatán and Chiapas. The Maya treated caves with reverence, carving and painting inside some of them, particularly Naj Tunich, and occasionally removing a stalactite for carving elsewhere, as they did at Yaxchilán. When the Maya dug into bedrock themselves, as they frequently did in making vaulted burial chambers, they may have had the sense of making a cave. The very hieroglyph for the Maya underworld is "black hole," and every cave, or black hole, may well have been perceived as an orifice, a place of entry into another world. They collected meteorites that crashed to earth from outside the atmosphere during seasonal meteor showers and offered them in sacred caches.

58. Draped with stalactites, the entrance hall of Naj Tunich, a grand natural formation, is illuminated by natural light. Most paintings are found deep within the cave.

Jade and turquoise

To the south, both Quiriguá and Copán lie near the rich sources of jade, and offerings that date to 900 BC at Copán reveal early exploitation of the precious material. The hardest rock of North America next to emery, jadeite occurs in rock and boulder form in and near the middle Motagua River, and it was worked in antiquity with jade tools, string saws, and leather strops. Both nephrite and jadeite are true jades, and both depend for their names on the fact that the Aztecs told the Spanish that the stone cured ailments of the liver (Spanish *hígado*, corrupted to jade) and kidney (or, in Latin, *nephrus*, eventually leading to the term nephrite for most Asian jade). The Maya most admired an apple-green jade whose precise source has never been found, and carvers frequently adapted their imagery to the veins of color in the stone, which could

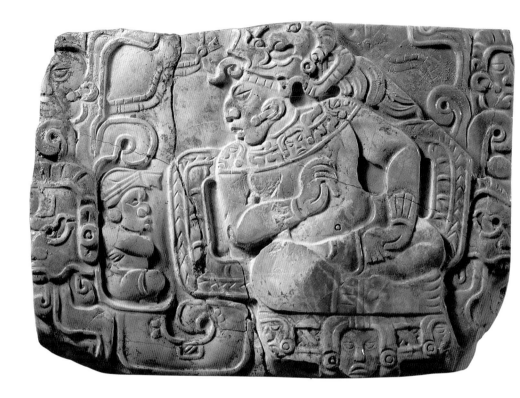

59. Using string saws, the Maya cut thin slabs of jade to form plaques, onto which they then carved two-dimensional representations of lords, the Maize God, dwarfs, or a combination thereof, as on this plaque from Nebaj. Archaeologists recovered numerous fine jades and painted ceramics at this highland Guatemala site, which may well have been a center for fine craftsmen.

range from white to black. The Maya preferred things green and blue-green over other colors, and may have seen them as like things— a green tropical bird feather, a jade bead, a young ear of maize sprouting from the stalk—and they used a single word to express the colors Europeans distinguish as blue and green. Sacred to earlier cultures, jade may also have connoted antiquity, and the Maya certainly collected ancient treasures. Devoted attendants placed a jade bead in the mouth of a dead loved one, either to serve as a receptacle for the soul, or perhaps to function as an endlessly replenished kernel of maize.

To the Maya, a jade bead was the symbol of preciousness itself, but objects in jade could range from the thinnest tessera to a 4.42-kg (9.75 lb) head. And, contrary to what we might expect to find, the Maya primarily identified the sun with jade, with the god they called K'inich Ahaw, or Ahaw K'in—Lord Sun in any lexicon. Squint-eyed, the sun apparently took on the squinty features that a human looking at the sun would have, within a very non-human squared eye frame. For reasons we do not know, K'inich Ahaw also had a front tooth in the shape of a capital T, and a fashion took hold.

59, 60

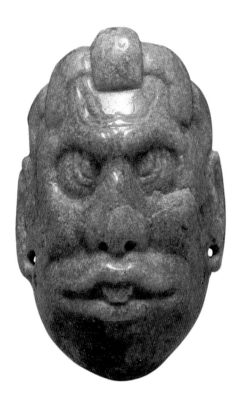

60. Head of the Sun God. Three-dimensional Maya jade heads usually feature either the Maize God or the Sun God, perhaps identifying the power of the sun with the value of jade itself.

To indicate both wealth and prestige, some Maya lords had their teeth filed into the T-form; others had them inlaid with bits of jade, a concept of human beauty that surprises us today. When King Hanab Pakal of Palenque died, his heirs assembled a jade mask on his face. The small flat jade tesserae yielded to large, specialized jade pieces for the nose and mouth; shell and obsidian formed his eyes. With the T-shaped tooth, the dead, masked Hanab Pakal must have taken on both the guise of the Sun God and the Maize God, two divine images of renewal, forever young and firm of face, even though he was a man of eighty years of age.

During the Classic period, the Maya used other greenstones, including fuchsite and serpentine, along with jade. Then, during the ninth century and into the Postclassic era, Toltec traders made a new material, turquoise, available to the Maya. Turquoise comes from modern-day New Mexico, and the Toltecs, Mixtecs, and Aztecs all treasured it for their mosaics. Most turquoise mosaics found in the Maya area were probably assembled elsewhere, and then imported to the Maya, but the Maya certainly incorporated the material when it was available to them.

Gold

Gold made only a late entry into Mesoamerica from South America, where metallurgy had begun in Peru by 3000 BC. Two broken legs, hollow, and therefore cast by the lost-wax method, of a Lower Central American figure, were found in a cache under Stela H at Copán, which could not have been sealed later than AD 731, making it the earliest securely dated gold of Mesoamerica. Well into the early Postclassic era, Central America remained the main source of finished and partly-finished metals. By no later than AD 900, the ability to manipulate raw lumps of gold had arrived in Mesoamerica, and gold began to be identified with the sun. Still, at the time of the Spanish Conquest of Mexico and Central America, most indigenous peoples favored greenstones over gold, a preference quickly exploited by greedy Spaniards, but little more than a few gold beads and bells turned up among the Maya of that period. Spanish conquerors seeking Maya gold went away empty-handed.

By the apogee of Chichen Itzá, and surely no later than the tenth century, Maya lords there imported quantities of metal from Lower Central America, particularly sheet gold. Little Maya goldwork has survived other than what divers have dredged from the Sacred Cenote. Some sheet gold may have been delivered in disk form, which the Maya then worked using a repoussé technique. The hammered imagery reveals sophisticated compositions, usually featuring the actions of Chichen Itzá lords in the middle zone, framed by sky gods above and underworld gods below. Slightly convex, the gold disks were probably affixed to wooden backing and worn by victorious warriors.

In the last few Precolumbian centuries, the Maya came to know and work other metals, including tin, silver, and copper, although most of these were imported, many from Central Mexico. The Maya at Santa Rita made ornaments using the lost-wax process, like the sophisticated craftsmen of Central Mexico. The Chichen Itzá cenote yielded a matching set of six copper bowls, all covered with gold foil, or what truly would have been a table setting fit for a king. In the sixteenth century, Bishop Landa would write of the cenote that "they also threw into it a great many other things, like precious stones and things which they prized. And so if this country had possessed gold, it would be this well that would have the greater part of it…" Needless to say, such lines inspired divers and dredgers to dream of what might lie in the muck of the cenote floor, and by 1904, Edward Thompson had

206

205

managed to find the first indications of the rich offerings he would retrieve from the murky sinkhole, including the precious metals Landa had predicted.

Fruits of the sea

Elsewhere, all across the Maya realm, and from early times onward, the Maya collected materials from the edge of the sea, seeking shells and pearls, as well as the host of animals who depended on the sea for their survival, particularly turtles. The Maya prized two shells over all others: the spondylus and the oliva. Found at depths which tax the limits of the unaided diver, the spondylus, or thorny oyster, yields a delicious high-protein food as its first prize, and the occasional pearl as its second. Although only occasionally found in archaeological contexts (King Hanab Pakal of Palenque's tomb contained jade jewelry studded with pearls), the Maya prized pearls, and adorned themselves with them. On Yaxchilán Lintel 24, Lady Xok's dress billows and drapes, revealing tiny sewn pearls on the selvage. Furthermore, the Maya valued the heavy and bulky shell itself, scraping off exterior spines and interior white nacre, reducing the weight by up to two-thirds, and revealing a brilliant orange interior. So worked, the spondylus shell trimmed the mantles of lords, formed a headdress ornament, or girded the loins of women. Workers cut other spondylus shells to become mosaic tesserae.

By comparison, other shells received simple treatment. Maya lords wore multiple strands of single-valve oliva at the hip, a noisy costume for dance or war. On Tikal Stela 5, Tikal's King Yik'in Chan K'awil has donned olivas, rendered with cross-hatching that may indicate a shiny surface or black paint. Pecten shells— the symbol of the Shell oil company—held their greatest value during the Early Classic, when foreigners from Central Mexico introduced their fashionability to the Maya. Simple surgery turned conchs into trumpets, although the Maya then carved and adorned them. We can well imagine that the iridescent fishes of the Caribbean fascinated the Maya, but only a few traces confirm their exploration of the coral reefs—for example, the widespread presence of stingray spines, a fish easiest to spot in reefs. At the time of the Conquest, the Aztecs had collected vast quantities of brain and other corals and interred them in their principal temple; the Maya, too, valued unusual sea material and added it to cache deposits, and occasionally to tombs.

Bone

Artists carved and worked bones of all sorts, human and animal. At Tikal, in the early eighth century, Hasaw Chan K'awil (Ruler A) departed the mortal world with a bag of some ninety carved bones, a number of them worked with delicate incision and then rubbed with brilliant vermilion. Some human bones may have been relics, or trophies. Just a glance at the pattern of burial at Early Classic Tikal reveals opportunities for both: the primary skeleton of the king in Burial 48 lacked femurs, a hand, and a skull, whereas his companions, presumably sacrificial victims, were interred with skeletons intact. Several things may have happened to this king's bones: if they formed a secondary burial, made after the flesh had rotted away or been boiled off, the heirs may have claimed relics. Or, if the lord had been captured and killed by hostile forces, only some parts of the body or bones may have been returned home. Excavators retrieved an elaborately carved skull from a Kaminaljuyú grave; a Chichen Itzá skull had been converted to a cup, reliquary, or incense burner. Either might well have been a trophy or prize. In distant Peru, shortly before the Conquest, enemies gloated that they would drink from the skulls of their enemies. The Maya may well have done the same thing.

61

62

61. Mourners buried nearly 100 carved human and animal bones in the tomb of Hasaw Chan K'awil, at the base of Temple I, Tikal. A single bone took the form of a tiny spatula: rendered on its surface in the finest of lines is the hand of an artist, painting—perhaps the very hand of the man who made this exquisite drawing.

62. With the cranium cut open and a wooden lid fitted into the opening, this human skull may have formed an incense burner or even a cup, for the apertures of the skull seem to have been sealed with wood and stucco fittings.

Stone stelae and other forms

A few years ago, the epigrapher David Stuart proposed a reading of *te tun*, or "stone tree," for the nearly universal upright prismatic shafts, or stelae, found at Maya sites. This was an appealing concept, for it seemed to incorporate in it the idea that stone sculpture had evolved from woodcarving. Other such evolutionary relationships between the perishable and the permanent can be seen in Maya material evidence: the stone roof of House E at Palenque is trimmed with stone that has been cut to resemble palm thatch. In other parts of the world such evolution is also specific, as, for example, in ancient Greece, where the great Doric columns evolved from tree-trunk predecessors, the very entasis (swelling) of their form related to the oak tree. Furthermore, Maya stone sculpture emerges as a well-developed tradition, without a lot of hesitant early efforts extant. One can only imagine that the grand tradition of Maya freestanding sculpture began with the sculpture of wood.

The Maya fortunately had a number of extremely hard tropical woods to carve, many of them more resistant to carving than stone but unfortunately biodegradable—and thus constitute a body of Maya art largely lost to us. Undoubtedly mahogany and

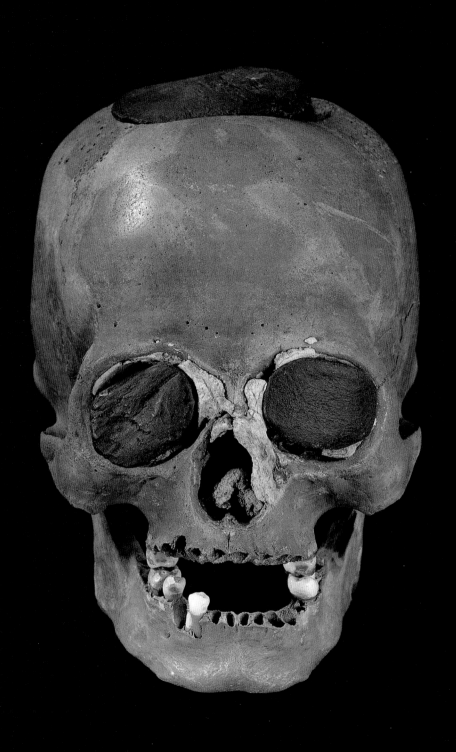

rosewood (the latter with its pungent, sweet smell) played a role in Maya wooden sculpture. Although only the tiniest sample remains, three-dimensional sculptures in wood were probably common throughout the history of Maya civilization. Surviving examples come from caves and cenotes; in one case, complete imprints of wooden sculpture survived at Tikal, where a tomb had been flooded hundreds of years ago, encasing works that subsequently rotted away. Additionally, Maya sculptors carved hewn boards of some of the hardest tropical woods (particularly sapodilla) to form figural and hieroglyphic lintels. Where these span the doorways of towering temples, as at Tikal, these lintels have survived *in situ.*

David Stuart subsequently came to argue that the Maya word stela was not "stone tree" but rather *lakamtun,* or "banner stone"— which nevertheless does not exclude wood as the model. The Maya set these stone banners in striking configurations, arrayed like trees of a well-planted orchard at the Main Plaza of Copán or like a receiving line of ancestors along the North Acropolis of Tikal. At Piedras Negras, each installation of a king initiated a new lineup of stelae, but never exceeding eight, and not in chronological sequence from the left to right, or vice versa. On other occasions, wooden banners or posts may have been placed in stone bases, as would appear to have been the case at Toniná.

Some sites favored stela-altar pairings, generally among dynasties whose efforts at stonecarving went back to the Early Classic, as at Tikal or Caracol. Scholars have occasionally sought to replace the term altar in the Maya lexicon, but in fact most of these round, low stones set in front of stelae feature imagery of sacrifice; at Tikal, for example, altar after altar illustrates the sacrificial victim. The wooden model for the altar was likely the stump or the sliced drum of a tree trunk. Particularly in the Early Classic, stumps of felled rainforest giants must have been ever-present, their concentric circles the model for concentric inscriptions common to altars, weeping sap the analogue to shed human blood.

Despite the general prevalence of the stela, the Maya adopted other sculptural forms. Palenque artisans assembled thin individual panels of limestone for large interior installations – and Palenque sculptors eschewed the stela form nearly altogether. At Yaxchilán and the Petexbatún sites, carved steps formed

63. The surfaces of altars at Yaxchilán bear concentric inscriptions, as do altars at some other cities. The resultant imagery suggests tree rings.

63

galleries for public intimidation. Piedras Negras builders incorporated carved panels into building facades—and although we may well think of them today as "outdoor" sculptures, awnings and canopies may well have made their positioning far more like that of "indoor" sculptures.

Limestone and other stone

At most sites, the Maya quarried limestone for their monuments, and at Calakmul, partly quarried shafts remain *in situ*. Using stone chisels, some of which have been found in ancient quarries, workmen freed blocks of stone on all sides until the prism could be broken off, leaving only a small "quarry stump" of the sort visible on some stelae butts. The quality of stone varied drastically from site to site: at Cobá, the grey-white limestone is full of fossilized seashells, which erode fairly quickly, leaving a nearly unintelligible monumental record. Tikal had access to a wide variety of limestones, ranging from the fine-grained stone of Stela 31 and most Early Classic stelae to the porous rock of Stela 11.

In general, limestone yields easily to the chisel when freshly quarried, hardening over time, and in the Maya west, sculptors carved fine-grained limestone as fluently as if it were butter. Particularly at Palenque (where the stone has a lovely golden

64. A small panel at the Art Institute of Chicago features a fine-grained buttery limestone, cut to suggest the architectural space of the ballcourt behind the playing figures. The victor stands at left, identified by his skull adornments; the loser has fallen, his legs tangled, the ball heading for his head, rather than his padded body.

64

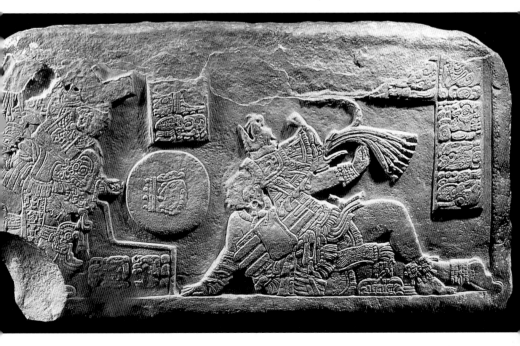

tone), the chisel worked almost like a paintbrush, whether in bas-relief or incision. Palenque painters and carvers may have been one and the same, in fact, as the sort of whiplash and pushed paintbrush lines were transformed to the chiseled surface.

On the southern margins of the Maya realm, stone other than limestone dominated sculpture. The volcanic tuff quarried at Copán ranges from brown to pink to green in tonality and was particularly malleable before hardening after exposure to the air. Not only did the stone lend itself to the greater three-dimensionality characteristic of Copánec sculpture, but it also provided material for massive mosaic facades. Most were covered with at least a thin wash of stucco, unifying tonalities, but today the colorful and varied underlying stone once again prevails. Balls of much harder chert naturally occur in the tuff, occasionally deforming sculpture, but on other occasions providing opportunity for innovation, and perhaps humor: in one circumstance, the name Waxaklahun Ubah K'awil is transformed to Waxaklahun "ball of chert," perhaps some sort of visual pun we can no longer recognize. At both Toniná and Quiriguá the local stone is sandstone, at Quiriguá a particularly hard and resistant red rock that defied attempts to transpose the three-dimensionality of Copán, try as Quiriguá sculptors might to achieve it. This red sandstone has great strength, however, with little predilection to shear off or fracture, and the Quiriguá lords used this to great advantage, erecting the tallest freestanding monuments of the New World.

Local stone was the rule, but exceptions occurred. Eighth-century Calakmul saw the erection of an anomalous stela of a black slate probably imported from the Maya Mountains, at least 320 km (200 miles) away—and perhaps evidence of political fealty conceded to the distant powerhouse. In the early sixth century, a problematic carved staircase began a series of long and improbable movements. In the first place, Nikolai Grube and Simon Martin believe that Calakmul forced Caracol lords to construct a staircase acknowedging fealty; later, defeated Naranjo rulers were forced to accept these same heavy blocks as evidence of their own demise. Two centuries later, the lords of Naranjo shipped a block— or perhaps more accurately, ordered the imposition – of the hated staircase to Ucanal, then their underling. Such movements of rock may become more apparent as scholars come to understand quarries and their sources better, but long-distance movement of heavy rock occurs elsewhere in Mesoamerica both from desire to import a material unavailable locally, as was the case for the Gulf Coast

65. A detail of Stela D, Copán. Copán sculptors and builders worked with tuff, a volcanic rock that often has balls of chert embedded in it. On the rear face of Stela D, sculptors worked the full-figure hieroglyphic inscription so that a ball of chert appeared as part of King Waxaklahun Ubah K'awil's name.

Olmecs of the first millennium BC, or to impose a brutal tribute burden, as was the case with the Aztecs at the time of the Spanish invasion.

Flint and chert

Flint and chert, the main materials for stone tools and weapons, occur throughout the Maya lowlands, usually in hills, where the Maya believed the material was deposited during strikes of lightning. A rock that sparks when struck, flint held both practical and ceremonial value. The Maya made thousands of flints that never saw use as tools. Artisans knapped flint into unusual shapes, ranging from actual weapon forms to simple dogs and turtles, and at their most prized, human forms. Archaeologists call these odd flints "eccentrics."

66. An eccentric flint. Using techniques difficult to replicate today, Maya flint specialists knapped the stone to release the delicate forms of gods and humans. Such flints were usually placed in dedicatory caches.

The knapping of stones was a specialized skill, and some artists who made eccentrics were able to achieve the subtlest detail of a pouty mouth or pronounced chin. 66 Eccentric flints in anthropomorphic form usually personify the god K'awil, whose characteristic torch may signal that he was the patron god of the material. Such flints may have been carried as K'awil scepters or tucked into a headdress; some may have been hafted into wooden handles. Other eccentric flints could neither have been worn nor carried, and they may have been made explicitly for architectural dedication caches, where they are often found, perhaps to channel the power of lightning into architecture. Eccentric flint figures sprout multiple human heads, some personifying body parts, particularly the penis.

Obsidian, cinnabar, and hematite

Other valuable materials came from farther away, from the Guatemala highlands, or the Maya Mountains of southern Belize. Volcanic flows provided obsidian, a material often considered the "steel" of the New World, used as it was for a wide variety of blades and projectile points, but it was also worked into art forms, and sometimes incised. The Maya found cinnabar, or vermilion, a brilliant red ore, as well. The Maya knew how to convert the soft ore to quicksilver—which they may also have encountered from time to time—first heating the ore to yield the volatile and poisonous gas mercuric oxide, and then cooling the gas to yield liquid mercury, dangerous enough but stable, which

archaeologists come across today in intact vessels, interred in caches and burials. More characteristically, however, the Maya preferred the red ore, and they applied it to sculptures and prepared bodies for interment with it. Mountains yielded hematite, a red iron ore, which found similar uses, particularly specular hematite flecked with mica, and which played an important role as a pigment in paint.

Stucco

Sculptors also shaped reliefs from stucco: the largest of all Maya sculptures are architectural facades, like those at El Mirador that represent massive heads of deities. Merle Greene Robertson's years of study at Palenque provide the best guide to the materials used: sculptors sketched imagery directly on plainly finished plastered walls, before building up an armature of small stones. Over these stones they built up layers of stucco, completely modeling human body forms before layering on their costumes. A single sculpture may have been repeatedly painted to preserve fresh imagery.

67

Stucco, of course, is made from cement, and cement itself was as essential to the builder as to the sculptor—or the painter, who depended on stucco for clean surfaces to paint on. To make a good quality cement that will in turn form a supple plaster or stucco, limestone must be burned, and it usually takes at least two days of steady burning to reduce limestone to powdered cement. The very process of production demanded fuel faster than the forest could replenish itself, and the widespread conversion from modeled stucco ornament to cut stone, particularly as seen at Copán, may have been driven by the disappearance of local supplies of wood for fuel. Stucco ornament flourished longer in areas of richer forest, notably at Toniná and Palenque. In the Late Preclassic, the Maya had millions of hectares of virgin forest at their disposal. By the end of the Classic period, they may well have suffered desperate scarcity of both fuel and construction materials, yet they probably kept right on burning wood to make cement.

The materials of painting

Smooth, plastered walls made ideal surfaces for painting, but we do not know the full extent of the monumental painting tradition. Buildings of perishable materials may have had stuccoed and painted façades, as well as roofs and roofcombs, some of which are depicted in Maya art, clues to a lost tradition. At Río Azul, Tikal, and Caracol, archaeologists have found Early Classic painted

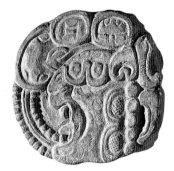

67. A stucco glyph from Toniná. Particularly at Palenque and Toniná, Maya artisans shaped soft pliable stucco over stone armatures, usually forming sculptural facades; in some cases skilled scribes worked the stucco forms into an elegant text.

tombs, many worked in a limited palette of cream, red, and black. The extent of full polychrome paintings may never be known, but the anomalous preservation of full-scale murals at Bonampak, painted at the end of the Late Classic era, raises the possibility that such powerful works may have existed elsewhere as well. The materials of monumental painting were expensive ones, and many had to be imported, including the azurite that Bonampak artists blended with attapulgite to make the powerful blue pigment that dominates the paintings. So valuable and rare was this ancient pigment that anyone looking at the walls of Bonampak may have looked at them with the awe of someone seeing the golden mosaics of Ravenna, where lapis lazuli—the azurite of the Old World— also studded the walls.

Maya codices

Small-scale painting inside fig bark or deerhide screenfolds, or codices, was a constant endeavor of the Maya scribe, right up to the Spanish Conquest, although the heyday was probably during the Classic era. In contemporaneous Dark Ages Europe, paper was unknown and vellum an expensive commodity: even at the time of the Spanish Conquest of Mexico, the Spaniards marveled at the Aztec profligacy with paper, for although they wrote on it, they also used it to adorn themselves, their headdresses, and the mannequins of their gods; they both made offerings on it and made of it a steady burnt offering on the altar. With fig bark so readily available, the Maya, too, must have considered paper a relatively inexpensive commodity. Although we can only guess what a book from the first millennium might have looked like—since the four books that survive all date from the centuries just prior to the Conquest—we can imagine that every Maya book was an illustrated book, with both pictures and text, every one the work of a trained scribe, and every one what we would today consider a work of art.

Fragile and perishable, some of those Classic books may still have been around when Bishop Landa conducted his *auto da fé*, or test of faith in sixteenth-century Yucatán, burning dozens of them in a single conflagration. Four Postclassic books survive, and they provide important clues to the writing and image-making of the Maya of earlier times as well. For the Maya, the book may have been one of the most important and precious works: Maya kings were buried surrounded by luxurious goods, but on the chest was often a book, although archaeologists find only its stucco coating.

Clay and ceramics

Almost every Maya stream bank provides a source of clay. Even today, potters guard good clay mines jealously, and a painter of pots keeps a kit of pigments to blend into clay slip. Made without benefit of a potter's wheel, like all Mesoamerican pottery, Maya pots were hand-built, almost universally constructed by coiling rolled strips onto a base, forming the essential chassis that might then receive feet, a lid, or whatever the potter had in mind. Although often glossy, no Maya pot was ever glazed: rather, Maya pots were painted with clay slips, blended with colored clays and minerals to yield a range of pigments, which were able to bond permanently to the pot itself, and burnishing may have brought up the sheen of the surface. No modern attempt has ever replicated the results of ancient Maya potters and painters using what we think are the ancient techniques, in part because of unanswered questions about ancient firing techniques: how did the Maya solve the problem of the fire clouds that usually attend open-pit low-temperature firing conditions? Did they ever engage in multiple firings? Regardless of the means, the resulting ceramic vessels became a prime repository of elite imagery, and one of the materials most successfully manipulated by the Maya artist.

Textiles

If we were to look at the living Maya today as our guide to the past, we would easily see that textiles dominate all other traditional art forms, with the possible exception of the domestic architecture tradition. From town to town, all across highland Guatemala and Chiapas, in patterns and materials about which one can generalize, traditional weaving has not only survived, but in many cases thrives, focusing both ethnic and local identity in color and motif, and adapting to new materials. Wool and silk—both materials introduced in the Conquest era—have played a key role in twentieth-century textiles, as have more recent introductions of rayon, acrylic, and polyester, all interwoven with native cottons.

The role of cloth as both an art form and as a means of storing wealth has not received much study from Mayanists. Outside the Maya area, there is good evidence of the latter: units of cloth bear specific exchange values in the Codex Mendoza, a Postconquest book documenting tribute paid to the Aztecs; a significant part of the Codex Magliabechiano depicts mantle patterns. What's more, it is not as though painted pottery or jade beads are given equal weight in the notations: if the Precolumbian material record as we know it were to vanish, leaving only manuscripts behind, one

might well conclude that textiles were the most valuable product, as we know them to have been throughout the ancient Andes. What is different in the Andes, however, is preservation: there, thanks to one of the driest deserts in the world, thousands of ancient textiles are known, from all periods of Andean civilization. For the Maya, we have only a few scraps—fragments from cenotes, cloth impressions left in burials. Archaeologists have described seeing what appeared to them to be bolts of fabrics that turned to dust in front of their very eyes when opening the dry tombs deep within ancient pyramids. The only real guide to the role of ancient textiles as an art form is their representation. On both painted pots and in monumental representations, chiefly in the Bonampak murals, the Maya elite wrapped themselves in sumptuous clothes, generally fine cottons with elaborate woven and painted designs, but also in deer hides and jaguar pelts, in woven mats and straw, and in feathered brocade. The patterning of Maya dress, with bordered selvages and continuous design, is akin to the patterns of painted architecture and painted ceramics, and, ancient as textile design might be, perhaps a medium far more influential than most scholars have thought.

68

The lost textile arts and the lost books we can at least know from documents to have once existed: wooden sculpture remains far more elusive, and assemblages of dough, of corn husks, of feathers and furs, or resins cannot even be imagined in most cases. These materials remain beyond our ken, a mirage that we know was once real.

68. The elegant costumes of these dancing Maya couples provide a window on lost textile arts of the Classic era. At far left, the woman's dotted skirt probably indicates a tie-dye technique; her upper body garment may well be a painted textile.

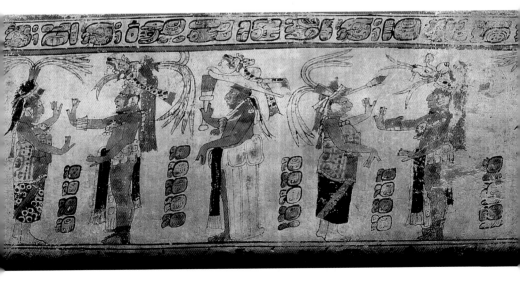

Chapter 4: Early Classic Sculpture

Background

By virtue of the range and number of surviving monuments, Tikal, in central Petén, offers the clearest picture of the artistic development that took place during the Early Classic, from AD 250 to 550. Even before the University of Pennsylvania project of the 1960s recovered tombs and stone monuments, including the earliest dated stela ever to be found *in situ*, a number of important sculptures were known, providing evidence of the making of art at the beginning of the Early Classic. Additional work by Guatemalan archaeologists in the 1980s yielded startlingly different stone sculptures that stand outside the ordered world of stela-making, particularly during the fourth century. Recent work by Spanish archaeologists has uncovered yet another well-preserved Early Classic stela, so the picture of Tikal sculpture is more informed than for any other Maya city.

What we think about Maya art is always determined by the sample, of course: what is difficult is to be prepared for discoveries that undermine what scholars have come to accept as truths and to recognize that even what seems to be exhaustive archaeology is never complete. Although this problem always afflicts archaeological art, in Maya art the problem is most acute for the Early Classic period: during subsequent centuries, the Maya were often reinterpreting the past in ways that called for the movement, hiding, or destruction of the earlier works, or they were simply planning new building programs that encased old ones. By contrast, at the end of the Late Classic era the Maya simply abandoned their cities , and public monuments were left intact, subject to little more than the creeping liana or the towering mahogany for over a thousand years.

Additionally, because production was limited to only a handful of cities, there have never been great numbers of Early Classic sculptures, nor did many distinct regional styles emerge until the end of the period, as the loci of Maya political power began to be more dispersed. At the beginning of the era, political power was concentrated at two cities, Tikal and Calakmul, both near the cen-

ter of the Maya heartland. The balance of power tipped to Tikal at the end of the fourth century, when Teotihuacan lords from Central Mexico both fought and married their way to the Tikal throne. In the mid-sixth century, as new cities began to develop far from the old centers of power, Caracol lords from the foothills of the Maya Mountains seem to have teamed up with Calakmul to crush renegade Tikal, bringing the Early Classic era to an end. Weakened by years of warfare, most of the Maya region suffered an economic collapse, and few works of art were made for a generation or two.

During the Early Classic, works of art were made not only to honor kings and gods, but also to negotiate the relationships between men and the powerful supernatural forces embodied by deities. In adopting permanent materials and standardized representations—particularly the stela—the Maya developed successful solutions that could, in turn, be used by an ever-widening gyre. At first limited to Petén-area centers, Maya sculpture began to appear toward the end of the Early Classic at Copán and Quiriguá to the south, Oxkintok to the north, Caracol to the east, and Yaxchilán to the west.

Late Preclassic to Early Classic
Massive architectural façades of the Late Preclassic era in the Maya lowlands had featured stucco representations of Maya gods—sometimes with individual heads of gods 6 m (20 ft) high.

69. This precious greenstone head took the place of a missing human cranium in an early burial (Burial 85) on the Tikal North Acropolis. A stylized portrait, the head wears a distinctive emblem of rulership on his head.

Stucco adheres and endures best when applied in rounded curvilinear courses supported by an architectural framework, especially tenons. The result was a program that eschewed the right angle altogether. Central frontal representations were often matched with flanking profile heads, and few bodies were represented. Scrolled details fill in backgrounds and borders. In the Guatemala highlands, emerging dynasties adopted this curvilinear style to formulate standing representations of rulers on the front faces of stelae, particularly at Abaj Takalik and Kaminaljuyú.

The cultural flowering known as the Early Classic period of the Maya, however, only takes off when this impetus to render the human agent and his deeds, in association with monumental architecture, becomes part of the permanent pattern of the Maya lowlands. During the Late Preclassic, the role of the king can be perceived in the Maya lowlands, but his actual representation rarely survives, and when it does, as, for example, on the greenstone head from Tikal Burial 85 (*c. 50* BC), the work is small in scale. With the advent of full-figure representations in the third

69

70. One of the earliest freestanding monuments from the lowlands, the Hauberg Stela portrays a Maya king as an embodiment of Chaak, the rain god, whose mask he wears.

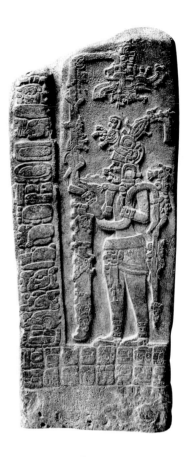

century, generally on stone monuments that feature a single figure, Maya kings proclaimed their right to rule.

Early Classic Maya artwork shares many formal characteristics that span the primary media of sculpture, ceramics, and architectural ornament, and it may have been the curvilinear limitations of Late Preclassic architectural ornament that established many of the formal qualities at the beginning of the era. The monuments not only retained many of the formal properties that had previously been developed to represent deities but the rulers were also rendered as the deities themselves, as is evident on the Hauberg Stela, an extremely early monument that may be from the second century AD but that unfortunately has no provenience. The rendering of parallel but separated legs in profile, frontal torso, and head in profile is typical of early sculpture. With the movement to lowland stone sculpture, both kings and gods acquire bodies, but the gods become diminutive and are often held in the hand of larger, active kings.

70

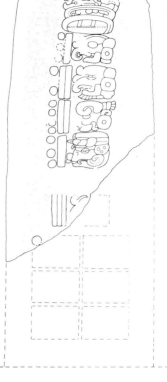

71. Stela 29, Tikal, depicts a late third-century king. Facing to the right, the king holds out the head of the Jaguar God of the Underworld, a patron deity of Tikal; an ancestor faces downward from the upper margin of the stela. Drawing by William R. Coe.

Early Classic sculpture at Tikal

Although one might anticipate that the earliest dated Tikal monument, Stela 29, would be a hesitant effort, any developmental quality is evinced in the workmanship, not in content. With a date in the Maya calendar that can be correlated to AD 292, Stela 29 is the first dated Maya monument found in context. Probably in an act of violence during the sixth century or later, the shaft of Stela 29 was smashed, and the large fragment known today was dragged to a garbage dump, where archaeologists found it in 1959. As a stone prepared for carving, Stela 29 has qualities associated with the Early Classic in general: stoneworkers quarried a fairly smooth shaft from local rock that nevertheless bore imperfections. The sculptor was then left to cope with an uneven surface. One would imagine that a heavy charcoal line drawing was made first. In order to accommodate the demands of the uneven rock, the glyphic cartouches adjust to its surface, listing slightly to the left, and including substantial gaps between the glyphs where the stone

71

features a natural recess. There is no border other than the edges of the quarried rock itself. All carved surfaces bear the same, low relief, the background carved away to leave the finished surface, particularly along the bar-and-dot numbers that are prefixed to glyphs. Carved lines adhere to the same thickness, and all carved surfaces are equally finished—no chisel marks remain in evidence, but the grain of the stone is still visible as well.

We think of the figural portion of a sculpture as the front, and so did the Maya: sculptures *in situ* always feature the figure looking at the plaza or public space. For most stelae, the reader of the text must address the sides or rear of the monument, moving away from the human representation. The text and the image carry equal weight, and were assigned equal space on Stela 29. The figure on the front of Stela 29 probably sat, as do the surviving complete early figures—the seated king on Stela 4, for example, or the seated figure on a Uaxactún altar, a monument that may well have

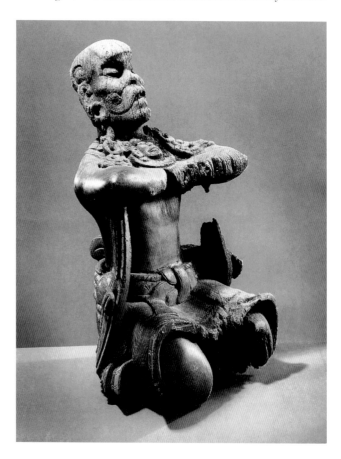

72. Preserved for over a thousand years in a dry cave, a seated figure of wood displays a conventional Early Classic posture, with fists pressed to chest. Probably a royal possession, the sculpture may once have held a pyrite mirror.

been cut from a stela. Early three-dimensional sculptural representations also sit, including the unprovenanced New York wooden sculpture, the "Hombre de Tikal," and ceramic sculptures that feature Tikal lords. Although the representation of powerful figures at Tikal during the Late Classic favors the standing figure, the seated one may have initially predominated during the Early Classic, embodying the very concept of "enthroned."

After AD 400, figures on the fronts of Maya sculpture almost universally look to the left, especially figures in profile. But although the Stela 29 figure seems particularly anomalous, looking to the right as he does, during the fourth and late third centuries the possibilities were more open, and other early monuments from the central Petén, from Xultún, or Uolantún, feature lords that face right. Stela 29 might once have formed part of a pair of facing monuments, or a charcoal drawing transferred from fig paper might also have resulted in a reversal. Typical of Early Classic rendering is the hand, shown as a simple mitten, clutching an angled serpent bar that Maya kings would carry as a token of their power for most of the first millennium AD.

To the uninitiated modern viewer, the multiple heads arrayed across Stela 29's surface present a confusing muddle clarified only by the greater open space surrounding the king's own masked face. In three forms—from the mouth of the serpent bar, at the waist of the king, and held out on draped cloth, perhaps as an opened bundle or perhaps to show it as a headdress—is the profile head of the Jaguar God of the Underworld, apparently the patron god of Tikal. The very image of the dormant sun at night, the Jaguar God of the Underworld wears the Tikal toponym as his headdress, as if to show that the sun rises and sets at Tikal.

The Tikal king on Stela 29 wears abundant insignia, including a shark-like Jester God on his forehead and what may be the mask of Chaak – god of lightning, rain, and decapitation – directly rendered onto his face, but, interestingly enough, no feathers, and no headdress of his own, although the Jaguar God of the Underworld in the king's left hand with cloth ties may be a headdress not yet worn. Rather, the crown of the king's head, from his forehead back to his fontanel, features a spiky "mohawk" haircut, studded with bones, a hairstyle that terrifying deities of the Aztecs wore at the time of the Conquest. At the top of the monument, a disembodied head floats, facing down at the standing lord. Like other heads of this ilk on Early Classic monuments, a now-eroded glyph in the headdress may have named the figure, and it may well be the lord's father.

73. An Aztec star demon from the Codex Magliabechiano, or tzitzimitl, features a spiky hairstyle studded with bones like that worn by early Maya kings.

In the century following the making of Stela 29, Tikal underwent radical political upheaval. Most dramatically, in 378, in a series of conquests, Teotihuacan lords systematically attacked a number of independent Maya kingdoms, culminating in the conquest of Tikal. The usurper who took the throne, Nun Yax Ayin (known elsewhere as Curl Snout), introduced new technology and a new ideology that resulted in fresh works of art, many of which were looked upon with disdain within a few generations. Loyalists took and hid the "Hombre de Tikal," probably a portrait of the defeated King Chak Tok Ich'ak, later adding its incised text. At other Petén sites, women became featured subjects, although usually on the back or side of a monument, as for example, on El Zapote Stela 5.

Several monuments connected to the fourth-century conquest stand out at Tikal: Stela 4 of AD 396, and the Ballcourt Marker of 378; and at Uaxactún, Stela 5 of 396. The Ballcourt Marker takes the form of a sculptural type known from Teotihuacan, where a similar stone representation of a feather standard was recovered. Teotihuacan paintings show such feather standards in use in a field-hockey-like game. Featured in the Ballcourt Marker's text is a Maya hieroglyph making its initial appearance, a small-eared screech owl holding a Teotihuacan-style dart thrower, or *atlatl*. Uaxactún Stela 5 features a striding warrior with such a dart thrower. The warrior also bears a spiked club of the sort known from later Aztec combat, the *macana*. In its spare depiction and

74. With its depiction of a striding warrior with Teotihuacan garb and arms, Stela 5, Uaxactún, introduced a new, active form of representation to Maya monuments. Of particular note are the Teotihuacan-style headdress with bird and the weapon in hand, as well as the burning toponym at the lord's feet.

75. Nun Yax Ayin came to power at Tikal in the wake of the Teotihuacan incursion late in the fourth century. On his monument, Stela 4, both Maya and Teotihuacan formal qualities are evident, as are deities from the two religious traditions.

active posture, the Stela 5 figure expresses a keen hostility, and at the warrior's feet, the Uaxactún toponym is ablaze, presaging Aztec imagery of temples afire to indicate conquest.

Stela 4 celebrates the installation of the probable usurper at Tikal. Seated on a throne, the king holds the familiar Jaguar God of the Underworld Tikal patron in one hand, at left, but the Central Mexican god Tlaloc in the crook of the other arm; he wears pecten shells around his neck and a great frontal helmet with attached feathers that is in fact a simplified image of the War Serpent, the Teotihuacan god of war. More than any other stela at Tikal, Stela 4 seems an unshaped boulder, clumsily prepared for carving, with a text that follows the surface up hill and down dale. However, what is usually seen as its most unusual feature is the frontal face of Nun Yax Ayin himself, seemingly an adaptation of the Teotihuacan preference for frontal protagonists to the Maya representation of the human form.

75

In 1963, archaeologists opened the richest Early Classic tomb ever to be found at Tikal. In Burial 10, Nun Yax Ayin lay surrounded by nine other individuals, what may have been his faithful dog, and a host of lavish offerings, including what may have been his animal spirit companion, a caiman or *ayin*. Pecten shells, like those rendered on Stela 4, edged the collar around the principal lord's neck. Elegant painted and stuccoed pots held the tomb's provisions, and many exhibit a fluent blending of Maya and foreign styles. Gods from distant Teotihuacan were featured on the painted surfaces of ring-stand vessels and tripod cylinders, both new formats in the Maya ceramic inventory, but their vessel lids featured three-dimensional Maya figures. Nearly identical to a rich tomb from Kaminaljuyú, in highland Guatemala, Burial 10 memorialized a king who had caused the Maya and Teotihuacan art styles to acknowledge the other's strengths.

In 451, King Siyah Chan K'awil memorialized himself and his lineage at Tikal with a new monument, known today as Stela 31. A model of both innovation and conservatism, it was carved on all four sides, unlike any surviving predecessor. In fact, the monuments that had immediately preceded it were so dramatically different that they almost seem to have come out of a distinct tradition. For the front of Stela 31, Siyah Chan K'awil returned to the format used on Tikal Stela 29, a stela that was by then 150 years old. Siyah Chan K'awil anchored himself to that early king, his divine patrons, and probably reasserted the lineage that linked them.

Although Early Classic monuments would continue to be created for another hundred years after its dedication, Stela 31 can be recognized as the single greatest achievement of the era, a monument that both sums up what had gone before and cleared the path for what would come later. Perhaps because of the monument's power to make visceral the troubled politics of its times, the sculpture's butt was smashed off and the larger upper fragment was hauled to the top of Temple 33 during later times, when it was then systematically buried with burnt offerings.

By the mid-fifth century, when Stela 31 was carved, Tikal had begun to quarry limestone of a finer grade, less vulnerable to pitting. Prior to sculpting, masons worked the slab into a nearly perfect prismatic shaft. The sculptors now worked with far greater skill: they carved away the background, throwing the relief onto another plane, in what we can call "cameo" style; the sculptors then worked with exacting tools so that the level of detail achieved on 29 seems little more than what would have been an outline for that of 31. Like the Stela 29 figure, Siyah Chan K'awil is masked,

76

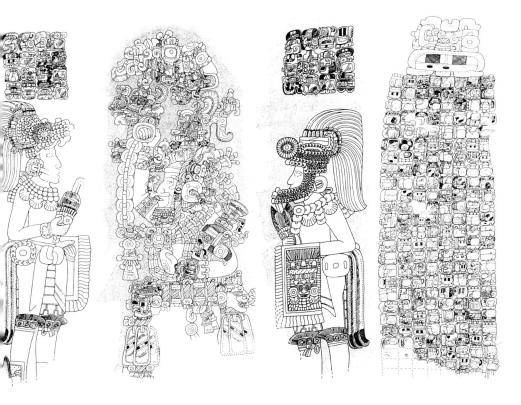

76. The greatest Early Classic sculpture to survive, Stela 31 depicts Siyah Chan K'awil on its front face (second left), with representations of his father Nun Yax Ayin on the flanking side panels (far left, second right). Despite its fragmentary nature, the text on the monument's reverse (far right) is the longest and most complex to survive the Early Classic.

indicated by both the face paint and the cut-away nose piece; both wear a thick twisted rope indicating power as a shaman priest along the side of the face, the Jester forehead adornment, and despite the agglomeration of head ornament, both are shown without headdress, in their "mohawks." Siyah Chan K'awil additionally wears his name, and the scrolls of that glyph reach right up to the down-facing figure of the upper margin, the representation of ancestry, and here shown as the Sun God, or K'inich Ahaw, and explicitly named as Nun Yax Ayin, his father.

Unlike the Stela 29 figure, however, Siyah Chan K'awil stands, and unlike previous representations of Tikal kings, he takes an active, even aggressive stance, holding up his headdress with his right hand. With its powerful earflares and chin strap, the headdress is the very image of those worn by Maya deities on monumental stucco facades, of the sort uncovered at Uaxactún and El Mirador, and so Siyah Chan K'awil is showing off his own unparalleled status, like the young Napoleon who took the imperial crown from the hands of the pope in order to place it on his head himself.

So, at first pass, the monument's imagery seems to be a technical and iconographic finesse of the earlier iteration.

A consideration of the entire program of Stela 31, however, thickens the plot. Unlike any stela made previously at Tikal, all four faces of the stela were carved. The narrower sides feature standing figures in profile who turn toward Siyah Chan K'awil; above them are nearly identical glyphic passages. Broken as the monument is, the text on the back of the stela begins with an initial date of 445 and follows not only with the longest Early Classic text known but also with the single most informative statement about the Tikal family from its founding until that date. In other words, just as the nature of the representation on the front of the monument returns to Stela 29, and quite likely other lost monuments as well, so the text also makes a reconnaissance of the past. And, although every Early Classic monument is complex, with dense iconography layered over the Tikal lords—demonstrations of ritual and paraphernalia that function more like a religious litany than any sort of literal portrait—Stela 31 is the most complex of any surviving monument, and may well have been recognized as such at the time of its making. The visual complexity is matched by textual complexity at every step.

In leapfrogging over the style and imagery of Stela 4 and in asserting a seamless sequence of rule in the text, Siyah Chan K'awil's monument seems designed to refute charges of usurpation. But tying Stela 31 to the war monuments of the fourth century is the central motif of Siyah Chan K'awil's raised-up headdress: an owl with the spearthrower, a motif from the Ballcourt Marker of 378. Furthermore, the sides of Stela 31 would seem to depict Teotihuacan warriors. Rendered with open space surrounding the human representation in Teotihuacan fashion, but with the lankier proportions characteristic of Tikal, even the Teotihuacan warriors feature a blended style of foreign and local. When the two profile warriors are seen simultaneously, a single Teotihuacan warrior appears, seemingly holding a shield in the left hand, an atlatl (spear-thrower) in the right, and with mirrored helmet, coyote-tail waist ornament and pecten-trimmed collar. Close inspection reveals that the two images are not exact reflections, but the result is that a single Teotihuacan warrior seems to materialize behind Siyah Chan K'awil, guarding him and quietly enforcing his position. Yet the text identifies the single Teotihuacano to be his father, Nun Yax Ayin. Stela 31 points the direction to the future, in its rock and refined surfaces, and in its flanking representations of simpler figures less burdened by ritual paraphernalia.

Stela 31 probably took its place on the North Acropolis, where Stelae 29 and 4 must also have been properly set, demonstrating that the visual narrative of Tikal's royal family could grow and change. Even the active stance of the king on Stela 31 may have derived from more active representations such as the warrior on Uaxactún Stela 5. The impetus to narrate more of the story pushed the inclusion of more text, formatted into clear and rectilinear columns. The recently discovered Stela 40 was made by Siyah Chan K'awil's successor to emulate the powerful father, but the monument simplifies Stela 31 without working in new complexities. Whereas the actions of war and its iconography overtook the late fourth-century sculptures, on Stela 31 they are incorporated; on Stela 40, they are watered down. Ultimately, the story of these few monuments is the story of Early Classic sculpture, whether at Tikal or elsewhere, in which the ideology of war joined rulership as public presentation. Absorbed into the canon, its iconography would be henceforth present, but never again with the shock value such imagery had when new.

Early Classic sculpture beyond Tikal
Although one might turn to Calakmul as an artistic foil to Tikal, few Early Classic monuments survive in any condition there. Made of porous rock, the known fragments offer few clues to artistic development. Mexican archaeologists have recently unearthed Early Classic tombs that attest to Calakmul's wealth but also its conservatism, for without the stimulation of war and foreigners, Calakmul art was slow to change.

By AD 500, human figures carried much less ritual paraphernalia, resulting in forms that are much easier to read from a distance. Tikal Stelae 6, 7, 8, and 9 of the late fifth and early sixth centuries all feature relatively lanky lords in simple costume, without any background scrollwork and cut in fairly high relief from that background, as if based in part on the side figures of Stela 31. At Tikal and elsewhere, the front of the monument gained a frame by the sixth century, enhancing the sense that these human representations were constructed pictures rather than organic shapes emerging from the rock.

At other sites, local features, usually focused on local gods or ritual practice, took hold—for example, the hand-held foliated jaguar first appeared on Xultún stelae in the fourth century and then continued into the ninth. Far from the central Petén, as new cities began to make stone monuments, they often came to different solutions, although the key elements of standing king and

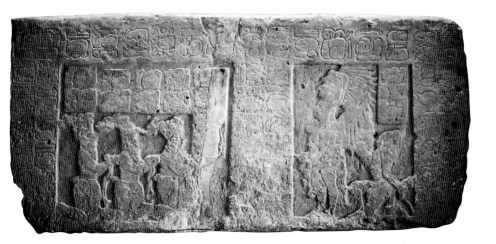

77. (left) Stela 27 at Yaxchilán features a bearded lord who performs the scattering ritual.

78. (above) As recorded on Wall Panel 12, Piedras Negras kings exercised power over their Usumacinta neighbors, particularly Yaxchilán, whose lords were rendered as captives.

79. (below) Monument 26, Quiriguá, provides evidence that the characteristic frontality of later Quiriguá and Copán stelae is present in at least one of the first works.

related text remained a constant. The first figural monument from Yaxchilán, Stela 27 of 514, features the "scattering" pose so typical of later Yaxchilán works. In showing his ability to cast this precious flow from his body, this early king presents himself as the regenerative force of his community. Wall Panel 12 of Piedras Negras, also from 514, is a fully developed multifigural composition with an extensive hieroglyphic text that divides the scene in half, so that the two sides face each other like pages of a book. The model for such representation may well have been a Maya book, or perhaps a tripod cylinder vessel. Surviving ceramics of the fifth and sixth centuries began to feature multifigural compositions, and such small-scale works may have been the inspiration for more monumental ones, particularly as the central Petén cities exported fine wares to regional towns.

One early Copán fragment, Stela 35, shows the side view of separated, parallel legs of a standing figure, rendered much like legs of a fifth-century Tikal stela. But a comparably early monument, Monument 26 from Quiriguá, reveals a different visual solution. The characteristic frontal face omnipresent in Late Classic sculpture at both Copán and Quiriguá probably caught on before 500, and the two communities may have had joint rule in that era. So exceptional in Early Classic sculpture, this frontal face seems not to have come directly from Teotihuacan-inspired works, such as Tikal Stela 4, but rather from the frontal faces of architectural facades and the incensarios—large vessels for offerings—that often comprised architecture in miniature. Widely exported, incensarios featured beads at the edge of the face, like the face on Monument 26. The result was an improvised, roughly incised

80. Incensarios (vessels for offerings) made in the Petén, featuring frontal, three-dimensional faces of both gods and humans, may have spread religious cults and provided the model for frontal representations when they were exported to more remote locations. Here Chaak is featured on the main, lower vessel.

body and a more polished, nearly three-dimensional, frontal face. The sorts of rock available at Copán and Quiriguá made good use of the frontal format and helped assert a regional style. Regional styles to both the west and the south all seemed to be set in place when a new round of warfare sent shock waves across the Maya realm that ended the Early Classic.

According to Caracol Altar 21, found at the site in 1986, the lords of Caracol (probably in league with Calakmul) went to war with Tikal twice, in 556 and 562, claiming a "Star War" victory on the latter date, or what scholars have come to think is conquest warfare, resulting in local devastation, destruction of monuments, and probably backbreaking tribute. The altar features a long text, the very interest in details of names, dates, and places demonstrating a near obsessive concern with expressing a point of view and underscoring its importance, like the long text on the back of Tikal Stela 31.

At Tikal, the Early Classic narrative of the city, so elegantly laid out on the North Acropolis in the sequence of Stelae 29, 4, 31, 40, and others, was dismantled by enemies, who smashed 29 and 31, and who probably reset Stela 4 upside down, the powerful frontal face buried and removed from view, with just the pathetic stumpy legs and feet left on public display. How did the conquest monument of the fourth century end up so humiliated? And when did this desecration take place?

In the 1930s, the discovery of a carved throne smashed on the steps of the Palace at Piedras Negras chilled scholars' bones: they imagined that an angry mob had risen up against their priests, bringing a peaceful civilization to a sudden close. But in fact, whenever enemy Maya lords claimed victory and entered a city, they smashed their monuments, took their god images captive or destroyed them. Tikal had wreaked such destruction on its neighbors, with results that reverberated into its own artistic production, in terms of subject matter, material, and style. At neighboring Uolantún, Stela 1 was hacked apart, the top fragment carved into a small round altar, perhaps to celebrate the city's demise in ballgame as well as war, and the section featuring the king's head destroyed altogether. With its vivid portrayal of the Teotihuacano usurper, Tikal's Stela 4 may not only have been violently reset upside down in the aftermath of the 562 battle but, more strikingly, never righted until archaeologists reset the sculpture in the twentieth century.

Such attacks had profound impact on the artistic record. Emulation and imitation, new attempts at imaginative works, even sheer economic wherewithal to take on a campaign of self-promoting grandeur are all more likely during times of abundance. The fourth-century conquest of Tikal, for example, yielded both new types of sculpture and new imagery in the short run; at the same time, a stone-age economic cycle may have yielded prosperity that supported the complexity of a project like Stela 31 in the one generation and gone bust by the time of the next.

In a world context, the complexities of warfare almost always leave their mark on the artistic record, whether in the formation of a new art in France following the French Revolution or the destruction of old art forms in that same conflict. Warfare frequently forces the movement of art: as booty, art is hauled off by the victors; as refugees, artists may infuse a new region with their works; as the victims of the colonial enterprise, artists may nevertheless resist the new master. Victory may enhance social organization or political repression, both of which may yield a change in the artistic record. All across the Maya area, the wars that wracked it sent stress fractures through the artistic enterprise, making of art not a slave of time's inexorable, steady progression but an expression keenly tied to local phenomena, developing in fits and starts. Behind every work of Maya art lie both makers and patrons; that work of art's ultimate survival depends on both accident and historical circumstance.

Chapter 5: Late Classic Sculpture

The Late Classic era

The idea of the Late Classic period that runs from AD 550 to 900 is of course a modern one, and at the beginning of the period the Maya themselves could not imagine the extraordinary works that they would come to make within a century. At the end of the 6th century the Maya were still reeling from warfare that had wracked the Petén, although the cities around the region's periphery— from Copán to Palenque to Piedras Negras—had suffered less devastation than Tikal and its neighbors. But by the end of the seventh century, Maya cities were thriving everywhere the Maya lived in the lowlands, and most Late Classic art was made between 680 and 800. The Maya experienced fabulous wealth for a tropical rainforest society in this era, and they used their economic wellbeing to support the making of art and architecture. At literally dozens of sites, local styles took hold, and the large cities at the center of the Maya world—Tikal and Calakmul—no longer provided the only barometers by which to gauge the developments of Maya art. Abandoned in the ninth century and not reoccupied, southern lowland Maya cities preserve the Late Classic slice of ancient life and art better than any other slice is preserved.

Accordingly, the texts that tell the history of the Late Classic also survive in great abundance. This chapter will look closely at monumental sculpture rather than the political intrigue that its texts may suggest, but the paths to war and peace spelled out in those texts often had repercussions in the visual record. Although victories on the battlefield led to more making of monuments than did defeats, Late Classic Maya art is not just shorthand for the history of the victorious. For one thing, some powerful cities carved monuments proclaiming their success on porous limestone, as was the case at Calakmul or Cobá, leaving only pitted and fragmentary efforts for modern consideration—and effective oblivion. Furthermore, when victors forced the artists of a place they had defeated in war to make works of art the results were sometimes new and imaginative ones that incorporated the pathos of loss into the triumph of victory. Remarkable works turn up in surprising

places: no equivalence exists between political and military power and the power of works of art.

During the Early Classic, one single historical event stands out above all others: the AD 378 arrival of Teotihuacanos at Tikal. By the time of the Late Classic florescence, no active Teotihuacan community or military force seemed in direct residence at any Maya site. Were they driven out? Did they settle into a role of handling long-distance trade? Or had the political climate at Teotihuacan itself begun to deteriorate? In any case, by the seventh century, no Maya city was dominated by a foreign relationship, and the central part of Teotihuacan had been burned to the ground by AD 700. But Teotihuacan ritual and gods played a role in elite Maya life, and Teotihuacan attire was donned for certain occasions. Maya lords usually preferred traditional Maya dress for formal portraiture on the occasion of installation in office, but formal war portraiture almost always featured Teotihuacan war attire. Andrea Stone has proposed that the Maya came to represent an organic, local Maya ideology in the iconography of lineage and a foreign, hostile Teotihuacan ideology in the iconography of warfare in order to enforce social separation. Even though the Maya were at war with other Maya, they called up the specter of "foreignness" and manipulated the power of Teotihuacan gods of war and sacrifice to enhance local prowess. Even as Teotihuacan's real power waned, its value as political currency took on greater significance.

The Late Classic period, and particularly the eighth century, represents the highest achievement of many aspects of Maya civilization. The Maya wrote many long texts with unprecedented complexities, relating the deeds of both gods and men, and demonstrating skill of both astronomical observation and its recording. Some of the numbers recorded during the time period go from hundreds to thousands to billions, orders of magnitude that astonish us today. In this respect, the Maya sense of time ever expanded, with a yet larger cycle always lying behind the largest stated one—and in this expressing a sense of infinity. Populations reached their peak as well, and many more noble Maya commissioned works of art. Thatch palaces of the previous era were replaced with stone ones during the Late Classic, and the Maya built most of their towering temples in this period.

But at the same time that some of the Maya's finest works of art were coming into existence, archaeologists have discovered that the quality of life diminished radically, even for the most elite individuals, during the eighth century. We might imagine the

81. Crushed beneath his victor on Dos Pilas Stela 16, Yich'ak Balam, a Seibal king, is shown gazing at his name and Seibal royal emblem. Chronic warfare wracked the Petexbatún region from the date of this monument, AD 735, until the collapse of the region in the ninth century.

cultural backdrop against which the visual narrative is set: over the course of the eighth century, and during the ninth, the southern lowland Maya experienced what is commonly called the "collapse." But contrary to what the term describes, the demise was gradual, a slow erosion of all aspects of life, punctuated by violent decline and subtle recovery. Simply put, population and its attendant demands outstripped the environment, which could no longer provide enough food, fuel, or material for shelter. Without adequate supplies of maize and beans, without wood to cook—and more importantly, to reduce limestone to the quicklime necessary to effect the nixtamalization of maize (without which maize has little nutritional value)—the Maya were driven to pursue any route to feed themselves.

Warfare ravaged many sites; kings fell captive or hostage: at Dos Pilas, where they had celebrated a victory in AD 735 with monuments that featured their king in a rich variant of the Teotihuacan War Serpent reigning over the devastated king of Seibal, they found the tables turned within a decade. Eventually a place like Dos Pilas' neighbor Aguateca was burned to the ground, even as invaders—or the population fleeing before the fire—fell into the chasm that had given the city some security. But a city burned was a city that might never be rebuilt, for where would the thatch or timbers come from? Not from a rainforest reduced to patchy scrub bordering tare-choked fields. An environment destroyed must have led to utter degradation, first of the physical world of the Maya and ultimately even the spiritual.

The story of Late Classic sculpture is not a substitute for the written history of the ancient Maya—nor for the civilization's archaeology. Late Classic Maya sculpture tells its own tales. In series of monumental stone works at city after city, the Maya used the format of the stela, the lintel, or the wall panel to present a picture of those who ruled and their achievements for posterity. But whereas the sculptural trajectory in one city might promote imagination and achievement of the artist, stubborn conservatism might set in at another. To know the work of one Maya city is not necessarily to know the work of another. To know Maya sculpture the modern viewer must look carefully and city by city, to see the paths followed by individual royal families.

Looking at Late Classic sculpture

No amount of historical reconstruction of Calakmul's political impact can compensate for the near-absence of legible, figural sculpture, although major archaeology at the site may yield new

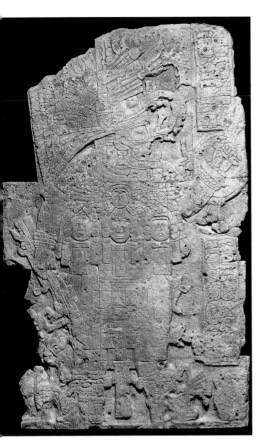

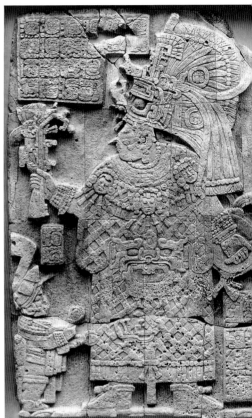

works for consideration in the future. However, even the fragmentary record offers a few insights into the program there of the Late Classic: Calakmul offered large, wide monuments, many apparently male-female pairs that celebrated united lineages, a practice at Naranjo as well, and one that may have been compressed into a one-stela format at Piedras Negras, with a male subject on one face of the monument and a female on the other. Calakmul's neighbors at El Perú adopted the male-female format, and the pair of monuments looted from that site and now divided between the Kimbell Art Museum and the Cleveland Museum of Art may serve to characterize the dominant sculptural forms of Calakmul. Erected at the end of the seventh century in 692 to dedicate the widely celebrated ending of 13 periods of 20 years, the El Perú sculptures are worked in very low relief, with many additional small texts—probably naming the members of the atelier who carved this set—incised onto the female representation but, tellingly, not onto the

82, 83

82. Once part of a pair with ill. 83, the Kimbell Stela features a standing male ruler, his face only barely visible within the large mosaic mask he wears.

83. The companion monument to ill. 82, today in the Cleveland Museum of Art, portrays the noble woman who was probably the king's wife. The two monuments were designed to be seen side-by-side, as shown here, so that each raised the inner hand and lowered the outer one, with a subtle alternation of ritual paraphernalia. The tiny inscriptions on ill. 83 name the sculptors who worked on both monuments; notably, only the female was so inscribed.

male. Such artist signatures (although some have argued that they may indicate patronage) were usually inscribed in the backgrounds of carvings, or on the bodies of captives or other secondary figures. So despite their equal size and posture, the male figure dominates the set.

Neither the most stunning nor the most pedestrian of Late Classic monumental efforts, the Kimbell-Cleveland pair provides a lens for examining the nature of sculpture in the period. The Maya artist could place another figure, such as the dwarf, in front of the woman, but could also choose not to do so with the man. Around both figures the background opens up as a clear expanse, with ritual paraphernalia rendered snug to the body. The lessons of Tikal Stela 31 would seem to still be in the air: like its paired side figures, these paired figures grasp nearly identical objects in right and left hands yet alternate their position. So the shield, with its wrist and hand straps in evidence, as well as the palm of the hand—a self-conscious display of sculptural accomplishment in the Late Classic—is held down by the woman, and up by the man, who likewise invert the cloth banners or "flapstaffs" that they carry. And despite the obvious differences in attire—the woman wears a long beaded dress belted at the waist, its patterned selvage vanishing from view once tied—their costumes are also paired, from the feathers of the headdress to the shrunken heads on their chests. Drapery is attempted, in the revealing squeeze the woman gives her flapstaff, and depth suggested as well, in the dwarf whose musical instruments are in front of the prominent figure. Text leaps across the picture plane and may well have begun on the now-lost carved sides.

Many monuments similar to these two were made at Calakmul, Naranjo, Cobá, and at sites in southern Campeche and Quintana Roo that feature scanty texts. The man's masked costume occurs across the Petexbatún region, at the cities of Dos Pilas and Aguateca, as well as some of their satellites, and at Piedras Negras. Simplified and reduced to a cutaway feature in front of the nose, the mask was also a part of formal portraiture at Tikal. Such successful conventions could be repeated time and again, across a century or more, part of the most stable and conservative tradition of Maya art.

Palenque

In every respect, Palenque sculptors examined the qualitic traditional and conservative Maya art and sought alterr solutions. As a result, at Palenque in the seventh and early

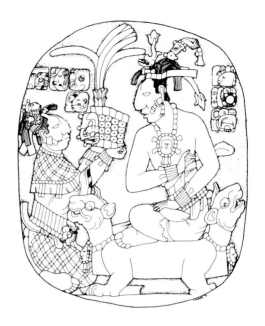

84. The Oval Palace Tablet is the only Classic stone monument to eschew a form created by straight lines, probably in order to take the shape of the jaguar throne cushion, an attribute of both kings and the Maize God. King Hanab Pakal is also depicted seated on a double-headed jaguar throne, to underscore his supernatural powers.

centuries, Maya sculpture achieved some of its greatest complexity as well as technical finesse, almost as if the sculptors there planned to trump the sort of work made in the Petén. They even discarded the conventional format of Maya sculpture, the stela, in favor of new types of wall panels.

Imaginative sculptors worked the first surviving wall panel at the site, the Oval Palace Tablet, into its characteristic oval shape to form the back of an elaborate throne, no doubt to be in the shape of a jaguar-covered cushion. When sculptors of subsequent generations carved an oval behind the king, they were invoking both real jaguar pelt cushions of this shape and the by-now-ancient Oval Palace Tablet, which was always on view. Probably carved in the mid-seventh century, the Oval Palace Tablet celebrates the young king Hanab Pakal's accession to the throne in 615, when he was twelve. Although a few Early Classic monuments feature women, the representation on the Oval Palace Tablet may be the first Late Classic one, and the first "group" composition with a woman. Lady Sak K'uk', in profile at left, hands her son the Jester God-studded headdress of rulership; with his torso turned to the front while the rest of his body is in profile, Hanab Pakal sits on a double-headed jaguar throne. Remarkably, this representation is the first public carving (and granted, it is a throne back, and so was not on public view in the plaza) of a ruler so simply attired, as if to show power embedded in the man, not the trappings of office.

84

91

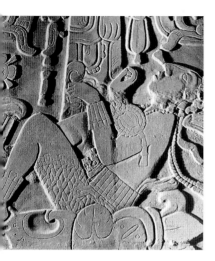

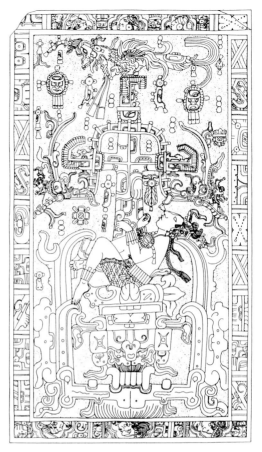

85, 86. In a reclining posture normally reserved for sacrificial victims, Hanab Pakal (detail, above) falls into the maw of death. From his belly emerges a new World Tree, indicating the fresh centering of the earth that takes place through Hanab Pakal's death. The king himself wears the costume of both K'awil and the Maize God.

Made shortly before Hanab Pakal's death in 683, the carving on the sarcophagus lid of his tomb reveals both elaborate compositional skill and hasty execution, with rough chisel marks still in evidence. We might wish to see this as a sign of the speed with which the tomb was prepared, or as recognition on the part of the sculptors that the funerary sculpture was not going to be studied by casual viewers—but in fact, other Palenque sculptures show similar workmanship, including the newly excavated large-scale wall panel on display at the Palenque Museum and the Dumbarton Oaks Panel, where the quality of finish diminishes from top to bottom, ending up with roughed-out toes. Dense and fine-grained, Palenque limestone *could* be polished so that not a single chisel mark remained, as was often the case. Palenque sculptors put their greatest energy into finishing representations of human faces, sometimes at the cost of other areas.

85, 86

In his eighties at the time of his death, Hanab Pakal may have indeed seemed immortal to his subjects, and the complex burial program he probably helped design conspired to promote the notion. On the surface of the sarcophagus, in the only rendering known of a glorified king on his back (for otherwise this is the posture of the fallen and defeated), Hanab Pakal, dressed as the Maize God—presumably at the moment of death or rebirth—falls into the open maws of death, whose image is conflated with the very glyph for "black hole." From his body arises the World Tree, the central axis of the earth that every king was responsible for sustaining in position. On the sides of the sarcophagus, ancestors sprout from earth that has cracked to let them grow, vivid evidence that Hanab Pakal's death has brought forth renewal for the entire earth.

Hanab Pakal's tomb was a sort of sculptural assemblage, or what one might consider today an "installation," including many different components. Key to the assemblage is its storytelling ability, for it constantly narrates the death and rebirth of Hanab Pakal. Inside the uterus-shaped sarcophagus, the dead body was dressed as the Maize God, jade jewelry by the pound adorning the remains but—in an unusual twist for a state burial of this sort—without any elaborate painted or carved ceramics. Hanab Pakal's food for the journey seems only to have been the jade bead in his mouth, like many a more common burial of the time. Yet his death and rebirth as a maize plant renews the entire range of human agricultural endeavor, for each of the ancestors emerges with a specific plant—the nance, the avocado, and so forth. The stucco figures along the wall serve as ever-constant guides. Hanab Pakal's own stucco portrait was wrenched 146 from a sculpture elsewhere (probably House AD in the Palace) and wedged under the sarcophagus itself, ceremonially "killing" Hanab Pakal in life as part of his transformation to life immemorial.

In 692, Hanab Pakal's oldest son K'an Balam dedicated his own magnum opus, the Group of the Cross. At the time when the carved panels of the Cross Group were dedicated, Palenque must have been at the height of its economic powers, plowing economic wherewithal into capital construction. Each massive Cross panel 87 is composed of three huge slabs built into a small shrine at the rear of the temple, forming what Stephen Houston has identified as symbolic sweatbaths, with a sculptural program that extends onto the front panels of the building and right up onto the roofcomb of each structure.

87. Each of the Cross Group temples at Palenque features an interior shrine that takes the form of a perishable dwelling. Stucco ornament above the cornice frames limestone panels below; the large limestone panels (e.g. Tablet of the Cross, Tablet of the Sun) are set within the shrine itself.

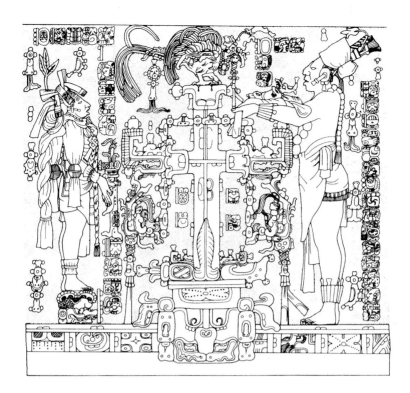

88. An adult K'an Balam, right, faces a representation of his own self as a child, left, across a large World Tree, on the Tablet of the Cross (AD 692). The adult K'an Balam holds out K'awil; the child bears the rear head of the Bicephalic Monster, who also supports the World Tree.

Designed as a group, the Cross tablets feature a unified iconography and text. Dates deep in supernatural history at left pair with events in King K'an Balam's life at right; each panel features both the pouty-faced K'an Balam and the diminutive, bundled figure of what may be his own self as a child. On each panel, K'an Balam displays the images of the gods: held out on cloth, and roughly the size of the actual god images discovered at Tikal, these figures probably offer a clue to the handling and wrapping such deities received. The imagery of the Tablet of the Cross takes its iconographic subject—the World Tree—from the sarcophagus lid; the Foliated Cross features the renewal of maize, and even the sacred mountain from which maize may have come; but it is the enigmatic Tablet of the Sun that may provide an insight into how the program may have come about.

Unlike works of art from other places that celebrate conquests, making it possible to imagine resultant wealth, the sculpture of Palenque resists action, emphasizing stasis and calm. An elaborate program such as the Cross effort includes no imagery of capture and sacrifice, no records of destruction and pillage. But at the heart of the Tablet of the Sun lies the Jaguar God of the

88

191

89

113

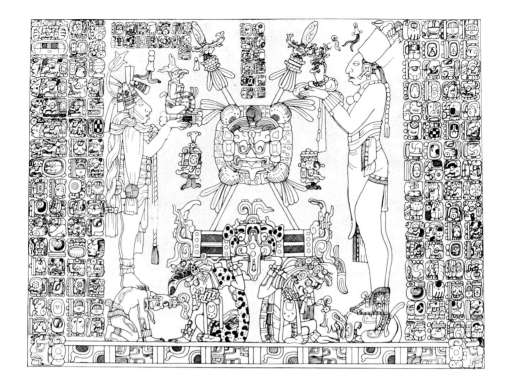

89. The Tablet of the Sun, Palenque. An adult K'an Balam, holding K'awil at right, is paired with his representation as a child, with a war god, left. The large frontal face of the Jaguar God of the Underworld, a war god, dominates the representation, supported by gods of trade and tribute. The two floating hieroglyphs with coefficients of seven and nine probably refer to sacred, supernatural toponyms.

91. (opposite) K'an Hok' Chitam II initiated work on the Palace Tablet but had probably been sacrificed at Toniná long before its completion and dedication in AD 720. Although probably a representation of K'an Hok' Chitam II and his parents (including Hanab Pakal, left), text added at the time the monument was completed names the successor who was called to the throne in his stead.

Underworld, a Maya god of war and fire, and also the deity who embodies the sun at night, during its Underworld journey. Nevertheless, in emphasizing the solar aspect of this powerful god, the modern nickname of the building undermines his other characteristics: the Jaguar God of the Underworld's visage characterizes shield iconography. This is the god, then, that Maya rulers would cover their faces with as they charged into battle. But furthermore, two crouching, aged gods support the great shield itself. At left is clearly God L, an aged deity who presides over the Underworld and who is the patron of merchants and traders; the unknown but similar god to the right may be another view of him, in a manner that recalls the similar but different sides of Stela 31 from Tikal. We can see this as a visual metaphor, and it is a metaphor that underpinned Aztec trade and warfare as well: trade supports war, and war crowns and leads commerce. If we marvel at the wondrous architecture and sculpture that flourished in the seventh century at Palenque, we need only look to this panel to see how they paid for it, with both war and trade, presented emblematically.

In no other work does the image of a god so dominate the picture plane as does the Jaguar God of the Underworld on the

Tablet of the Sun. For Maya works of art, the compositions of the Cross panels are outrageously novel, without successors, an avant-garde that failed to attract a response other than rejection.

One other sculpture on the Cross Group may indirectly insist that the question of warfare be asked: Palenque's only stela came from the side of the Temple of the Cross. An anomalous and unusual work, it features K'an Balam in a three-dimensional rendering. In fact, in its style and proportions, it is very much like the sort of sculpture seen generally at Toniná, although the material is not the sandstone used there. But it may well have been sent to Palenque as a gift or payment by Toniná, one that would come back to haunt Palenque.

Palenque low-relief sculpture seems to follow a seamless stream: the two-figured Oval Palace Tablet leads to the Cross Group monuments, where the two-figured repertory is, perhaps, exhausted, followed by the three-figured panels, particularly the Tablet of the Slaves and the Palace Tablet. Of the three-figured panels, the Palace Tablet is more important, having formed the back of the new, monumental throne of K'an Hok' Chitam II, the successor to K'an Balam. Carved roughly in the shape of a capital letter H, with the figural portion set in the upper, central, portion, the workmanship is of high and even quality: elaborate full-figure hieroglyphs initiate the text, and finely wrought details right down to eyelashes and toenails only a few millimeters long. Yet what we know about the monument gives us pause, for its chief subject, King K'an Hok' Chitam II, was taken captive when the city of Toniná, to the south, claimed to have come and made Palenque

90. (above) An anomalous monument at Palenque, Stela 1 is the only freestanding stela at the site. It once stood on the steps of the Temple of the Cross.

90

91

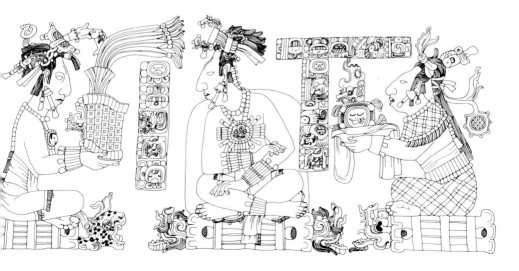

"fall down" in 711, an event not acknowledged at Palenque itself. For nine years, work ceased on the monument (and it didn't "fall down" after all), and only in 720 did it pick up again, with an odd text in the final columns naming a new successor. In other words, at the time of the disastrous battle (if you are a Palenque partisan!), artists were at work on the monument, and then abandoned their efforts—and the *in situ* carving—for nearly a decade. Was the sculpture draped in cloth, as if the very shroud of K'an Hok' Chitam II? Whatever the case, the subsequent workmanship left no trace of this hiatus.

The recent discovery of a small panel fragment in the rubble to the west of the Temple of Inscriptions may shed some light on sculptural practices at this time. Against a backdrop of steps— 92

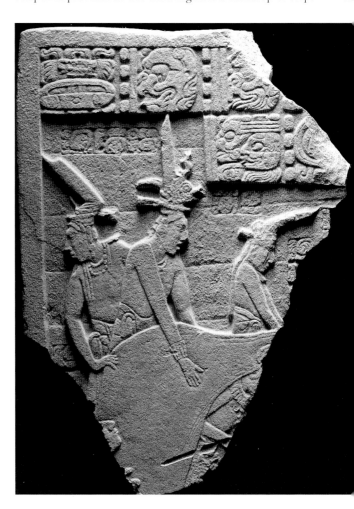

92. From the rubble of Group 16 has come this stunning fragment, possibly depicting the literal tribute burden placed upon Palenque's lords by Toniná early in the eighth century. Staircase representations usually indicate explicit hierarchies.

often a clue to warfare, ballgame, and sacrifice—what seems to be a Palenque lord carries a huge sack on a tumpline. In its format—a small wall panel, with steps—as well as its fine carving, the panel is characteristic of other western Maya cities, perhaps Piedras Negras, or possibly Toniná. The subject is not obvious, but it might well represent a tribute payment by Palenque to outside oppressors—and which might also explain why years later it was smashed and buried.

The final chapter of Palenque sculpture is, quite literally, written, for the last works not only emphasize text but derive from the scribal arts. Two monuments from the reign of K'uk' Balam II at mid-eighth century characterize the late sculpture. Small in scale, each was probably executed by a single master sculptor, and quite

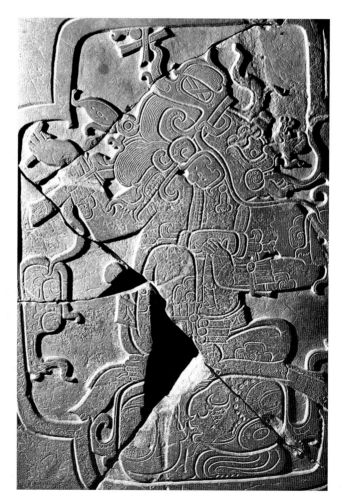

93. Using a flowing, calligraphic line, the Palenque sculptor shows Chaak flexing his arm and lifting his axe, as if ready to hurl a thunderbolt, on the Creation Tablet. The panel was once probably part of a throne assemblage.

94. On the Tablet of the 96 Glyphs, Palenque sculptors fluidly inscribed text, adopting many of the characteristics of the painted word to the carved limestone.

95. (opposite, above) Toniná sculptors developed a three-dimensional art to complement the two-dimensional low-relief sculpture at the site, perhaps taking advantage of the softer sandstone used for many of the carvings. Although headless today, this Toniná stela still calmly commands those in its presence with its stately demeanor. The monument once featured inlay and perhaps perishable attire.

96. (opposite, below) Monument 122 at Toniná depicts K'an Hok' Chitam II, the unfortunate Palenque king felled by his Toniná foes in 711.

possibly the same one: the large-scale projects of earlier regimes had vanished, yet the energy concentrated into small works yielded new results. The Tablet of the 96 Glyphs demonstrates Maya calligraphy at its most remarkable, for the sorts of lines one achieves with a brush have been transposed to stone, where they flow like a silken thread, denying the inherent stoniness of the matrix. On the Creation Tablet, Chaak the rain god flexes his arm in anticipation of the blow he will strike. The static, completed action typical of earlier Palenque sculpture yielded to a more fluid and pregnant action just before sculpture at Palenque vanished altogether.

94

93

Toniná

After Toniná's abandonment, many of its finest sculptures fell down its steep embankment, whether pushed or moved through the forces of nature. In recent years archaeologists have rediscovered a wealth of monuments, from the Giant Ahaw altars, large short cylinders marked by a huge Ahaw glyph marking the end of a twenty-year period, that lay alongside the ballcourt, to finely

carved three-dimensional renderings, to pained representations of captives.

Most stelae stood in three dimensions, text frequently running down the figure's spine. Although ill. 95 bears no text, it probably represents an eighth-century ruler, one hand gently folded across the other; precious inlay once studded neck and chest. Three-dimensional rulers dominated two-dimensional captives on the Fifth Terrace, where a depiction of Palenque King K'an Hok' Chitam II in bondage was once set. Strikingly, although the panel consists of local sandstone, the fluid style belongs to Palenque, suggesting that Toniná lords captured Palenque artists along with their king.

95

96

Piedras Negras

At the end of the Early Classic, Piedras Negras had seen the most complex multi-figural compositions of the period, but apparently had confined such configurations to small, exterior or interior wall panels. Set like pages of a book across the fronts of monumental, freestanding pyramids, such wall panels remained the locus of figural complexity during the Late Classic. Across the front of O-13, the largest pyramid ever constructed at Piedras Negras, three such wall panels were set in about AD 800, at the end of the city's

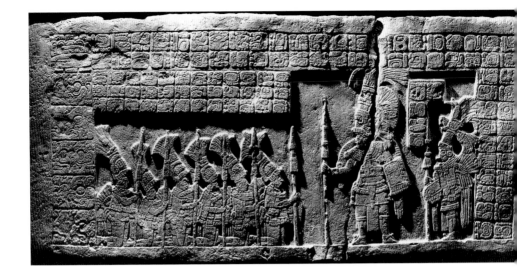

97. (above) Wall Panel 2, Piedras Negras (AD 667), depicts a victorious Ruler 2, right, flanked by an heir. In front of the king kneel five subjugated lords from Bonampak with a sixth, the smallest (second from left), from Yaxchilán. For most of the seventh century, Piedras Negras dominated the Usumacinta River and the cities along it and its tributaries.

florescence. (Early explorers called them "lintels," by analogy with Yaxchilán practice, but not a single carved stone was placed over a doorway at Piedras Negras, to modern knowledge. Rather, the small-scale carved panels at Piedras Negras were set into the exteriors of pyramidal platforms.) 78

Wall Panel 2, at the center, a seventh-century panel reset a century later, recalls both the program and subject of Wall Panel 12, with its portrayal of the king as victorious warrior. The two panels framing it offer scenes of courtly life, executed to enhance the sense of visual space and to accommodate large numbers of individuals. 97

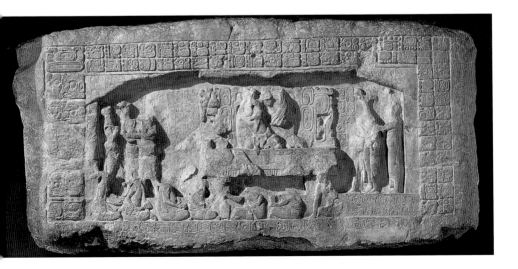

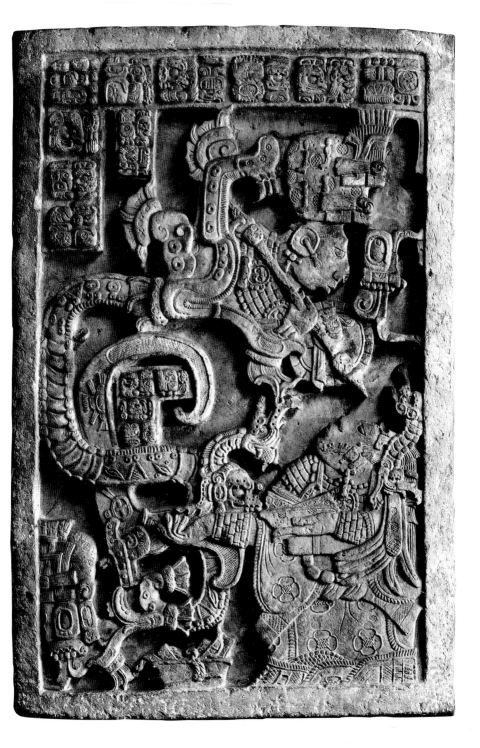

104. A generation after ill. 103, on Yaxchilán Lintel 15 a wife of Yaxun Balam repeats the serpent ritual depicted on Lintel 25, where the complexity of the composition has been simplified, making the woman's role more visually clear. She leans toward the vision in the serpent's maw while the vision and serpent seem unaware of her gaze.

105. Yaxun Balam dominates Lintel 16, his staff visually piercing the very face of his captive, who admits fealty in pressing his hand to mouth and in touching the broken parasol on the ground.
Cut cloth drapes across the captive's left arm, additional evidence of captive status.

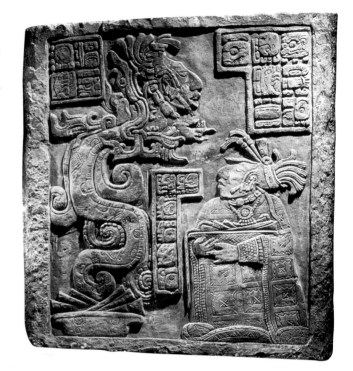

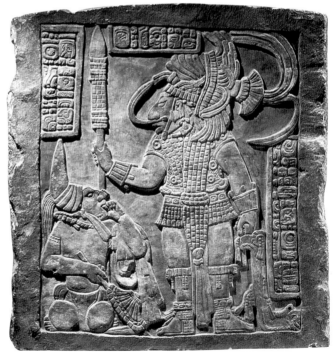

on the scene without precedent, and so misdated Lintels 15, 16, and 17 to make them the visual forebears. We now know how wrong Morley was in constructing a curve along which sculpture might rise and fall, for in fact, invention and artistic genius can propel innovation in erratic beats. Not only were Lintels 24–26 of astounding quality, but they also captured subject matter never before executed on stone. And, simultaneously, Itzamnah Balam II memorialized his success in a war that had raged to the southwest, with Bonampak and other cities, with an equally innovative program that encompassed both lintels and carved steps on Structure 44. Furthermore, in a departure from all previous monumental representation, this new subject matter was shown to be in progress, rather than completed or anticipated, the more standard moments represented in Maya sculpture: Lady Xok conjures her vision, and Itzamnah Balam II grasps his captives by the hair, his back leg showing the effort of throwing his entire body into the action.

In the subsequent generation, Yaxun Balam took these same subjects, as well as others, and ordered more buildings and more sculptures to commemorate his reign. Where one or two monuments might have been carved under Itzamnah Balam II, Yaxun Balam commissioned up to a dozen to celebrate a single event. In the process, new representations of human form were introduced, but the actual quality of carving dropped off so significantly that

105

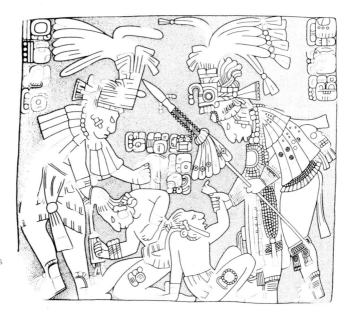

106. Yaxchilán Lintel 8 was carved in exceptionally low relief, perhaps in a style introduced through the war represented on the monument itself. The composition—two victorious lords at the margins, the captives at center—also presented a composition not previously used.

107. The last dated monument at Yaxchilán, Lintel 10 enumerates the endless battles and claimed victories at the beginning of the ninth century, including what may be the demise of Piedras Negras. Increasingly cramped inscriptions at right may indicate a patron who insisted that the artist incorporate new information, without regard to the planned format of the monument.

many key monuments from the era—especially the famous Lintel 8—are known almost exclusively in line drawing, the actual stone surface so poorly graven that photography barely captures its sense. One might want to consider this a form of artistic "inflation," in which the increased coinage has actually reduced the value of any single image. By the year 810, such practice yielded a final result: Lintel 10, a purely textual monument, where the clumsy framing of the text suggests that the carver must have had to cope with new information as it was presented to him, so that as he reached the final area to carve, the lower right-hand corner, he simply jammed in more words, without regard to the sort of thought-out configuration of a century before.

So, if one wanted to see a visual record that "reflects" in some way what archaeologists think Maya life of the eighth century may have been like, one would probably propose Yaxchilán. Here, concentrated wealth and power at century's beginning did not hold for long. Yaxun Balam turned to new, somewhat more collaborative forms of government, resulting in a visual explosion in which he shared the public record with his lieutenants. Ironically, like a latter-day Gorbachev, even as he amended the political structure, his efforts undermined his own polity, for the regional lords took increasing power and began to make works of art that outstripped

his own—leading, ultimately, to the demise of Yaxchilán, a sad end that can be read in the testimony of a Lintel 10.

Tikal

Although pre-eminent in the Early Classic, Tikal lagged desperately during the Late Classic, apparently struggling to recover from external attack. At the end of the seventh century, the first monument the Tikal lords were able to erect (Stela 30) is worked 108 in the style and with the iconography of their oppressors at Caracol. Ultimately, the Tikal kings developed a strong local style in the eighth century, characterized by the sequence of Hasaw Chan K'awil's Stela 16 (711); Yik'in Chan K'awil's Stelae 21 (736) 109 and 5 (744); and Nun Yax Ayin II's Stelae 22 (771) and 19 (790). All set within the specialized architectural precincts called Twin Pyramid Complexes, the stelae carefully follow the model established by Stela 16: a laconic text, limited to the front of the monument, names the protagonist and one or two events. Presented with frontal body and profile head on Stela 16, the royal representation became one completely in profile after Hasaw Chan K'awil's

108. Diminutive in scale, Tikal Stela 30 was the first monument to be erected—or to survive—after the city's long struggle with its neighbors in the sixth and seventh centuries. In format, it draws on the monuments of Caracol, one of its principal enemies.

109. (below, right) With Tikal Stela 16, the Late Classic sculptural template at the site was established. Both text and figure were confined to the front surface of the monument, and both were concise. Hasaw Chan K'awil celebrates the completion of fourteen katuns (noted in the text over his head) in 711.

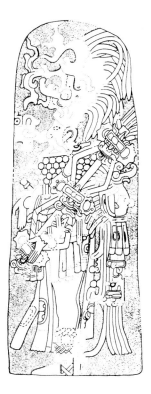

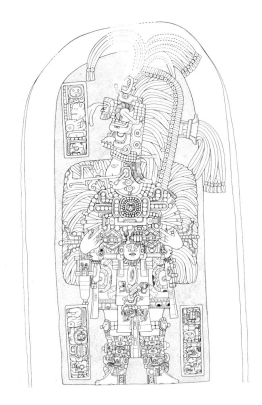

110. The surface of Altar 8 depicts a prone, tied ballplayer, his lower legs and feet in the air. The rope runs from the captive's tied arms to the perimeter of the stone, to make the observer read the entire surface as if it were a great ball.

death. As depicted from 711 to 790, the king's royal uniform—including cutaway mask, feather backrack, hipcloth with crossed bones and death-eye trim—must have been meticulously preserved to be worn by one generation after another. In the final iteration, one can see that the hipcloth has been folded like a handkerchief—and like those of Toltec lords in Central Mexico—but the costume's consistency only emphasizes the similarity in size, scale, and style of rendering, such that any attempt to develop style dates results in a chart of remarkable stasis.

At the same time that the most public monuments resisted change, Tikal experienced at least as much political ferment as any other Maya city-state of the era, if not more, for its dynasty suffered an apparent schism in the seventh century, resulting in a rival capital at Dos Pilas, in the Petexbatún. At Tikal, two sculptural formats thrived in the eighth century, infused by fresh political success: altars and lintels. On altars, round stones consistently placed in front of stelae, Tikal lords rendered their hapless captives in humiliating postures, taking liberties with the captives' representations that were not taken with those of the rulers. On Altar 8, the unfortunate is trussed up like a Maya ball, probably to indicate his death in a ballgame; on Altar 10, the captive is bound to a heavy scaffold and rendered over a quatrefoil cartouche, indicating an opening to the Underworld.

Although many Maya sites used wooden lintels hewn from tropical hardwood trees, the most elaborate ones to survive come

11(

111. Most lintels at Tikal feature great litter or palanquin scenes, as if their very placement as lintels required them to be read as images that would be carried on high. Depicted in an unusual frontal sitting presentation is Yik'in Chan K'awil, who celebrates a military victory in AD 743. Carved of sapodilla wood, Lintel 3 of Temple IV was in nearly perfect condition when it was taken to Basel, Switzerland, in the nineteenth century.

from Tikal, where beams of sapodilla spanned the inner doorways of temples sacred to ancestor worship. Many featured giant god effigies and their litters, of the sort also scratched in Tikal graffiti, and the novelty of these lintels, set in high places where even a peek at their imagery would have been a rare privilege, offers a counterpoint to the repetitive stelae. The effigies themselves were among the most precious invocations of divinity in Maya life. 111 We may suppose them to have been made entirely of perishable materials, perhaps papier-mâché or wood or cloth. Inscriptions intimate that these images were warfare's most treasured booty, and their isolated naming at Calakmul and representation at Piedras Negras (Stela 10) may indicate that Tikal lost them to or gained them from rivals at some point.

Tikal and its "suburbs" managed to keep the stela tradition alive into the ninth century, and Stela 11, from AD 869, typifies the last monuments of the Petén, with the exception of those from 112 Seibal. Ninth-century monuments flare at the top, and decorative motifs frame the edge of the pictorial field, abruptly truncating

112. The stela tradition survived well into the ninth century at Tikal; Stela 11, shown here, was dedicated in 879. Floating figures and articulated frames became common on ninth-century monuments.

feathers and scrolls. Spindly legs support human figures in the ninth century leaving them weightless and ungrounded; torsos frequently do not quite align with legs below, as is the case on Stela 11. In scrolls above that may signify clouds, the gods known as "Paddlers" hover. But even the gods that canoe the Maize God to the Underworld for his annual renewal cannot renew Tikal, although that may have been the message. To a degree unknown elsewhere, Tikal remained a place that the occasional Maya visitor encountered through the centuries, but by 900, it had ceased to be a place for new Maya sculpture.

Copán and Quiriguá

At both Copán and Quiriguá, Maya sculptors worked with local, idiosyncratic rock, which may have led them to experiment with the two-dimensional format established in the Petén. Ultimately, although perhaps hit upon originally by experimentation with the

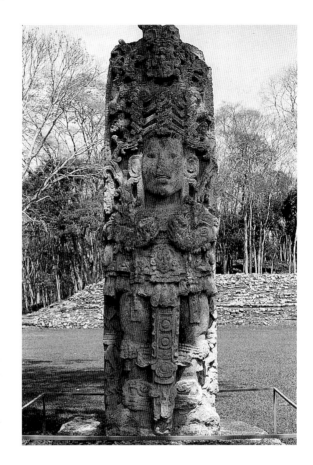

113. Powerful in the sheer perfection of Waxaklahun Ubah K'awil's physiognomy, early eighth-century Copán Stela A achieves a greater three-dimensionality than is known of any earlier king of the city. Although proportions often grow lankier over time at many Maya cities, the monuments of Waxaklahun Ubah K'awil emphasize and enhance the face itself, with overall stocky proportions.

presentation on incensarios, a format of low-relief representation enhanced by an isolated three-dimensional face became the dominant one at Quiriguá. Slightly more yielding than the limestone of the Petén, the red sandstone of Quiriguá provided a medium that allowed this enhancement of the human face.

At nearby Copán, workers discovered that the volcanic tuff they quarried from the hills yielded easily to the chisel when first taken from the ground but then hardened in the air. With such easily shaped rock, they carved elaborate programs of architectural ornament while nevertheless preserving the stela tradition. By the sixth century, they were carving massive, disproportionately leggy sculptures, with three-dimensional relief of head and arms, 113 yet still held fast by the prismatic shaft of the stone itself. By the eighth century, the prism melted away as the sculptors instead freed profoundly lifelike sculptures. Many appear as if oversized kings had just been frozen in time on the plaza, formally posed,

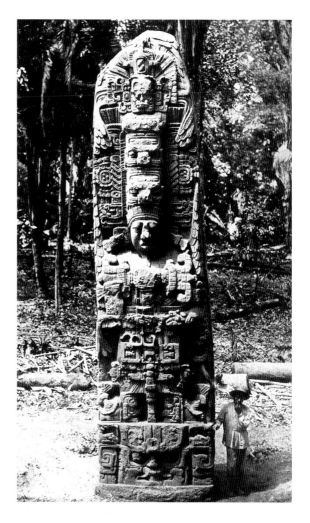

114. When Cauac Sky captured Waxaklahun Ubah K'awil of Copán, he sought to replicate his enemy's great plaza. The result at Quiriguá was a powerful plaza, occupied by towering stelae (here Stela D, erected in AD 766) that depict the king in the guise of various gods.

with fully-formed feet obliquely planted to support the full regalia.

Copán achieved sculptural glory with the production of the stelae that celebrate Waxaklahun Ubah K'awil's reign in the early eighth century, and that still dot the principal plaza today. But in 738, the king of Quiriguá took Waxaklahun Ubah K'awil captive, and then, back at Quiriguá, beheaded him. At mid-century, fueled by their prowess, Quiriguá erected a potent stela program, setting in place the tallest group of sculptures ever made by the Classic Maya—and that still form a Quiriguá "skyline" today. So many Quiriguá stelae mimic the subjects of Copán—a text presented as a woven mat, for example—that one wonders whether the Copán sculptors themselves weren't captured along with the king and

114

forced to create the program. Only later in the eighth century would Quiriguá sculptors bring an original format to its fullest form in the carving of several-ton river boulders into what scholars have dubbed "zoomorphs," characterized by Zoomorph P, for example, where one of the last kings sits within the open mouth of a great turtle-like creature. 115

The usual artistic response to defeat on the field is silence: at Palenque or Tikal, foreign wars brought production to a standstill. So, too, at Copán. But within a few years of Waxaklahun Ubah K'awil's demise, his successor had commissioned the grandest of all sculptural programs, the Hieroglyphic Stairway, featuring over 40 2000 carved glyph blocks and six seated lords, all in celebration of the very stability and order of Copán. The effort was an effective visual erasure of the Quiriguá attack. Across the Maya realm, hieroglyphic stairways celebrate defeat and subjugation, often executed by freshly captured slaves and artists. What makes the Copán Stairway so unusual is that the architectural metaphor of the staircase is turned on its head, becoming a statement instead for freedom and continuity. The recent decipherment of the Stairway and its excavation let us see that the Maya could take old sculptural forms and formats, and particularly during the eighth century, manipulate them for new meaning. In this re-invention we can also see some clues to the innovation that takes place in the north, particularly at Chichen Itzá, beginning in the eighth century.

115. Quiriguá sculptors must have ordered great boulders to be moved from the Motagua River to Quiriguá, where they were carved *in situ*. Zoomorph P depicts one of the city's last kings, emerging from the mouth of a great turtle, perhaps in reenactment of the rebirth of the Maize God.

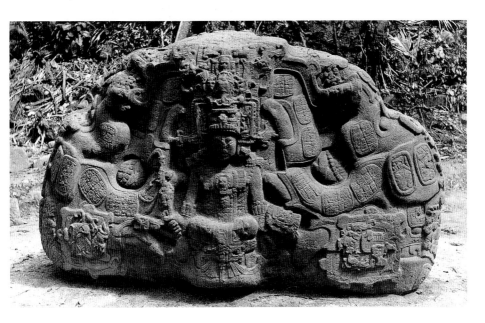

Chapter 6: Sculpture of the North: the Art of Yucatán and Chichen Itzá

Maya art of Yucatán—and that of Chichen Itzá in particular—developed along a somewhat different trajectory from the art of the southern lowlands and with a distinctly different timeline. Although Maya art ceased to be made to the south after AD 900 altogether, the end of the millennium was a rich and fruitful time in the north, and the making of Maya art continued unabated until the arrival of the Spanish in the sixteenth century. It was, after all, in Yucatán that Bishop Landa met with local elders to record their writing system. The sculptural media of the south—and the freestanding stela especially—adapted to local conditions in the north, where the raw materials were of a different order and where the very environment of scrub tropical rainforest differs from the high-canopy deep rainforest of the south. Time and ethnicity also played a role, so that continuities with the south can be seen in the widespread carving of stone stelae in the Puuc (literally "hills" in Yucatec Maya), the hilly region to the west, with innovation and discontinuity in far greater evidence at Chichen Itzá.

The study of the art of Yucatán has also differed from that of the southern lowlands. Whereas recent investigations of the sculpture of, say, Palenque have been driven by hieroglyphic decipherment, the northern monuments bear laconic texts, if any. This makes the sort of personal and local historical interpretation that has fueled the study of southern lowland art difficult, if not impossible. And Yucatán sculptors—from the earliest efforts in the fifth century to the years just before the Spanish invasion—had a different quality of limestone available to them. The porous rock they worked on both resisted fine detail in the first place and then gave it up to the elements in the second. Best preserved are those sculptures that were three-dimensional in their format, conceived as architectural ornament, or planned for an interior location—a description that in fact describes many of the works at Chichen Itzá.

Additionally, whereas the high-canopy rainforest long shielded the southern lowland architecture from scrutiny—and thus focused attention on the freestanding sculptures—the architec-

ture of the north has always stood out against the scrub forest. The architecture—but not the art—of the north early on began to play a role in the modern imagination: for the 1893 Worlds Columbian Exposition in Chicago, the meat-packing magnate Armour sponsored a campaign of great cast-making of architectural facades of Yucatán and they played a prominent role at the fair.

So while architectural studies of the north flourished, studies of its sculpture have often foundered. Northern sculpture operates on different terms from Classic sculpture of the south. Some of its characteristics include flamboyant and exaggerated poses that enhance legibility, particularly when viewed from a distance. Its impulse to three-dimensionality infused new energy into sculptural programs. Processional friezes, common at Chichen Itzá, invite the viewer to become a participant and to move along prescribed paths. More specifically architectural than other Maya sculpture, Campeche and Yucatecan sculptures occur as door jambs, lintels, and built-in wall panels, both making the buildings permanently populated and emphasizing particular ideologies.

The dating of northern sculpture has long been problematic, but recent work by Jeff Kowalski on Puuc architecture and sculpture makes a convincing case for dating most of it to the eighth and ninth centuries. More controversial are renewed efforts to redate Chichen Itzá, and to interpret its entire time frame as a shallow one, rather than extending for many centuries. Charles Lincoln first posited Chichen Itzá's overlap with the Late Classic period in the Puuc and among the southern lowlands, rather than seeing the Chichen florescence as a unique, early Postclassic phenomenon, and recent Maya hieroglyphic decipherment bolsters the case for the earlier dating. For the purposes of this chapter, the apogee of Chichen will be assigned to the ninth and tenth centuries. Although sometimes called the Terminal Classic, that term is too redolent of both the forgotten train station and a certain decadence for use here. Simple century assignments will be preferred.

Wars of conquest during the eighth and ninth centuries fueled the economic success of the north at the expense of the south. Populations flowed toward the north, perhaps as the result of direct enslavement, but also possibly for economic opportunity, for surely the construction of such remarkable centers required vast amounts of skilled labor. Uxmal's ceremonial precinct draws on a city like Palenque's for its plan, but its galleries and palaces with elaborate mosaic ornament would appear to have drawn on the precedents of distant Copán. They may have developed their low-slung architectural styles simultaneously, but even the wide-

spread use of curly-nosed Chaak—the Maya rain god—and Wits—personified mountain—masks would appear to have its prototype in early eighth-century Copán architecture. Because of new patterns of migration, the greatest influences on the north seem to have come from the Maya peripheries, whether to the south—Copán—or west—particularly from the Usumacinta cities. The impulse to three-dimensionality seen at Copán and other sites to a lesser degree achieves its richest florescence at Chichen Itzá. The leggy proportions that take hold at Chichen and elsewhere last appeared in the south on monumental sculpture in seventh-century Copán, and the frontality that the north so fluidly experiments with also characterizes much Copanec sculpture.

Sculpture of the Puuc region
At Uxmal, a well-developed sculptural tradition dovetails with that of the late eighth century in the Usumacinta lowlands. Standing figures hold copal bags, engage in scattering or sprinkling rituals, or stand atop hapless captives. A border clearly demarcates the scenes of most monuments, in many cases forming a roof over the protagonists. About 900, the lords of Stela 11 and 14 both adopt huge feather adornments, more hat-like than most headdresses, and on Stela 14, the hat includes a cutaway mask of Chaak, the Maya rain god, which hangs in front of the king's face. Although little remains today, such be-hatted figures worked in three dimensions were once featured on the front facades of some principal palace buildings, the West Building of the Nunnery and on the House of the Governor among them. But whereas the Nunnery figures once sat, the stela figures are generally active. The ruler on Stela 14 lifts his weapon high with his left hand, bringing it in front of his headdress, in a daring pose.

In some respects Stela 14 is a conventional effort: it aggrandizes the ruler, setting him atop a two-headed jaguar throne which in turn rests above two mirror-like captives (with yet a third tucked behind), their genitalia explicitly exposed in humiliation. But with a complexity of composition rare in monumental art, it also reveals the ideology that this powerful local lord sought to promote. Up above him, an ancestor's deified head gazes down, framed by two diminutive, floating figures. These floaters are the Paddlers, the gods who ferry the Maya Maize God from one stage of life to another, and who occur on Maya ceramics and in the upper margins of very late Classic stelae at Tikal and elsewhere. Here the Paddlers may well carry the ancestor as harvested maize. But what renews the Maize God is human sacrifice: at the base of

116

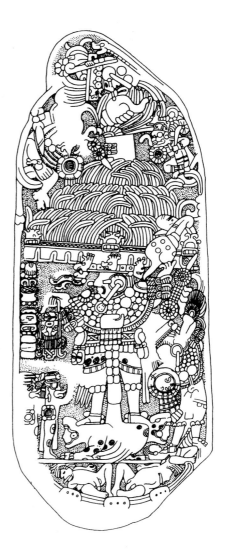

the monument, the humiliated captives provide that sacrifice to
the Underworld, rendered here as the "black hole," and inscribed
like a giant glyph around their naked bodies.

So embedded in what seems to be a florid version of a conven-
tional stela is actually a suppressed narrative—which may of
course be the case in other instances as well. A knowledgeable
Maya audience needed only a few cues to see the entire narrative,
much as a crucifix can initiate the story of Jesus in a Christian
viewer's mind. For the Maya, the story of the Maize God was the
heart of their religion, and his growth, flourishing, and decapita-
tion followed the agricultural cycle. His sons, the Hero Twins,

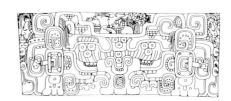

117, 118. Maya sculptures, such as Tzum Stela 1 (left) of Yucatán, emphasize the ideology of the Maize God and frequently depict the king as young maize reborn from the stony earth, a subject more elaborately portrayed at Bonampak, in the southern lowlands (right).

119. At Xkulok's Building of the Sculptured Columns, frontal warriors support carved lintels of Maize Gods that face downwards and are invisible until one steps into the doorway, in a vivid re-creation of their apotheosis.

bring him back to life from the Underworld, whereupon the Paddlers convey him to the site of creation—a constant renewal and recreation, from which the cycle begins once again. The base of Stela 1 from nearby Tzum, like that of Stela 1, Bonampak, also features young Maize Gods, this time springing out of the Wits monster, indicating personified rock. At Xkulok, three lintels featuring Maize Gods span the doorways of the Sculptured Columns Building. Supporting the principal doorway are two sculptured columns, each featuring a frontal lord in warrior dress: it may be their prowess that releases the Maize Gods and sets them overhead.

Northern sculpture often bears a vivid sense of narrative. Not only do figures in general take active postures (e.g. Oxkintok Stela 21; Edzna Stela 6), but many stelae are laid out with three specific registers. Compositions featuring registers also occur in the

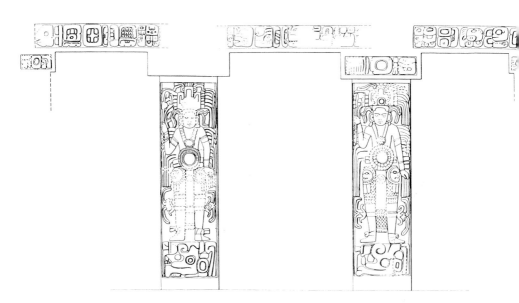

southern lowlands, but generally only at the end of the eighth century and into the ninth, just when they also take hold in the north. The register, of course, is an essential feature of a complex program like that of the Bonampak murals (Chapter 8). With three separate frames, often separated by text, such compositions on northern stelae are keenly similar to the pages of surviving Maya books, like, for example, the Dresden Codex which features three registers on most, although not all, of its pages. Oxkintok Stela 21 may present a king at top, with his war captain at center, although that individual is the most prominent individual—perhaps because he is the local lord represented. The composition of Piedras Negras Stela 12, probably from the same period, includes some of the same elements, but successfully integrates them, unifying the war captains below their lord in a single scene, without the presentation of three separate registers. Nevertheless, one can easily imagine the whole of the Piedras Negras stela deriving from such a compartmentalized framework.

One of the most elaborate buildings of the north, the House of Masks of Kabah, also features elaborate door jambs that frame an interior room. Each jamb presents two scenes: above, apparently a dance between victorious warriors, and below, their domination of an abject captive. One protagonist wears an elaborate woven sleeveless jerkin, often characteristic of Jaina figurine warriors (Chapter 7) and distinctive face markings, indicating a gold or mosaic mask or perhaps the sort of tattooing found on at least two

120. Stela 21 at Oxkintok is divided into three separate registers but bound together by a twisted cord frame that unites the scenes. An ancestral figure on top may sprinkle offerings onto the central register figure, a striding warrior, while two lords perform a dynastic ritual on a throne, at bottom.

121. Door jambs from Kabah present a sequence of warfare and dance. Following success in taking captives, rendered on the lower half of the monument, the victors dance on the upper half. Distinctive scarification, face paint, and jewelry mark the protagonists, indicating that the same victors appear in each scene.

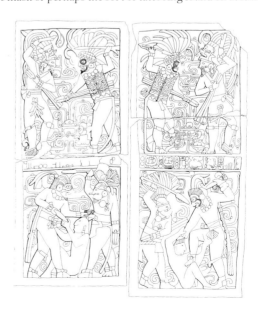

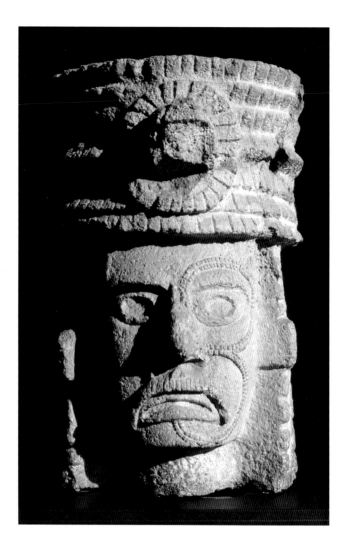

122. One of two nearly identical stone heads, about 50 cm high, features the tattooed or scarified lord of ill. 121. The eyes once held shell or obsidian inlay.

great heads from Kabah, probably portraits of this same man. Unlike any other Puuc sculptures, the figures overlie elaborate background scrollwork and heads, similar to the device used in the Great Ballcourt sculpture at Chichen Itzá.

 The widespread use of the column in the north lent itself to processions and continuous compositions, and some surely derive from the formats common to ceramic vessels. With its bejeweled dwarf, elegant musicians, and attendant lord, the column of Champoton, for example, suggests the luxury of courtly life. Like many painted vessels, the column's composition is closed, with figures who all face toward the dancing dwarf, and not continuous.

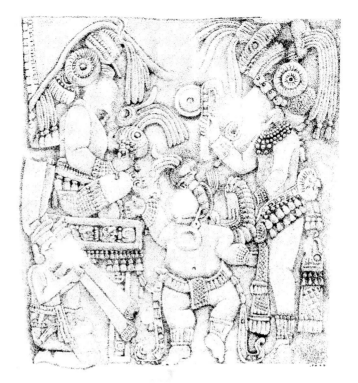

Chichen Itzá

While their neighbors to the west and south built cities and erected monuments that emulated the sacred practices of the southern lowlands, the Itzá Maya at Chichen Itzá constructed a new kind of sacred city. The Itzá came from the south, although they were probably not the dominant Maya of the older southern cities. Unfortunately, most modern knowledge of this period depends on Colonial sources from Yucatán, rather than epigraphy or archaeology, and so it has been hard to sort out just what the Itzá were doing prior to arriving at Chichen. In Yucatán, the Itzá married into local lineages; after the fall of Chichen, the Itzá were to go back to the Petén, where they remained free of Spanish domination into the seventeenth century.

Chichen Itzá was perceived to be a capital without rival, a Tollan, or a "place of cattail reeds." The concept was widely held in Mesoamerica, and may also have been of great antiquity: the Aztecs considered their capital city, Tenochtitlan to be Tollan, and the Toltecs before them believed their capital, Tula, to be Tollan. Until AD 700 or so, the reigning Tollan of Mesoamerica was at Teotihuacan, in Central Mexico. In their day, both Tikal and

Copán may have been known as Tollans, but their day was setting by AD 800. With the demise of Teotihuacan in Central Mexico and the weakening of southern Maya cities, new lords came to Chichen, and in one of the most elaborate programs of art and architecture ever devised in Mesoamerica, described the divine charter that gave them right to rule. Simultaneously, the Toltecs built their capital at Tula, Hidalgo, and the two powerhouses came to share art and architectural styles. Whether Tula was the dominant partner remains unknown.

Although the Chichen lords may have manipulated the jade and gold trades, providing themselves with an unprecedented economic base, the story of public art and architecture at Chichen speaks only of divine charter. The lords of Chichen were the first to seamlessly incorporate the ideology of Central Mexico and the Maya, making their city one of the greatest in all Mesoamerica.

In detailed registers in the Lower and Upper Temple of the Jaguars, as well as the North Temple of the Great Ballcourt, sculptural narratives engaging vast numbers of individuals would seem to tell the tale of the city's divine charter, with the complex and dense paintings of the Upper Temple spelling out the sacred wars that put its lords in power. The story told would seem to be a cosmic one, the vast numbers of the defeated recalling both the mass interment at the Temple of Quetzalcoatl at Teotihuacan and the mass slaughter that would take place late in the fifteenth-century dedication of the Great Temple of Tenochtitlan.

Very low relief carvings line the interior walls of the Lower Temple of the Jaguars and the North Temple. Individual slabs were assembled and then probably carved *in situ*, before receiving a light coat of paint. In the Lower Temple of the Jaguars, the sculptors relate the creation story once again, with the role of the Itzá Maya evident. At the North Temple, elaborate rituals accompany the seating of the Itzá rulers, including auto-sacrifice, ballgame, and hunting.

The six massive sculptural panels lining the Great Ballcourt recount the aftermath of victories of Chichen lords: it is this success in warfare that leads to the reenactment of the narrative and that would seem to resurrect the Maize Gods from the crevice time and again, right at the site of the ballcourt. Like the warrior door jambs from Kabah, scrolls fill the background, but suggesting at Chichen swirls of blood and smoke, or moisture-laden clouds, like those of Yaxchilán Lintel 25.

Contrary to the modern myth that was established between World Wars I and II and promulgated by generations of on-site

124
12
103

guides and guidebooks, in which the "winners" were sacrificed by "losers," the evidence in these grisly panels is that it is the losers who suffer decapitation. But there is no progression here, only a static inventory of six great sacrifices. Each sacrifice takes place over a great ball, a gaping skull described on the surface. These skull balls may tell us that the Maya recycled the human skull to the center of the rubber ball, thus forming a hollow that would give it some bounce. Other skulls were deposited in the Tzompantli, or Skullrack, just outside the court, one of the earliest such racks in Mesoamerica.

Although scholars have tried to develop credible sequences for construction phases at Chichen Itzá, the best answer currently is that any time depth is limited to no more than two centuries, and that differences in artistic style can be explained by the varying subjects, or by multi-ethnic populations at the city. Recently, Linnea Wrenn and Peter Schmidt rediscovered a huge carved sacrificial stone, imaginatively formed as a ball lodged in a ballcourt ring. Its indisputable date records 864, and the imagery has confirmed the stylistic coincidence of the lanky lords inside S-shaped rattlesnakes during the ninth century. This sculpture anchors the imagery that has long seemed very "late" (some scholars have even wanted to read Chichen Itzá as an immediate prelude to the Aztecs) to specific first-millennium dates.

Yet if we think of Chichen Itzá as the effort of less than ten generations, then the concentrated energy of the artistic program is quite astonishing, for everywhere the city was carved or painted, or both. All Chichen Itzá sculptures were carved *in situ*, and the very process of production must have filled the city every day with skilled laborers. Across the main plaza from the ballcourt, dozens of columns and piers were carved, forming the colonnade in front of the Temple of the Warriors and the so-called Mercado. Carved

124. On each of the Great Ballcourt panels of Chichen Itzá, victorious players face their defeated foes. At center, a single loser has been decapitated; the oversized ball features a human skull.

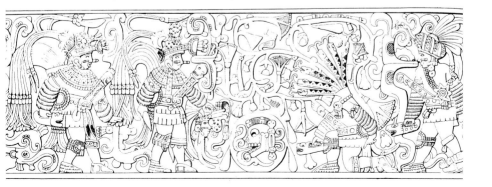

benches establish the format that would be replicated time and again, right up until the Spanish Conquest of the Aztec capital.

Three-dimensional sculptures

An impulse to three dimensions thrived in the north. In the Puuc region, figures in flayed skins wield star-shaped maces (Oxkintok) or may have supported thrones (Xkulok); enormous erect phalluses projected from walls or were set up in courtyards. But the greatest success in this regard was at Chichen Itzá, where entirely new categories of sculpture seem to have been invented. Many appear simultaneously at Tula, Hidalgo.

Chief among the new sculptural forms at Chichen are the chacmools, serpent columns, mini-atlanteans, and standard bearers, all of which become omnipresent in the buildings of rulership. The chacmool—literally "great or red jaguar"—was so dubbed in the nineteenth century by the workmen of adventurer Augustus Le Plongeon, and the term has come to mean all sculptures of reclining figures with the head at 90 degrees, who hold a vessel for offering on the belly. The local workers who coined the term may have retained some ancient lore of a buried red jaguar, although surely one could not have mistaken the reclining chacmool figure for a jaguar. Nevertheless, at least one red jaguar throne was buried at Chichen Itzá, and it came to light in 1936, when José Erosa Peniche's men stepped into the chamber at the top of the "fossil" temple buried so pristinely within the Castillo, where the visible temple of today encases a hidden one. In fact, the red jaguar throne had been sealed in place with its accompanying chacmool, and the

125. (right) With their consistent reclining postures and frontal faces, the chacmool sculptures of Chichen Itzá recall some captive panels of Maya stelae, and they may symbolize fallen warriors.

126. (opposite) Archaeologists found a completely preserved earlier building, its throne and chacmool intact, buried within the Castillo. The chacmool holds a disk for offerings; a ruler would have presided from the red jaguar throne in the background, sitting on its turquoise-studded *tezcatcuitlapilli*, a Toltec mirror back known from Central Mexico.

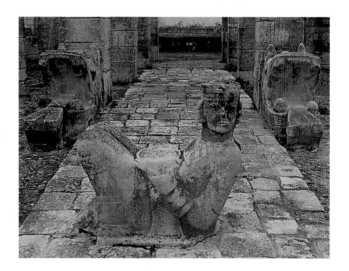

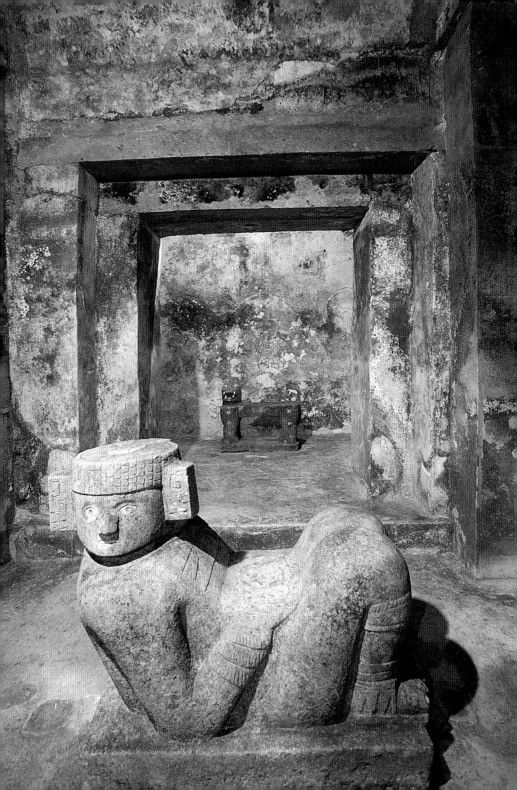

two sculptural forms usually function together, the throne the seat of rulership and the chacmool the place of offerings to rulership.

Eventually, chacmools would be found in many places, not surprisingly at Tula and even farther to the north; and in recherché versions created for the Aztec sacred precinct, where Tlaloc (Central Mexican rain god) imagery is layered onto the forms. Consistently, through time and across cultures, the chacmool seems to function as a locus for offering, the receptacle on the belly for human offerings, in all likelihood. At the same time, these chacmools bear the iconography of the Mesoamerican warrior, and the disk they hold up on their bellies is akin to the disk held by Maize Gods, where it is the point of renewal and self-replication. Jade plaques hurled into the Sacred Cenote depict Maize Gods who hold just such disks. The relationship between warriors and Maize Gods is spelled out at Xkulok: the chacmool may concentrate such ideology into the body of a single figure, furthermore making of it the sort of liturgical furniture that indicates ritual function to all comers. 119

After the decline of Chichen Itzá

Chichen Itzá's world of so many high-status individuals suffered such cataclysm around the end of the millennium that, after that point, almost nothing was built, few sculptures made, and only scarce ceramics fired. With Chichen Itzá only surviving as a pilgrimage point, if new theories are correct, both the southern and the northern lowlands supported little elite activity, and even the developments in the Guatemala highlands lagged until the final 200 years before the arrival of the Spaniards. When works made after such cultural collapse are called "decadent," the observer is bound to deprecate the efforts. In fact, if the pause is as long as archaeologists now think it was, then the renewal in the thirteenth century is remarkable, a revival of ancient traditions that survived some very grim times indeed. In the thirteenth century cities like Mayapán, Tulum, and even Santa Rita sprang to life, supporting the lively culture that Bishop Landa witnessed and described in the mid-sixteenth century.

An exploratory mission under the leadership of Juan de Grijalva spotted coastal Tulum in 1517 and identified it as a trading hub. Prevented by the massive coral reef from venturing close to shore, he nevertheless waxed eloquent over what he saw, comparing it to far-off Seville. Tulum is best known today for its diminutive architecture and elaborate paintings, both described in other chapters; two seventh-century stelae probably came there as

127. A stone turtle at Mayapán features thirteen katun, or twenty-year period, signs, probably designating its use as a katun wheel, marking 260 years.

128. Stela 1 at Mayapán depicts a pair of figures inside a thatched shrine. This concept of stela as "house" may have been present generations before—Copán's Stela J also had a stone thatch "roof."

tribute or perhaps as booty from a Classic site—exactly what the Tulum lords may have insisted on from the passing traders who sought to stop and drink from its freshwater springs.

In their prominent town west of Chichen Itzá, the lords of Mayapán systematically sought to draw on the past. At their order, laborers hauled pieces of sculptural facades from the Puuc region; radial pyramids replicated Chichen's Castillo. In forging their own tradition, Mayapán sculptors turned to both three-dimensional forms, in clay and stone, as well as a renewed stela tradition. Large and small ceramic sculptures present single deities, many associated with agricultural fertility, and the widespread "diving" gods from the period offer tamales or corn *masa*. Stone turtles at Mayapán register the count of katuns, the twenty-year periods celebrated on the round altars of the southern lowlands, particularly at Toniná and Caracol: poles for human sacrifice may have been fitted into their backs. The stelae configure the carved face as a house or shrine, the text forming the roof, and with gods within. A single standing stela may have presented a standing ruler, but the sculpture has taken such a battering over the years that no other detail can be determined.

Little Maya sculpture can be attributed to the time of the Spanish invasion, but some perishable materials offered to Chichen's Sacred Cenote may well belong to the era. Wood and fiber, cloth and resins all offer testimony of both practices and art-making that may have lingered into the Colonial period. Under Spanish rule, particularly in Guatemala, Maya carvers wrought remarkable wooden saints and adorned them with native textiles. Throughout the Maya region, wood carving remains an important tradition today.

Chapter 7: The Human Form

In Maya art, the human form is omnipresent, whether in representations of gods or of humans. What makes that human form so appealing to the modern eye is the seeming naturalism of Maya representation. Figures sit, kneel, hold objects, or touch one another in ways that are astonishingly lifelike. And the emphasis on people, as well as the things people do, has made Maya art seem approachable.

The main subject of monumental Maya art is the king, and the most featured representation is his royal person—so much so that many Maya stelae depict only the king and narrate only his deeds. Even when the featured representation on a monument is not the king himself, either the nature of the depiction or the text relates that individual to the king. When one goes beyond the limited possibilities of stone sculpture and the sort of weight that was given to it, however, many other elite individuals—surely many from the royal family but also merchants, priests, and war captains—were able to commission their own depiction in art. One might

129. Often rendered as grotesques, the Monkey Scribes are usually shown hard at work, writing, painting, or carving. Here an artist with a quick and free line may indicate that the hand for writing could have been bound; like a great spatula, an exaggerated left hand supports a jaguar-covered book.

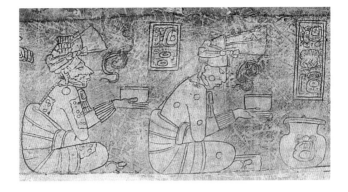

130. On an elegantly incised vessel, seated Hero Twins proffer cups with offerings. Xbalanque, left, wears distinctive jaguar pelage patches on face and body; Hunahpu features spots. Young and handsome, they share the concept of perfect beauty with their father, the Maize God.

think this is logical, if only because they were the ones with the economic wherewithal to do so. However, among the Aztecs many representations of rulers survive, but essentially no representations of other nobles, so the same situation did not emerge among that later civilization.

Additionally, some of the most powerful Maya supernaturals had human form. Human perfection was summed up in the shape of the Maya Maize God, whose representation as full-grown male youth included a strong, taut body, smooth skin, and luxuriant tresses. The Hero Twins, demigods who could exert their powers 130 both on a plane with mortals and among the gods, also took idealized young male form. Their half-brothers, the Monkey Scribes, 129 took grotesque but recognizable human form in most cases. Many

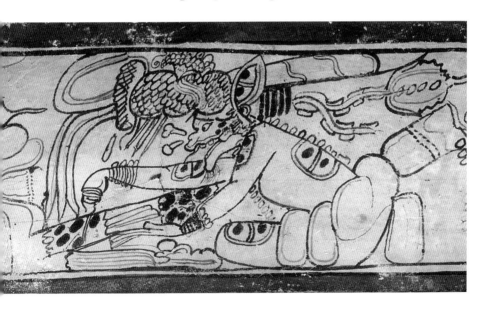

members of the Maya pantheon—Itzamnah, Chaak, and K'inich among them—were anthropomorphic, but with specialized non-human facial features: Itzamnah and K'inich always feature square eyes, and the latter's are always crossed; even K'awil, whose face is based on a serpent and one of whose legs ends in a serpent head, features a human torso and arms.

Over the period of a few hundred years, the Maya mastered the skills to render these divine and human forms for a number of purposes. The Maya came to represent both gods and humans in natural poses—overlapping one another, reaching out to one another's bodies, and in a variety of positions, from sitting and standing to playing the drums or playing the rubber ballgame. Mastering such representation was no small matter: no other civi-

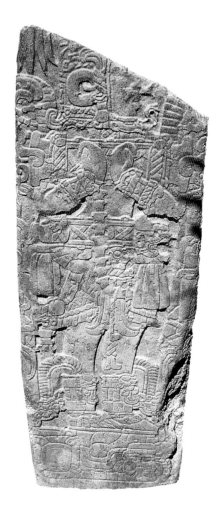

131. On Stela 1, the fifth-century artist wrapped the two-dimensional carving of a Tikal king around three sides of the monument. While the king's posture remains static, small figures on the sides are animated.

lization in Mesoamerica came close to the achievement of the Maya in this respect, and only a few civilizations of the pre-modern world were their equals. In fact, the first works of Maya art to be seen by Europeans so astonished them that they quickly led to the appellation of the ancient Maya as the "Greeks of the New World."

Representing the body
Many of the Maya skills in representation seem to have been perfected in the seventh and eighth centuries AD, but the story of their development began centuries earlier, during the Early Classic. During that period, the Maya artist typically made a highly conventionalized rendering, in which the body was carved as it is *known* by the mind to be, resulting in a human form completely *shown*. For example, Stela 1 (fifth century) from Tikal features the standing king Siyah Chan K'awil: in order to include the entire body, the artist renders both legs, parallel but separated with the slightest of overlap at the feet; the torso faces front, and the arms adopt an almost impossible position, in order to show upper and lower arms, as well as hands drawn as if they were in mittens. The head then faces to the side, in profile. Of course no one other than a contortionist can actually stand like this, but the point is that the features of the human body are complete, at least in profile.

But if one looks closely at the monument, the seeds of repre-sentational change have already been sown. The small figures who scale the ritual staves at the seams of the front and sides are rendered far more fluidly. A jaguar at lower left of Siyah Chan K'awil flexes a lower limb and reveals the inside of a paw, providing an early signal of foreshortening. The paired figure at right rests languidly on a shiny disk; above, coming out of serpent mouths, small god figures on both left and right sides feature legs and arms almost completely overlapping and torsos in three-quarters rep-resentation. By the time this monument was made in the fifth century, new modes of representation had been adopted for minor figures, while retaining the most conservative style for the ruler.

The presence of less conventional representations among the minor figures on Stela 1 may have been stimulated by develop-ments in other media that had fewer technical limitations than stone sculpture. At Río Azul, during the Early Classic, the art of making clay figurines flourished. Their bodies modeled entirely by hand, the figures sometimes featured mold-made heads. Delicate hands applied clothing layer by layer and hair in strands,

131

133

yielding life-like figures that adopted natural poses. Even with their standardized faces, the figurines are engaging little humans, lively in their aspect.

Maya painters may have adopted new modes of representation for pots and walls before artists considered using them on monumental sculpture. Few Maya wall paintings survive at all and only one major example of Early Classic painting is known, but the mural from Structure B-13 at Uaxactún, probably made late in the Early Classic period, provides a window on the sort of representation that was possible. Most interesting for the purposes of the representation of the human form are the many figures on two registers: they are shown shifting their weight, one foot off the ground, in energetic exchange with one another, and bodies overlapping. The Maya artist demonstrates the ability to show the human figure in motion in the Uaxactún mural.

Ultimately, by the height of the Late Classic the Maya artist created representations that featured the human figure the way it is *seen* by the eye, foreshortened and with overlapping parts, rather than as the body is *known*. For example, on Bonampak Sculptured

132. (below) On Bonampak Sculptured Stone 1, three lords (yet with only two visible feet!) present their king with a royal headband. The king's arm across his chest helps retain his center of gravity even as he leans toward his nobles.

133. (opposite) Shapers of figurines may have found lankier proportions more desirable, in order to have more body length for accoutrements and to balance what can be towering headdresses. Elegant hand-modeled figurines such as this one flourished at Río Azul, where costume elements were built up one layer at a time.

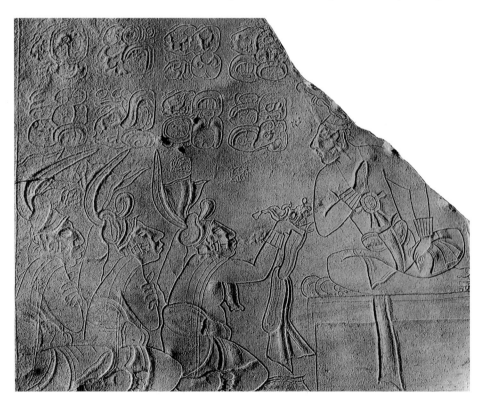

154

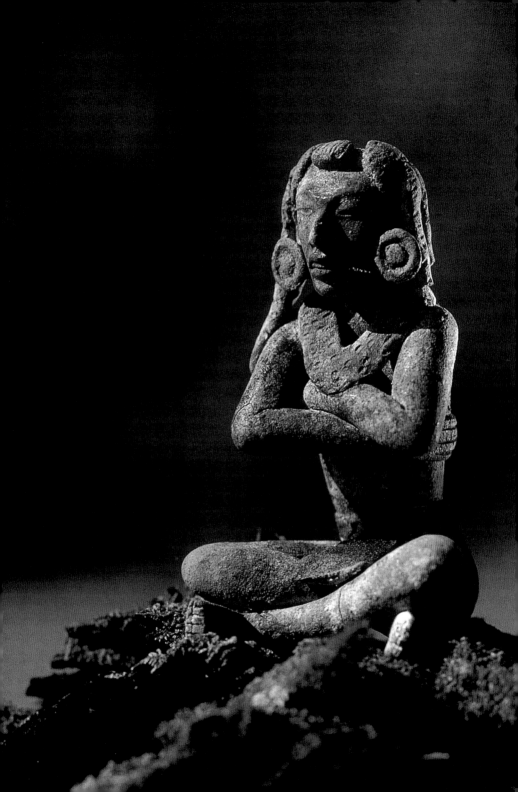

Stone 1, probably dedicated in 692, the enthroned king's legs are rendered with dramatic and confident foreshortening. The effect is so convincing that the eye does not question the rendering. The seated lords at left are rendered effectively in profile, the limited views of their crossed arms suggesting the posture of ease. Additionally, the first of these lords reaches up with a proffered headdress, revealing his bulging paunch. The frame cuts off part of the final figure, but the eye sees each body, head to toe, to be complete: only upon careful scrutiny does one realize that there are just two feet rendered for three men. It is as if the sculpture were some visual puzzle that the viewer, the brain and eye conspire to complete.

13

A late eighth-century panel at the Kimbell Art Museum further refines the possibilities of foreshortening, such that the human figures seem to occupy space. A victorious warrior presents three captives to a provincial Usumacinta-region lord, who sits cross-legged upon a throne named with the Yaxchilán king's titles—or it may be the king himself who presides. This lord easily moves his weight off-center, to approach his underling. His right hand presses into his thigh and the left is deftly turned. The center

13

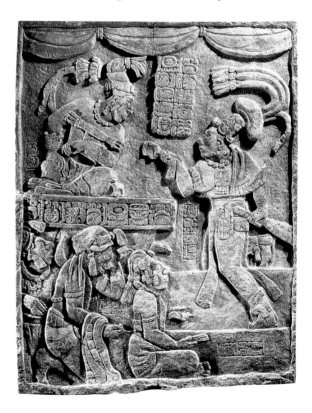

134. Just as the war captain at right reaches up and across on this Kimbell Art Museum panel, so does the line of captives slant downward from left to right, as if reading their demise in the very layout of the panel.

line of the lord moves in an arc that leaps across the text to the presenting warrior, whose body is also poised in motion, his rear foot flexed upon the step and then balanced by the gently lifted front foot. The lord sits under swag curtains, inside a palace space; the warrior approaches from just outside the palace, one foot still on an approaching step, as if in some very careful grading of social status. Outside the palace chamber, the captives sit and kneel two steps below. The carving of the panel is very shallow, but the human figures occupy the space effectively, conveying depth.

Draped lavishly in cut and shredded cloth, a visual metaphor for cut and shredded flesh, these three captives express heightened emotions with their dramatic gestures. The captive at far left may kiss or lick dirt from his hand in submission, the middle one raises his hand to his forehead in what seems to be a gesture of woe and resignation. The captive at far left is severely truncated by the panel's frame, yet there is no mistaking the artist's confidence that the viewer will see the complete human figure.

Such skills in rendering the human figure became conventionalized, and thus the range of solutions to both the organization of the composition and the rendering of an individual figure are limited. Some attempts never reached successful solutions: rear views of bodies rarely convince the eye, although the Maya tried to do this with the uppermost captive of the north wall of the Room 2, Bonampak murals; frontal faces in strictly two-dimensional media (as opposed to the high relief of a Copán stela) were tried on the

135. Although the Maya artist occasionally attempted to render frontal faces in two-dimensional, linear formats, he usually reserved such trials for the faces of captives or secondary figures, such as the humble servant smoking what looks like a cigarette here at left on a painted cylinder vase. He stands flanking a text that notes the initial date of the Maya calendar; other figures may seal a tribute negotiation, presumably at night.

153

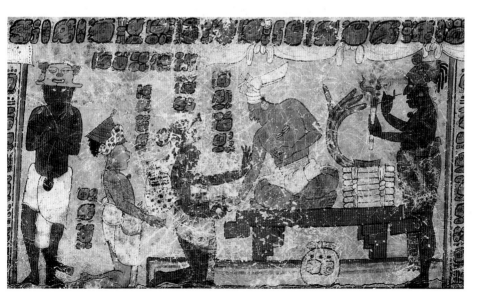

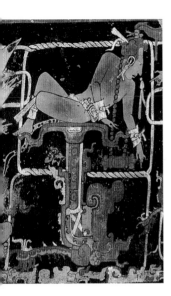

occasional secondary figure on Maya pots and on some carvings of captives at Naranjo and elsewhere.

135

In a few cases an exceptional artist developed a fluid three-quarters view of the body, as, for example, on the Black Background Vase. More typically, the painters of cylinder vessels managed to suggest the body in a three-quarters view by a handful of specific techniques. In a number of examples, the painter leads the viewer's eye from the frontal, foreshortened crossed-legs to the torso. To arrive at a convincing portrayal of a face in profile, one shoulder drops down, and the other rides up, revealing an expanse of neck: it is here that the turned body is achieved. Although the face seems to be in profile, its three-dimensionality can be suggested by a single stroke projecting the eyelashes or brow from the hidden side of the face. Turning one hand to reveal the palm or the wrist to reveal the ties of its bracelet also enhances the effect that the figure itself is turning. Despite what is often deft handling of the human figure on Maya vases, Maya artists could also exhibit seemingly reckless disregard for right and left hands, sometimes reversing them and sometimes painting two of the same on a single figure.

136

136. On the Black Background Vase, the Maya artist captures the body in three-quarters view, the subtle torsion evident at the belly. Despite these skills, he has painted a left foot on the right leg and a left hand on the right arm, although these features may have a meaning no longer retrievable.

Throughout the Classic period, Maya artists portrayed the human body along a narrow proportional range, with the scale of the head to that of the body from 1:5 to 1:8, the lankier proportions occurring even during the Early Classic when the figures *seem* shorter because of the heavy adornment with ritual costume. Proportions of 1:7 and 1:8 are used nearly universally on painted ceramics of the Late Classic; squatter proportions on carved lintels may derive from the compact and compressed format of that sculptural form. Reflecting their shorter stature, women rarely stand more than seven headlengths to the body.

Maya ceramic sculptors also came to use a slightly shorter proportional system, with most figures standing about six or seven headlengths. Faces often receive the greatest emphasis, along with headdress, and some bodies are simply rendered. Proportionally very large feet provided a standing figure with the means of staying upright. Some figures were modeled entirely by hand, with a separate mold-made face often added and then detailed by hand; some figures were made entirely in molds.

Maya figurines made during the Late Classic reveal a far more extensive range of activities and emotions than monumental sculpture. Most of the figurines known come from the island of Jaina, a burial island off the coast of Campeche, but fine quality figurines were made at Palenque and at Río Azul during the Late

Classic as well. Some portray the nobles of the court, often dressed as warriors or ballplayers; others explicitly depict Maya gods. More female figures are rendered as figurines than in any other medium, suggesting that a broader clientèle may have commissioned or purchased the figures.

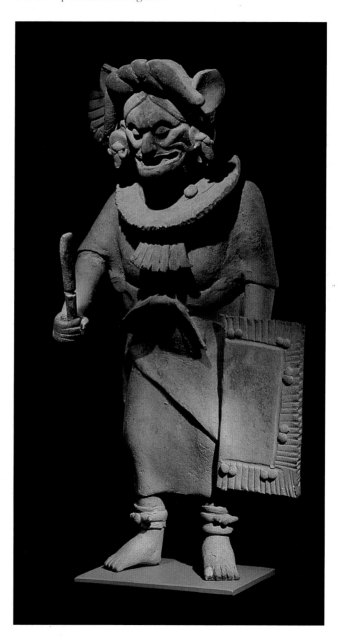

137. The Maya considered Chaak Chel to be a woman warrior, the old midwife who both delivered infants and brought on destructive floods at the end of the world—the latter perhaps thought of as akin to the unstoppable flow of amniotic fluid. As with many other Jaina figurines, she retains brilliant tenacious blue pigment that was applied after firing.

138. (right) Arms in motion, this Jaina figure is armed for war or the hunt. The deer headdress also characterizes some ballplayers, as does the padding he wears on his left arm. Large, thick feet helped such a figure stand up on a dirt floor.

139. (opposite) Although the joined bodies of this amorous pair were formed in a single mold, their faces and headdresses were finished with exquisite care by hand, as was the woman's outstretched arm, her willing embrace belying her coy lack of interest. Substantial feet helped keep Jaina figurines upright; many have whistles worked into their backs and shoulders (ill. 1).

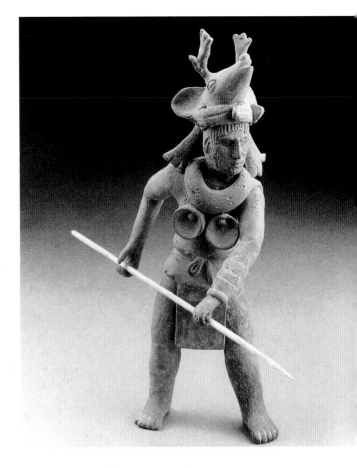

Working in pliable clay, the artist successfully mastered the stooped posture of age in a figurine of Chaak Chel, the old midwife goddess of the Maya. A woman warrior, she also prepares to attack, her shield at her side. A male warrior stands poised in movement, his grasping hands once having held a now-lost spear. Dressed in a deer headdress, this figure may be a hunter as well as a hunter of men. His serene expression—perhaps due to the molded construction of the face—belies his aggressive stance. A pair of ballplayers at the National Museum of Anthropology in Mexico City is frozen for all time in dramatic postures, an imaginary ball between them.

But some figurines reveal expressions—and actions—rarely seen in Maya art. Probably about a dozen examples feature a young woman and old man embracing—or a woman and a rabbit, or other beast! An example at the Detroit Institute of Arts was

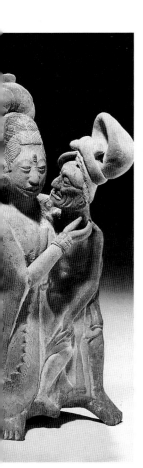

probably made with three molds, one for each head and one for the conjoined bodies and then finished with added detail and brilliant pigments. While the woman stares impassively into the distance, the old man leers directly at her, as if in hope of some reaction as his hand slides along her leg, lifting her skirt above the knee. The very same mold may have been used to fashion the bodies of a similar pair at Dumbarton Oaks, but this time the artist used different heads and oriented them toward one another, so that the viewer reads a loving sexual intensity in the couple.

Throughout the Late Classic the human figure could be rendered in ways that seem to the modern eye to be truly naturalistic. But the rendering of the human form takes a sharp turn in another direction at the end of the period. In the ninth century, at Halakal and other satellites of Chichen Itzá, the human form started to be rendered neither as it is *known* nor as it is *seen*, the two modes of representation that had previously informed representation of the body. Artists rendered the three figures on a panel from Halakal with legs that do not line up with their upper bodies, as if one team of artists started carving from the bottom, another team from the top, and then failed to meet in the middle.

Ninth- and tenth-century Chichen Itzá sculpture developed highly conventionalized forms of representation—particularly for monumental sculpture. These conventions required that the legs be in profile, parallel, and overlapping above the knees. All faces are in profile, and torsos may be represented in profile or frontally. Artists rarely used foreshortening and show no modeling of arms and legs. Figures often seem weightless and in fact may float off their groundlines, as they do in Chichen Itzá paintings. Postures vary little from figure to figure on most monuments, creating the sense of corporate identity rather than individual human forms.

Physiognomy and portraiture

Like other Mesoamerican peoples, the Maya idealized youthful male beauty and particularly the handsome, unblemished face of the Maize God. For the Maya, Maize God theology was complex: the Maize God was the father of the Hero Twins and Monkey Scribes; he also personified the yearly agricultural cycle, the renewal and death of plants. But in addition, other gods took ground maize dough to fashion human beings, making the possibility of ideal beauty attainable for all noble humans.

Most representations of the human face in Maya art focus on this ideal beauty. The face of the Maize God was understood to be

140. The Maya Maize God embodied human perfection, from his tapering forehead and prominent nose to his luxuriant tresses, where a thick head of hair also guaranteed an abundant maize crop. His hands gently wave, like the foliage of the maize plant. Once tenoned into the cornice of Structure 22, Copán, the Maize God would have seemed to grow organically from the building itself.

141. A staircase riser, Monument 27 at Toniná positions the aged profile of the captive to be trod on time and again. Few humans ever feature the telltale signs of aging; that this captive does may be part of his visual humiliation.

the growing ear of maize, still on the stalk. The Maize God has flawless facial features, but he also has abundant straight hair that the Maya understood to be like luxuriant corn silk. On the maize plant, every kernel sends out a single strand, so luxuriant corn silk—or luxuriant hair—signaled bounty and plenty. At the top of Structure 22, at Copán, Maize Gods were tenoned into the cornice, vivid symbols of the abundance guaranteed by the king who would stand in the doorway below.

An ear of maize grows long and narrow, tapering to a point. In their profiles, the Maya sought this same line, a continuous line from the nose to the forehead and then tapering nearly to a point. Most noble Maya underwent head deformation as newborn infants: strapped to their cradleboards, their still soft crania were shaped to give them long, tapering foreheads. Sculptures at Palenque indicate that some Maya lords affixed something to the bridge of the nose so that the line from tip of the nose to top of the forehead would be a continuous and nearly straight line. The heads of both King Itzamnah Balam II and his wife, Lady Xok, on Yaxchilán Lintel 24, aspire to this ideal, as does their hair—the bead through which it is threaded at the center of the forehead emulates the Maize God's usual hairstyle. Like the Maize God himself, such portrayals of Maya nobility never indicate aging, but only vibrant youth. 9

At the same time that the Maya idealized the Maize God, they also sought to emulate some aspects of the sun god, K'inich. Unlike the Maize God, K'inich never features a human face: he always has large, squared eyes with the pupils crossed. Additionally, his upper front teeth are filed into the shape of a capital letter T. The Maya incorporated these two aspects of his physiognomy into the noble persona. First of all, at the same time that babies' foreheads were reshaped, mothers often dangled a bead over babies' faces so that their eyes would become permanently crossed. And secondly, many adult males filed their four upper front teeth into the shape of the T. Additionally, some lords added jade inlay: an ideal smile may have featured both cut teeth and dark green spots. 60

In contrast to these ideals, the Maya may well have viewed a protruding forehead as one of humanity's most disfiguring features, along with the wrinkled lower face that comes from both aging and tooth loss (we cannot speculate as to whether the Maya tooth filing and inlay led to increased tooth loss). A captive carved onto a step riser at Toniná features both, and the profile of his face forms the edge of the step itself; a youthful warrior may have taken particular pleasure in stepping on his less-than-perfect visage. A servant in the dressing scene of the Bonampak murals has a sharply protruding forehead, perhaps even marking him as a foreigner or of low birth. 141 150

Interestingly enough, many gods have less than ideal faces, and some are particularly wizened and wrinkled. While noble lords rarely age (although they do gain weight!), some gods just have old age as an attribute, and so they are aged, wrinkled, and craggy. The old cigar-smoking God L, for example, is specifically 142

142. Maya artists took great pleasure in drawing God L broadly, emphasizing his toothless mouth, sagging face, pointy chin, and hunched shoulders. In the north, artists frequently adapted his image to door jambs and entryway columns, where he wearily supports the building. This example is probably from Santa Rosa, Xtampak.

toothless, his nose bulbous, and his chin pointy. The Jaina figurines of old toothless men who make love to young women may well be portraying the exploits of gods, perhaps even God L himself, since he, too, surrounds himself with young female courtiers.

Of all the Maya supernaturals, only the Monkey Scribes aspire to the human grotesque. Their half-brothers, the Hero Twins, take after their shared sire, the Maize God, in their beautiful faces and physiques and so do the Monkey Scribes in many instances. The scribal entourage includes other members of the court who do not conform to the Maya ideal, among them hunchbacks and dwarfs, known to have been the confidants of kings throughout Mesoamerica. But some Monkey Scribes are hideous, their faces barely human or turned to monkeys altogether, their fate in Maya mythology. A sculpture excavated from the Scribal Palace at Copán evinces pathos from the viewer, for although homely, the Monkey Scribe seems altogether human, but with the sort of face never seen on a Maya king.

Although rendered as a divinity—and unnamed—this Monkey Scribe from Copán more surely portrays the face of a specific individual than any commemorative stela from that city. Artists frequently include images of themselves and their circle on Maya vases, but few suggest portraiture. In fact, when portraiture is as idealized as it typically is on Maya vases or monumental sculpture, it barely seems portraiture. Few two-dimensional renderings without shading—a description of most Maya formal portraiture—can capture a particular physiognomy. Most of the world's traditions of portrait-making were, in fact, effective exploiters of three dimensions, whether in Rome or Ife. A few Jaina figurines would seem to have been specific portraits—and these are mainly captives. One can distinguish Itzamnah Balam II's monuments from Yaxun Balam's monuments at Yaxchilán, but this is largely because of both identifying texts and the workmanship, not because the faces of these kings are readily identifiable. Furthermore, the principal figures on many Maya monuments have suffered such damage to the face that a particular physiognomy would be hard to recognize in any case.

Despite such obstacles to recognizing portraiture in Maya art—its linear two-dimensional quality, the pattern of damage, and what may have been a preference for ideal, Maize-God-like renderings—there is one striking exception: Palenque. At Palenque a tradition of stucco sculpture evolved and with it, a tradition of life-like, evocative portraiture. A stucco head without specific provenience at the site bespeaks a particular individual

143. Archaeologists had the good fortune to find both halves of this remarkable Monkey Scribe when excavating a palace compound at Copán. Alert and pensive, homely but not ugly, this sculpture may well represent a particular chief scribe, one later revered as a deified ancestor and then buried in a compound that may have gained its prestige through the scribal arts.

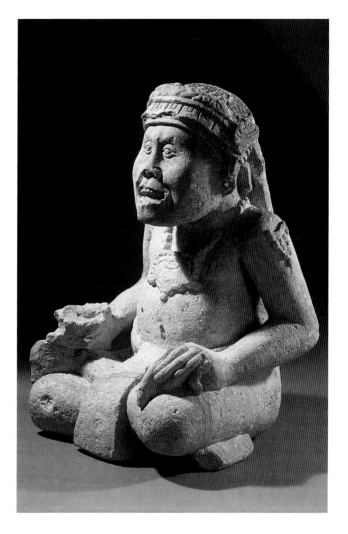

beyond the limits of youth with his deeply brooding expression and focused intensity. Larger than life, the head seems to have been made by an artist directly studying his subject, or perhaps from a life or death mask.

A head from the rubble of Temple 14 at the site clearly portrays K'an Balam, who ruled at the end of the seventh century. Even conventional carvings identify K'an Balam's unusual features, specifically the six digits or toes on all his extremities, and a strongly protruding lower lip. The stucco head vividly conveys his lip, as well as a lower face so long that it would seem to rest on the chest, permanently in a sulk.

145

144. (below left) Pensive and calm, this portrait at Palenque exemplifies the skills local artists mastered in shaping pliable stucco into lifelike forms.

145. (below right) This stucco head from Palenque clearly depicts K'an Balam, whose two-dimensional renderings also featured the characteristic protruding lower lip.

146. (opposite) Wrenched from a now-unknown architectural setting at Palenque, the stucco portrait head of Hanab Pakal was found interred in his tomb, probably completing the ritual "killing" of his essence.

Finally, the portrait of the most famous of Palenque kings, Hanab Pakal, probably once reigned over Palenque from various stucco facades at the site. As we have seen, when the great patriarch died, his heirs wrenched one of these portrait heads from a wall and jammed it under the sarcophagus. Hanab Pakal wears identical hair ornaments on the Oval Palace Tablet, his accession monument, and this head, with its youthful aspect and seeming optimism, may date from the earlier years of his long reign. Another portrait was constructed of jade tesserae directly onto his face once he had died. Although each jade rectangle was like a kernel of maize, and the entire mask converted Hanab Pakal into the Maize God himself, the jade mask was a powerful portrait of the old man, with its piercing eyes and narrow jaw. Even in the most recalcitrant of media, jade, the Palenque artist could express the individual.

146

84

203

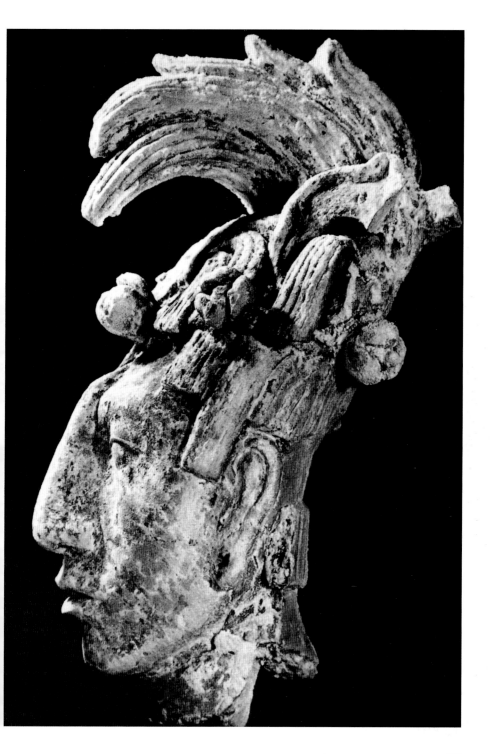

Chapter 8: Maya Murals and Books

From the end of the first millennium BC onward until the time of the Spanish invasion, the Maya frequently took brush in hand and painted walls. Most paintings are found in tombs, but these were often hastily painted to accommodate the needs of speedy burial. More rare are the extensive programs in buildings for the living, in palaces, caves, and temples, but enough of these survive to provide evidence of a vibrant tradition. Often called frescoes, Maya paintings are never true frescoes in which wet stucco is impregnated with pigments, but rather paintings of various sorts on dry stucco.

Maya painters also worked in other media. Because of the remarkable survival of painted ceramics, they form the subject of a separate chapter (Chapter 9) of this volume. But Maya artists also painted books, only four of which survive today, and which will receive brief treatment here with monumental painting.

Early Classic paintings
The early paintings are bi- or monochromatic and rarely feature mere mortals. Only fragments of the earliest works survive: at both Uaxactún and Tikal, the heads of figures were effaced, probably in ritual killing. For the walls of Burial 48 at Tikal in AD 445, the artist quickly sketched out his program in charcoal on dry white stucco; then painted over the lines with a black carbon paint, leaving drips and blobs in his haste. Framing a Maya date that probably records the date of death, the stylized symbols create the ambiance of sacred essence for the Maya—here, apparently, the watery world through which the deceased must travel.

Far more carefully executed are the nearly contemporaneous tomb paintings at Río Azul, painted in reddish brown with black highlights. Richard Adams excavated several of these tombs in the 1980s, and some feature paintings that wrap around protruding stalactite-like formations; others limn stucco surfaces carefully cut into the limestone bedrock. The paintings of Tomb 12 consist of eight simple and very large glyphs, two to a wall—but what astounded Maya scholars about their discovery was that they

148

147. On the walls of Burial 48 at Tikal can be read the Maya date of 9.1.1.10.10 in bar-and-dot numeration, equivalent to a day in AD 445. Symbols of preciousness float to the left of the date.

recorded the cardinal points of the Maya world, indicating north, east, south, and west, like points of a compass. The interred was then at the center of the cosmos, a symbolic pillar of the universe, and destined for resurrection in Maya cosmology.

Early Classic palace paintings are rare: a single extensive one was found at Uaxactún in 1937 flanking one side of an interior doorway and was presumably part of a larger program that had fallen from the matching wall. Stepping through the doorway, a

148. An Early Classic painting at Uaxactún features scenes in registers. Here, members of the court take sharp spines or bones and prepare to draw blood from their own bodies.

noble would then have stood in the throne room of one of the most important Early Classic palaces of Uaxactún, a building whose program is similar to Chak Tok Ich'ak's Early Classic Palace of Tikal. Underneath the paintings was a running 260-day count, the ritual calendar of divination characteristic of many Mesoamerican books known from the time of the Conquest, a thousand years later. Events are punctuated along the linear day count, and perhaps to be correlated with the elaborate figural scene above. Framed by a broad red outline, as are Maya books, the Uaxactún painting gives us the sense of what a Maya book of the period would have looked like.

The figural program above features vignettes of the court at about one-quarter life size, and they reenact the rituals that would have taken place within the palace. A visiting warrior in Teotihuacan dress receives a cordial welcome; women gather on the stoop of a palace whose roof is decorated with woven mat signs; lords prepare for bloodletting. Like the Bonampak murals, the Uaxactún murals include numerous musicians. These musicians demonstrate the great skill of the painters, for the figures overlap one another, and a single musician turns to the man behind him, in part of a formula for the representation of musical retinues that would be repeated 300 years later, at Bonampak.

Late Classic paintings: Bonampak
In the Early Classic, artists made paintings in spaces for the living and the dead wherever the Maya made monumental constructions. However, during the Late Classic, the mural painting tradition became more focused to the west and north, and a masterful cave painting tradition took hold at Naj Tunich, in the Petén. Some simple tomb paintings of a date or short text were made at Caracol, in Belize, but in general, tomb walls remained without ornament, or, as in the case of the Temple of Inscriptions at Palenque, received stucco sculpture.

Artists painted monumental murals in dynastic structures both in the Yaxchilán region and in Yucatán during the Late Classic period. Few murals survive in conventional temple structures; most were painted on the walls of small palace chambers. Across the river from Yaxchilán, explorers found fragments of wall paintings at La Pasadita; fragments of stucco paintings also remain at Yaxchilán itself, mostly in buildings before 750. The finest Classic wall paintings to survive, however, are *in situ* within Structure 1 at Bonampak, a site whose modern name roughly translates as "painted walls."

Just 26 km (16 miles) from Yaxchilán, the Bonampak lords had affiliated themselves with both Yaxchilán and another smaller nearby town, Lacanhá, by the end of the eighth century, when the great paintings were made. The paintings celebrate the relationship among these centers and the victory they shared, although the text of Room 1 explicitly states that the building itself belonged to the king of Bonampak, Yahaw Chan Muwan. Structure 1 was painted inside and out, although little remains of the exterior ornament. Just below the cornice runs a long text, probably once consisting of nearly a hundred glyphs, framing the outside of the building the way a Maya vase rim text frames the vessel. The unusual architectural design of the building also provided for the viewing of the paintings by including wrap-around built-in benches within each of the three separate chambers—and also protecting the colorful walls from casual damage.

The Bonampak murals stand out from all other Maya works of art for a number of reasons. First of all, the paintings depict literally hundreds of members of the Maya nobility, in the most realistic representations that survive of many rituals known otherwise only from texts and laconic representations. As a result, the paintings are frequently the illustration called upon for so many aspects of ancient Maya life—from social stratification to warfare to palace life—without regard for the nature of the paintings themselves. Second, the paintings are scaled at one-half to two-thirds life size, so they create a life-like environment for the viewer sitting on the benches. Few other ancient Mesoamerican works are so experiential for the modern viewer as well. Third, the paintings reveal emotion, particularly in the rendering of the captives in Room 2. Emotion and humor feature in the painting of ceramic vessels, but no other monumental work so captures the spirit of agony and victory from ancient America. And finally, although there are several artists who worked on the paintings, some of the painters, particularly the masters of the north walls of Rooms 1 and 2, were extraordinary in their ability to render the contours and movements of the human body.

The three rooms can be read in sequence, although Room 2 is the largest and its bench the highest, so it would surely have served as the throne room from which the most important lord would preside. In sandwiching the room celebrating battle between rooms celebrating additional dynastic events, the paintings also provide a united, harmonious narration of a world that seems simultaneously fractured by war and sacrifice.

149. In Room 1 at Bonampak tribute-paying lords speak energetically among themselves while a servant presents a child to upper right. Frames for captions over their heads were never filled in.

Room 1 features the introductory notation ("initial series") for a Maya text, indicating this room's likely primacy in the reading order. Above the text, lords in white mantles—some of whom are explicitly titled "ahaw," or lord—approach a royal family assembled on a large throne, including a small child who is held up to the lords by a servant. A bundle to the right of the throne bears a few glyphs that identify the contents as five 8,000-bean counts of cacao, in what would have been a substantial tribute or tax payment in a world where the cacao bean was one of the few standard means of exchange. The lords, then, are presumably paying their taxes and cementing their loyalty to the royal family at the same time. The text below notes an installation in office, possibly of the child presented above and under the supervision of the Yaxchilán royal family, and also notes the dedication of the building in 791. Whether a Bonampak or Yaxchilán king is sitting on the throne remains unknown: the caption frames overhead were never filled in.

Only a viewer seated on the built-in bench could have studied the north wall over the doorway. This wall shows three principal lords preparing for celebration and dance, which they

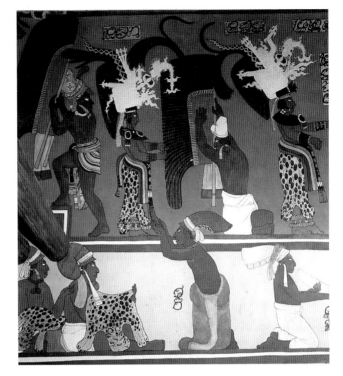

150. The principal dancers at Bonampak each don a jaguar pelt, stuffed boa constrictor, and great feather backframe on the north wall of Room 1. While they stand in conservative poses, their attendants adopt imaginative positions. Copy by Felipe Dávalos.

subsequently perform on the south wall, once their matching costumes of jaguar pelt, quetzal feathers, and boa constrictors are completely in place. A servant to the right of the lord at center daubs his master with red paint; a servant strains to secure a feather backrack in the frame of the lord at left. Recent infrared photography unmasks the long-invisible skill of the painter, who applied a lively final black outline over the blocked-out colors. Body contours and the rendering of torsion reveal a deep understanding of human form and the foreshortened, rounded way in which the eye *sees* rather than what the brain *knows*. Not only is the rendering of hands particularly meticulous, but the detail of the line on this wall also indicates close kinship to the sculptural tradition of Yaxchilán rather than to the small-scale paintings of Maya vases.

The principal lords of the dressing scene north wall are represented a second time, dancing, on the wall one sees upon stepping into the room. The sequence is clear: dressing precedes performance. But in making such sequences specific, the Maya painters emphasize the narrative that threads its way through the rooms. Protagonists reappear from scene to scene, providing a sense that the story moves both backward and forward in time. In this

173

regard, the paintings are more visually narrative than any other Precolumbian work of art. If we were to describe this in linguistic terms, we might say that the paintings are like a series of verbal events—and in this, they differ from the more typically nominative representations of Maya stelae—or of almost all other Precolumbian works of art. The paintings of Bonampak may be the only works of Maya art that visually surpass the narrative complexity of Maya writing.

On the lowest register of Room 1, Maya musicians and regional governors flank the dancers at center. Here the Maya artist attempts to represent aspects of movement and sound otherwise unknown in Maya art. The maracas players move as if in stop motion, their arms changing frame by frame; the drummer's hands were painted with palms turned to viewer, his fingers clearly in motion. The casual examination reveals only the blur. In this, the painted wall attempts to represent sound itself in the drummer's fluttering hands. What is remarkable is that the Maya artist knows here what the eye will *see* and brain will *believe*, a step yet beyond the problem of what one knows and what one sees. Such sophisticated phenomena are completely unexpected—but the Maya artists represent aspects of motion that would not be captured by western artists until Eadweard Muybridge made frame-by-frame photographic records of body movement in the late nineteenth century.

The very sensibility of Room 2 differs from Room 1: a single battle scene encompasses all three walls surrounding the viewer upon his or her entrance into the space, seemingly drawing any viewer into the fray. Dozens of combatants charge into battle from the east wall, banners and weapons held high, and converging under a large elbow of text on the south wall, where jaguar-attired warriors, including Yahaw Chan Muwan, strike their enemy with such energy that his body almost seems to fly right out of the picture plane. The text itself offers only an enigmatic date, perhaps to be located a few years before the Maya equivalent of AD 790 inscribed in Room 1. In the upper west vault, defenders try to protect a wooden box, perhaps the same one that then appears under the throne in Room 3. Damage along the join of the wall and bench may conceal concentrated captive-taking and dismemberment. Unusual dark pigments used in the background indicate that the violence takes place in the dark.

Encoded into the battle painting is a different rendering of time and duration. On the upper east wall, the battle has just started, and while some warriors hold weapons high, others let loose

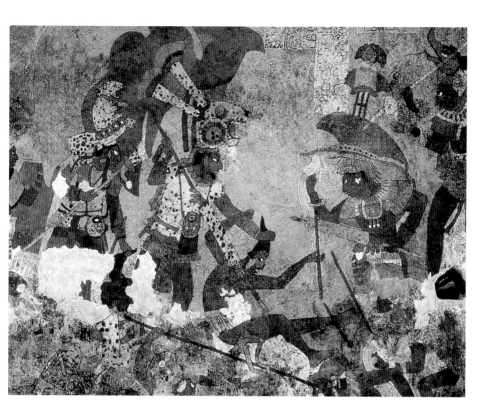

151. Two victorious lords converge at the center of the south wall of Room 2, Bonampak, and the captive they seize seems to fly right off the picture plane.

the blare of trumpets, in prelude to the dominant scene of the south wall, where Chan Muwan smites his enemy. The sense of movement through time for the duration of the battle continues onto the west wall and the lower registers, as captives are seized by victorious teams of two or three, with the final scene presumably the lower east wall, where capture is complete. In other words, time is shown in sequence, with preliminaries followed by the climax of conflict, and ending with the mopping up of the defeated. Some individuals are rendered more than once, providing evidence of the Maya ability to create a narrative that was to be seen at once but embedded within a sequence—or what is called simultaneous narrative in European art and which is usually understood to be one of the breakthroughs of fifteenth-century painters in Italy.

On the north wall, Yahaw Chan Muwan, accompanied by warriors and female dynasts, including his Yaxchilán wife, receives presented captives on a staircase seven tiers high, the preferred locus for such an event. Maya constellations oversee the sacrifice, including the Turtle at right (Orion) and the Peccaries, probably

153

175

indicating that the sacrifice begins at dawn. Elegantly drawn, with sweeping, continuous lines defining body outline, eyes, hands, and hair, the captives are among the most beautiful figures of Maya art. Captives at right reach out, as if to protest their treatment at the hands of the warrior at far left, his figure partly truncated by the crosstie holes. Bending over, this warrior grabs a captive by the wrist, and either pulls out the fingernails or trims off the final finger joint. Blood arcs and spurts from the hands of captives sitting in a row, most of whom also seem to have lost their teeth, and one howls in agony. A single captive presented on the upper tier appeals to Yahaw Chan Muwan, who stares over his head. At his feet, a dead captive sprawls, cuts visible across his body; his foot leads to a decapitated head, gray brains dribbling from the open cranium.

No figure in Maya art is painted with greater understanding of the human anatomy nor with more attention to the inherent sensuality of naked flesh than this dead captive of Room 2. The powerful line of the diagonal body both leads to the comparatively wooden rendering of the king but also subverts his image: for any individual seated on the bench, the captive's body is in the center of what one can see. In making this visual statement, the artists of Bonampak pushed their skills to the limit, making sensuality of sacrifice and death: the eroticized body of the dead captive of Room 2, sprawled on the diagonal, dominates the scene altogether and undermines the representation of victory.

In Room 3, the lords of Bonampak don great "dancers' wings" for a final orgy of autosacrifice and captive dismemberment, all 152

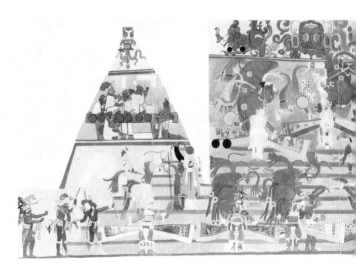

152. Dancers with great feather wings attached at the centers of their bodies perform on a vast stepped pyramid in Room 3, Bonampak. Copy by Antonio Tejeda.

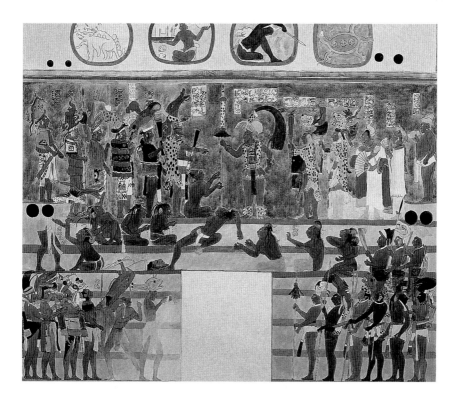

153. Under constellations arrayed across the highest register, victorious Bonampak lords survey the captives taken in battle. Copy by Antonio Tejeda.

arrayed against a large pyramid that reaches around east, south, and west walls. Whirling lords have pierced their penises, and blood collects on the white diaper-like cloth at the groin while captives led in from the side are slaughtered at the center of the south wall.

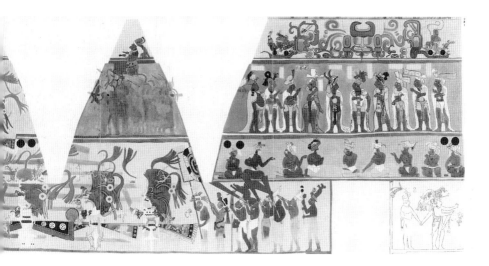

"Microtexts" about 2 cm (0.8 in) high—that is, the size of many a pot inscription—are painted in several locations, but a particularly fine one at the center of the south wall where it would easily be spotted names Itzamnah Balam III, the coeval king of Yaxchilán at the end of the eighth century. What is unusual about the positioning of this central "microtext" is that it appears to be on a banner that has been unfurled between two lords in "wings." If this is indeed a large unfurled cloth, then this would be a unique representation in Maya art of the sort of painting on cloth known as a *lienzo* in Central Mexico at the time of the Spanish invasion. Of course, the very presence of large cloth paintings would have

154. A kneeling male servant hands spines to the royal women on the throne in Room 3, Bonampak. The babe in arms may be the same child seen in ill. 149; the box under the throne is probably booty shown in the Room 2 battle scene.

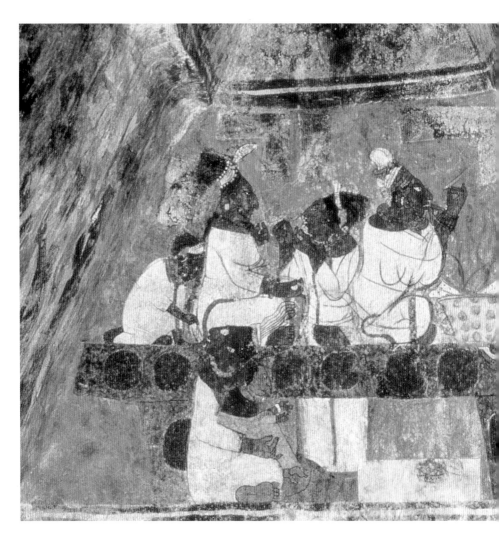

provided a means for the transmission of art about which modern scholars have been completely unaware.

In the upper vault scenes that flank the dance on the pyramid, Maya artists have rendered other intimate views of palace life. A band of deformed musicans perform on the west vault, perhaps to be read as moving in a circle. The ladies of the court gather in the throne room depicted in the upper east vault, to pierce their tongues and instruct a little child, presumably the same one featured in Room 1, who holds out a hand for piercing.

Rendered only in the first and final scenes of the program, the little heir may have the ostensible motivation for the entire sequence of events. But the scale of warfare on this occasion may show an elite world out of control: if this battle is just one of many carried out by Bonampak, and perhaps indirectly to serve Yaxchilán as well, then the Bonampak murals reveal a world convulsed by war and chaos, beyond the reach of order and control that human sacrifice sought to reinstate.

Perhaps the single greatest achievement of Maya art, the Bonampak murals are also undoubtedly the finest paintings of the indigenous New World. Over the years since the discovery of the paintings in 1946, time has taken its toll, and today the *in situ* paintings are a shadow of their former selves. Fortunately, new technology, particularly in digital infrared imaging, is contributing to the reconstruction of the Bonampak murals.

Cacaxtla

At roughly the same time that artists were at work on Bonampak, Maya painters also worked at Cacaxtla, a hilltop acropolis hundreds of miles north of the Maya region, where these surprising works came to light starting in 1976. Although the paintings of Cacaxtla cannot be considered in detail here, the painters used both a visual vocabulary and technical expertise similar to that of Bonampak, and it would seem that these extraordinary expressions in paint took place at about the same time, late in the eighth century.

Most scholars have considered the Cacaxtla paintings in the order in which they were found, but probably the latest discovery deserves to be read first, that is, the Red Temple staircase paintings. Maya gods, including the patron of merchants, God L, walk on a painted stream of water that runs along the edge of the stairs. As the deities move upward along water that is known to run downhill, the artist has conveyed one of the contradictions of quickly moving water, in that it seems to be running uphill, an

observation that has fascinated western poets and philosophers. The presence of both God L and the Maya Maize God further suggests the tension between the two poles of the Mesoamerican economy, commerce and agriculture. 155

The bottom step itself is painted on both tread and riser with imagery that articulates the relationship between war and commerce: Central Mexican place names line the riser, while hideously skeletal captives sprawl on the tread, where they would be stepped on. These place names must refer to the sites conquered by Cacaxtla or paying tribute to it; the captives remind the observer of the living death—so ironic amidst the wall representations of plenty—awaiting those who do not comply quickly.

At Cacaxtla, this economic underpinning runs up to a vast scene of war and dismemberment that dominates the north plaza, a conflated rendering of both the action of battle and its sacrificial aftermath. Like Bonampak's battle painting, the Cacaxtla painting is sometimes mistaken for a snapshot of war rather than the carefully constructed ideological image that it is. And like Bonampak, the Cacaxtla battle scene also includes room for the aftermath of warfare, the presentation on steps, with a massive staircase of seven levels set at the center of the battle. 156

In the battle, Central Mexican warriors with distinctive non-Maya profiles arrayed in jaguar pelts and simple headbands annihilate their enemies, reckoned to be Mayas by most scholars, based

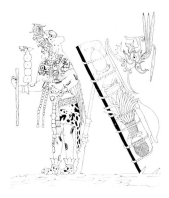

155. The Maya God L stands at the base of Cacaxtla's Red Temple stairway, where he has rested his heavily laden merchant pack.

156. Maya victims fall, overpowered by their Central Mexican enemies in the battle painting that frames a staircase at Cacaxtla. One victim holds a broken spear while he cradles his spilling entrails; a severed torso lies in front of him.

180

largely on physiognomy. Aggressors have cut one of their victims right in half; another crumples as he cradles his own entrails. Have they been butchered for a cannibalistic feast?

Both Maya and Central Mexican lords are rendered with dramatic foreshortening, and the sure mastery of overlapping hands and feet tells of artistic practice that has not survived elsewhere. Strangely enough, the painters have given many of the Maya two right hands, surely symbolic, but symbolic of what, we can only wonder.

In the grim toughness of the faces of the Central Mexican warriors, one reads the seriousness with which the painters treat their hardness. Yet some of the defeated Maya howl in agony: a standing noble (or perhaps noble woman, based on costume) grasps the arrow stuck in his cheek as blood streams down the face. Did some eighth-century sensibility favor emotionality, making the viewer empathize with the defeated and prefer their cause? Did Maya painters render a defeated Maya in such a way as to subvert authority and to transcend the victory celebrated in this painting?

Ironically, the Maya rendered as defeated reign triumphant in 157 what is probably the last of the paintings. Framing a doorway, 158 splendid Maya lords in bird and jaguar suits guard a sacred mountain whose outline once continued above the doorway. Just as the concept of Coatepec, or Snake Mountain, may have been as ancient

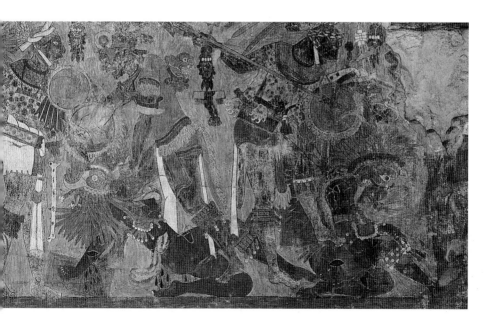

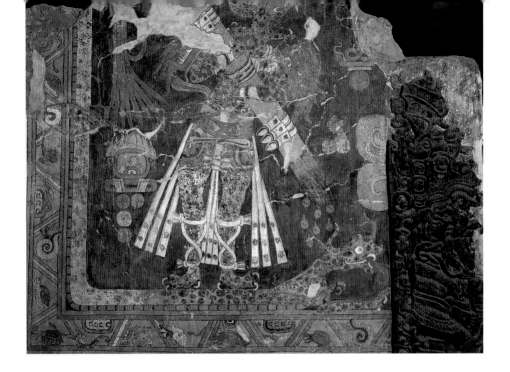

157, 158. (above and opposite above) Two lords, dressed as if Maya kings, frame a doorway at Cacaxtla. Water flows around them, perhaps suggesting the Central Mexican concept of a water mountain, a place of abundance and plenty.

among the Maya as in Central Mexico, so too the concept of Tonacatepetl, Sustenance Mountain, from whom all bounty flowed. The Maya painters at Cacaxtla freely used Central Mexican motifs and even concepts, yet worked in a Maya fashion that spelled them out in a way unfamiliar to most Central Mexican audiences.

Paintings in the Puuc

In the eighth century and probably throughout the ninth, artists also began to paint the walls and vaults of buildings throughout the Puuc region of Yucatán. As yet unspecified relationships may link Puuc sites to Bonampak and its painters: Bonampak Structure 1 has an unusual vertical facade for a building in its region, but such facades are common in the Puuc region. Few paintings in the Puuc survive intact now, although some painted capstones do survive, many celebrating K'awil, the patron of lineage. Consistently, for these vault stones, artists used a black or red paint on a cream ground, the color scheme usually associated with Maya books. In ill. 159, K'awil empties the bag of seed corn normally seen in the hands of the Maize God.

At Chacmultún and Mulchic, artists painted in registers and used a broad palette to render dozens of figures engaged

159

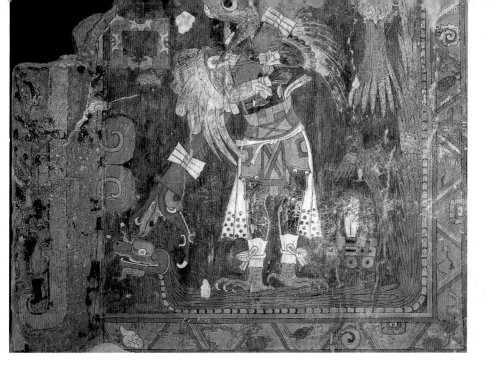

159. Painted capstones in Puuc buildings usually feature K'awil or the Maize God; here a K'awil spills the Maize God's sack of seeds.

in some aspect of warfare. On Chacmultún's lower register, great litters are hoisted aloft, perhaps carrying images of gods; fragments of red and orange parasols—like those of Bonampak—survive, but those who carried them do not. The running step frets at the lower margin are also like those lining a bench at Bonampak.

More survives at Mulchic, where a knife-wielding lord sits above the fray, his posture and headdress similar to the king's on Stela 12, Piedras Negras. Victims pile up at his feet, some crushed by stones and others garrotted. The victorious warriors all don the costume of Chaak, the rain god.

Naj Tunich

Drawings, incised petroglyphs, and handprints are all found in Naj Tunich cave, but the most important works, even if judged only by their scale and completeness, are the paintings made by artists using a brush and a black paint that was like a thick ink. Based on the texts in the paintings, Andrea Stone has determined that the nearly one hundred paintings were made in eighty years or less, and no later than 771. The paintings read as vignettes that compose no particular whole; many are purely textual. Some include surprising iconography, including one of the few erotic images of

160. Skilled hands rendered the monochrome paintings at Naj Tunich. In Drawing 21, Hunahpu, one of the Hero Twins, prepares to strike a ball bearing the coefficient of nine.

Maya art. One of the most striking is Drawing 21, part of an important group of paintings. In the painting, Hunahpu, one of 160 the Hero Twins, prepares to strike a rubber ball that bounces down a flight of stairs. The artist demonstrates particular skill in rendering the line of the shoulder: both its strong contour and the quick squib drawn as the interior ankle bone provide evidence of Maya mastery of human form.

Chichen Itzá

A new style of painting appeared at Chichen Itzá, probably at the beginning of the ninth century, when Itzá lords tightened their grip on Yucatán. Aware of new styles of art in Central Mexico and along the Gulf Coast, artists gave up their attention to the individual human form and the situation of that form in scaled architectural settings. Conventionalized renderings depict human beings who dwarf their diminutive architectural settings, and backgrounds no longer provide convincing definitions of deep space. Furthermore, although the paintings of the southern lowlands and the Puuc had presented historical scenes that could be interpreted in terms of larger religious themes, the paintings at Chichen Itzá, especially those of the Upper Temple of the Jaguars, specifically lay out a religious matrix, against which history can be interpreted. Artists overlap figures to a limited degree, but essentially they have given up the foreshortening that suggested depth and have elected, instead, to layer figures in registers, even though there are often no specific ground lines.

The result is that the Upper Temple of the Jaguars paintings have little visual focus, and the even disposition of figures in six of seven panels has made it difficult to isolate central action of the sort that focuses the related battle painting of Bonampak, for example. Nor are there are any inscriptions, which can also enhance the reading of a Maya work of art. Nevertheless, these paintings were disposed across all four walls of the inner chamber of the Upper Temple, itself one of the most ornate of Chichen Itzá temples, its massive serpent columns poised atop the Great Ballcourt. They may well have been the most important paintings at Chichen, a city where the mural tradition thrived in many locations. So what did they mean?

Reading order is guided by the central panel of the East Wall, the wall one sees upon entering the chamber. The central panel is 16 the only one to feature just two figures, who sit in dialogue with one another. At right, resplendent yellow rays flare from the figure's body: he is some kind of solar deity, shown within a great

161. On the central panel of the East Wall of the Upper Temple of the Jaguars, Chichen Itzá, a viewer would first face two large figures in dialogue with one another. At right is a solar deity; at left the Maize God. Chichen Itzá artists mastered green and yellow pigments, rather than the blues used at Bonampak.

162. In a detail of the final scene set in late day or evening, Chichen Itzá warriors scale scaffolding to overcome an enemy city. Here Chichen painters may document the brutal wars that swept away their competition from the south.

feathered serpent; at left, in brilliant jade and feathers, is the Maize God, just the edge of his jaguar cushion visible behind him, yet he, too, has taken on aspects of the radiant sun. Prostrate beneath both is a panel depicting the dead Maize God, the source of endless renewal, his jade-bead costume the kernels of maize. This wall would have been illuminated during the mid-August zenith passage of the sun, the anniversary of the day when the Maya believed Creation had taken place in the fourth millennium BC. August is the season of green corn celebrations, the time of determination of the viability of the year's crop of maize. All other action flows around the cycle of these gods of maize and sun, with the repeated motif of the dead Maize God, starting with the panel to the right of their portrayals and reading in a counter-clockwise fashion.

The paintings offer a temporal progression, beginning with scenes of simple preparation and move on to warfare and havoc. On one level, the paintings seem to show the changes through the day, from dawn to dusk; they may also show the shifting seasons. Throughout the program, the Maize/Sun God rules from a solar disk; the Feathered Serpent reigns from within the undulating green snake. Battles take place in locations defined by specific landscapes, including strikingly red hills. In the last painting, the victorious warriors mount scaffolds and climb steps to slaughter the population, in a very different kind of warfare from the one

162

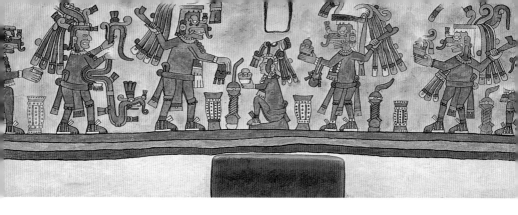

163. Armed with sacrificial axes, Chaak impersonators close in on a seated Maize God. His decapitation was understood to be analogous to the harvesting of the ears of maize.

engaged in at Bonampak, where the painting depicts capture, not death, on the battlefield. With the representation of water nearby, the scene could be the ninth-century demise of one of the Usumacinta cities, even Piedras Negras, whose sacked jades would later end up in the Sacred Cenote as offerings to the Maize God.

Tulum, Tancah, and Santa Rita

During the final florescence of Precolumbian Maya culture, Maya painters adorned the walls of temples at Tulum, Tancah, and other towns along the Caribbean coast of Yucatán, as well as some farther south, such as Santa Rita, Belize. The palette emphasized dark and intense colors, rather than the lighter values of the color schemes of Chichen Itzá and Bonampak, with conventionalized figures that were nevertheless rendered in a naturalistic proportional scheme. Whereas the Bonampak artist knew where the eye made visual adjustments, the Tancah artist made no such accommodation, and thus showed complete renderings of both arms and both legs, for example, of the Chaak impersonators. These Chaak impersonators converge on the Maize God—probably his impersonator as well—in preparation for his sacrifice.

At nearby Tulum, a dark-background negative painting scheme was devised for Structures 5 and 16. Such a program made the figural representation jump out and the ground recede, heightening legibility and visibility. Across multiple registers, highly conventionalized gods and/or god impersonators approach seated lords. In some examples the cosmos is configured, from the aquatic world at the base of the painting to the stars at the top. The Maya adopted the symbols for the starry heavens from their contemporaries in Central Mexico, and they shared with them many aspects of conventionalized representation.

At Santa Rita, iconographic details reveal close kinship with manuscript traditions of Central Mexico, especially in the representation of decaying flesh or the meshing of two flint blades, yet the writing and iconography remain consonant with Maya traditions. In a scene of ecstatic music and dance, the old Maya Sun God has been decapitated just as a new sun rises.

Maya books
Four native books survived the Spanish invasion. Three survive in European libraries and they take the names of the cities where they reside (Dresden, Madrid, and Paris). A fourth, known as the Grolier Codex, apparently came to light in a cave in recent decades and is now in Mexico City. All were painted within a hundred years of the Spanish Conquest.

Maya books of the Classic period presumably looked quite a bit like the survivors: taller than they were wide and consisting of folded fig-bark paper laboriously prepared, beaten, and overlaid to create continuous sheets. Maya books of the Classic period usually appear to have been bound between two wooden boards covered in jaguar pelt. The books themselves are often seen on pots, but the organization of the painted imagery in Maya books affected the very nature of much of Maya art. The stela form retained book-like proportions and probably adopted book imagery from time to time; the continuous folded paper allowed for narrative to flow across the pages, with subjects ideal for transfer to fine-line painted vessels.

Michael Coe and Justin Kerr have recently provided compelling evidence that the Madrid Codex was painted after the

164. Various gods carry out sacrifices to propitiate rain in the Madrid Codex "serpent pages"—a section characterized by undulating snakes who continue from one page to another. At left, a death god holds a torch to a deer readied for offering. Days in the 260-day calendar form a central band. With its screen-folded pages, a Maya book can be opened to many pages—and even sections—simultaneously.

164
165

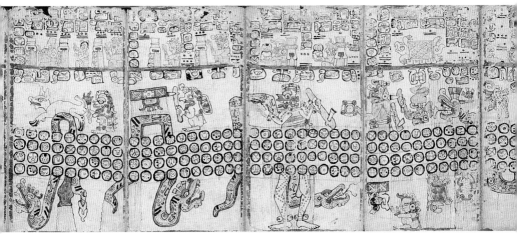
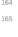

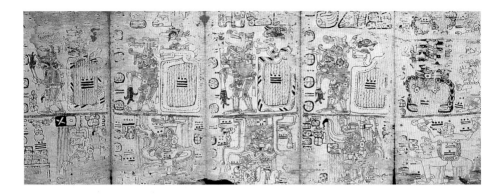

165. The artist of the Madrid Codex probably consulted many sources, incorporating agricultural almanacs, guides to divination, and star charts. Here, representations of Chaak in the upper register provide auguries. The scorpion at far right refers to the constellation, known in both New and Old Worlds.

Spanish arrival, perhaps as late as the seventeenth century, and by a single painter who hastily absorbed imagery and text from several sources. On the other hand, several artists labored over the Dresden Codex, perhaps painted in the fifteenth century. Its most stunning pages deal with a sequence of malevolent Venus gods. Painted with a broad and subtle palette that ranged from red to orange to blue, the Venus gods take shape across distinctive backgrounds, blue, red, and cream. Coe and Kerr have argued that the artists of Dresden worked with quill pens, surely rendering contour lines to define each character.

Like the painters of medieval manuscripts, Maya manuscript painters copied from pre-existing works in many cases, perhaps bringing innovations to suit local patrons and adding new details where they might be called for. Different artists laid out their pages distinctively in the Dresden, in part driven by the character of earlier works, but probably also to suit new patrons or even their own artistic sensibilities. The painter of the Venus pages has laid out his figural panels as if they were windows into another world, a sort of surprising punctuation at irregular intervals, while other painters worked to lay out every figure in absolute regularity.

There are some ancient art forms for which we have not a single fine ancient example—textiles, for example—yet we know of their existence from other art forms. The surviving books do offer us a glimmer of ancient Maya book art, but little more, although they were once ever-present among the elite. Maya kings took a book into the Underworld with them, usually resting on the chest, where archaeologists find clumps of stucco sizing today. This written word was clearly of the greatest value to the Maya: its power clearly alarmed Bishop Landa, for had he thought their books to be trivial, he would have had little reason to round them up and set them on fire as he did in 1565.

166. In this page from the Dresden Codex bar-and-dot numeration records the synodic movements of Venus, understood to be a malevolent heavenly body in the New World. Under Venus's baleful influence, darts and disaster rain down upon all in its way.

Chapter 9: Maya Ceramics

Painted Maya vessels are the most extraordinary ceramic art of the New World. Although Maya ceramics serve archaeologists in the usual fashion—as evidence of dating, like most archaeological sherds—their changing rim shapes are almost trivial when compared with their surfaces. In the lively paintings and carvings that encircle their exteriors, Maya pots provide a window on ancient religion, ancient story-telling, and even the way art came to be made. They are, perhaps, for the art historian, one of the most rewarding and least studied media of the Maya. The only analogous tradition in the world was in ancient Greece, where the surviving ceramics painted by remarkable artists also provide a wide-ranging picture of religious and civic practices.

The Maya, of course, used ceramics every day, small cups for drinking vessels, tall cylinders for storing and pouring ritual beverages, and plates for all sorts of delicious foodstuffs, from tamales to corncakes served up with sauces. Among the elite, many of these vessels were finely potted and elaborately painted, and some of them probably held foodstuffs even in the tomb, so that a traveler through Xibalba, the Maya Underworld, would have sufficient nourishment. But the Maya also made pots to commemorate important life passages: an accession to kingship, a victory in battle or the ballgame, or the negotiation of a dowry. Most of all, when a noble man or woman died, friends and relatives commissioned new ceramics that might accompany the deceased into the tomb. The paintings on the vessels may have been sacred themselves. These elite and commemorative vessels formed a powerful visual tradition for a thousand years.

Techniques

167. At the beginning of the first millennium AD, the Maya began to make elaborate polychrome ceramics. Many of the first were supported by mammiform legs, a form out of fashion by the advent of the Early Classic era.

Always working without the wheel, the Maya depended on two basic techniques to form pots, and they sometimes used them in tandem. Most commonly, artisans built ceramics using the coil method, although no trace of that technique survives in finished elite vessels. Sculptural additions needed to be carefully added, in order that no breakage occur during firing; firing holes can occur

as the open mouths of creatures or where they are not particularly visible. The other basic method for making a pot was slab construction, most obviously used to form ceramic boxes. Small slabs were carved or stamped before being added to cylinders to serve as tripod feet. Few vessels show any evidence of fire clouds—the dark blotches characteristic of vessels fired in pits—so the Maya must have been firing them inside saggers, protective ceramic vessels designed to protect polychrome slips from carbon deposits.

Various media were used to finish fine vessels. Despite the deceptively high gloss that many of these wares still bear today, the Maya did not invent glaze or glass: like ancient Greek wares, Maya vessels were painted in clay slips made from tested recipes of clays and minerals. Broad slip palettes came into use in the fourth century and lasted until the ninth, with results that ranged from mustard to purple, with shades of red and orange in between. Low firing temperatures defeated attempts to master blues and greens, leaving only lingering grays. Some schools of Maya ceramic painting eschewed the broader palette, notably the codex-style painters, who used only carbon black, red, and sometimes cream.

At the end of the fourth century, post-fire stucco techniques from Teotihuacan were adopted for Maya use. Using a thin, prepared quicklime into which mineral pigments were dissolved, painters developed a broad palette, complete with blues and greens. Common in fifth-century burials, completely stuccoed pots became rare during the Late Classic. Applied post-fire, stucco paint was sometimes used in conjunction with other techniques, particularly carving but also painting. Sometimes the slightest dots of post-fire paint were used to accentuate details; post-fire blue was occasionally applied to rims, as in ill. 177.

Both deeply carved and lightly incised ceramics were also created by Maya artists, more commonly during the Early Classic than later on, and in many cases to render even more fine detail than Maya brushes could create during that era. Maya artists carved leather-hard wares, dipped them in slip either before or after the carving, and then burnished them before firing, yielding solid glossy dark browns and black tones.

Early Maya ceramics
The beginnings of Maya vessels lie in shapes cut from gourds, a reliable and unbreakable source of containers both in the past and today. Eventually the Maya began to make these shapes in clay, and they finished their vessels with rocker stamps or with simple slips. At the end of the Late Preclassic, Usulatan ware became wide-

spread, its distinctive cream-on-red stripes produced through the application of a waxy substance that burned out in firing. The Maya invented new shapes for these early pots, and many had tetrapod mammiform supports.

Early in the first millennium AD, the Maya begin to finish their ceramics with polychrome slip paint. As this practice became the standard everywhere, the Maya began to evince a greater sense of cultural homogeneity, in what can be considered one of the markers that the Early Classic had taken root. These earliest polychromes provide evidence of the same clearly defined Maya gods who appear on Preclassic monumental stucco facades and the earliest stone sculpture of the Early Classic. Some of these early mammiform pots are works of fine potting, as well as painting.

Into the fourth century AD , the lidded basal flange bowl—a new form that had entered the Maya inventory—dominated as the most important ritual vessel shape. Some demonstrate a successful hybridization with other forms and have four bulbous—but no longer mammiform—legs. Large, heavy, and rarely showing much wear, these vessels may have been presentation vessels for dedications or for funerals. Typically, the knob took the sculpted form of an animal or human head, its body then completed by a two-dimensional painting flowing across the surface of the lid. The integrated painting and sculptural form suggest that the painters of these vessels were also their potters. Ancient Maya artists articulated the various surfaces: the narrow vertical panel of the bowl itself, the large arcing lid, even the handle and the flange are usually painted.

The most elaborate examples of the basal flange vessels and related hybrids provide evidence of shared religious concepts in works that engage the viewer directly, often by articulation of ceramic elements that must be handled. For example, on a small bowl with matching lid from Tomb 1 of the Lost World Complex at Tikal, the head and neck of a water bird form the three-dimensional handle, its wings painted in two-dimensional outline on top of the lid. In its beak is a fish, visibly being pulled from two dimensions into three. The basal flange has been worked into the body of a three-dimensional turtle who swims through linear undulating dotted scrolls, a Maya shorthand for water. This constant interplay between two and three dimensions forces the viewer to confront the artificiality of artistic renderings; the experimentation between sculpture and painting seems surprisingly modern in its focus on the liminal interface between those two media. But liminality is also the subject: this watery world occupied by fish,

168. (left) Unusually small and delicate in scale, this basal flange bowl from Tikal's Lost World complex features a water bird in both two and three dimensions on its lid and a turtle swimming in water as the bowl itself.

169. (right) Four snout-down peccaries support this lidded vessel, firing holes forming their mouths. The fully formed paddler on top is a personification of the day, making its diurnal journey.

turtles, and predatory water birds is one of the porous membranes of the cosmos, where actions of those on earth and those in the Underworld come in contact with one another.

Many Early Classic ceramics express such concepts of the cosmos. But a few lidded bowls try to do more, as Maya artists begin to articulate sacred *narrative* across their surfaces. The Dallas Tetrapod features the interplay of the cosmos, but it also shows the action of a supernatural figure. Each leg is the snout-down head of a peccary, the wild boar of the tropics, marked by a long curl that indicates earth. The Maya appear to have believed that the earth's surface was supported by peccaries at its four corners. The convex surfaces of the bowl and lid show fish who swim in scrolled water, so that the Dallas Tetrapod also presents the concepts of the surface of the earth. But atop the lid sits a fully sculptural figure in a canoe, his oar poised mid-stroke. His monkey-like features are complemented by the hieroglyph for day or sun on his head, probably indicating that he is the supernatural incarnation of the concept of the day, making his diurnal journey.

More than almost any other introduction from outside the Maya area that can be identified today, the tripod cylinder vessel— almost certainly a Teotihuacan invention—was an instant hit 172 among the Maya. Even before the Teotihuacanos had imposed their will on the Tikal throne, their characteristic style of pot-making had already worked its way into the Maya repertory of vessels. In the fifth century, the tripod cylinder was the most important elite vessel; by the seventh century, however, the Maya of the Petén and Chiapas made not a one, although the archaic vessel type still appeared among the inventory of pots depicted on other pots and the form still found favor from time to time in Belize.

A single offering at Becán, Campeche, emphasized the cultural interaction between local Maya and distant Teotihuacan, with complex meanings we can no longer retrieve. Within a locally-made cylinder vessel sat a large two-part Teotihuacan figure who in turn held within ten tiny solid figurines and a host of jade, shell, and ceramic adornments. Did the Maya themselves perceive the tripod cylinder as the vehicle that had opened the door to Teotihuacan?

Other vessel types entered the Maya inventory during the apogee of Teotihuacan influence, including ring-stand bowls and two-part jars (sometimes called "cookie jars"); the Maya may have 170 been the inventors of the lock-top pot—often described as "screw- 171

170, 171. A few "screw-top" vessels are known from the Early Classic period, when the Maya developed pots whose lids would stay in place, allowing the consistent alignment of iconography on both lid and vessel. The design was probably invented in the Central Petén, where examples have been excavated.

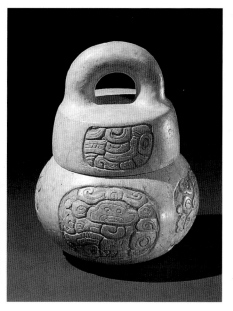

top" jars—and some of the other ephemeral forms that fell from favor almost as suddenly as they appeared. The "cookie jars" made especially good god effigies, and their interiors may have held precious offerings. An old Underworld god from Nun Yax Ayin's tomb at Tikal sits on a stool of crossed human femurs and holds a severed head in his hands, probably indicating that his cavity should hold human sacrifice. The only archaeological example of a lock-top pot has come from Río Azul, where testing demonstrated that it entered the tomb full of Maya chocolate. Shaped like a very small handbag, the vessel has a handle painted as if wrapped with a jaguar pelt, a sign of its royal ownership.

Nun Yax Ayin's tomb at Tikal from early in the fifth century and contemporary tombs at Río Azul provide the most dramatic evidence of the success of tripod cylinders. They entirely replaced earlier forms, and many of the tripods were finished with post-fire stucco paint that even in its palette remained close to the Teotihuacan formulas. Like the Teotihuacan vessels, many Maya ones have matching lids, but unlike Teotihuacan ones, most Maya vessels have zoomorphic or anthropomorphic handles. Some vessels, particularly early fifth-century ones are squat, with proportions akin to Teotihuacan-made vessels; others are taller, with a mid-vessel tapering "waist" that also makes them anthropomorphic. An example possibly from Río Azul almost seems to walk away on its tripod feet, the body of the pot standing in for the body of the man whose head is the knob. This sort of allusion was also achieved in basal flange vessels, but it became more convincing in the tripod cylinders. With knobs and tripod supports that were sometimes mold-made or stamped out, these pots were probably easier to produce than basal flange vessels, and their relatively smaller size and lighter weight made them easier to handle without damage.

The new shape of vessel encouraged new sorts of representations. The taller proportions of the cylinders made complete figure representations easier. Teotihuacan stucco style quickly became the medium for the representation of Maya gods, including the Pawatuns of ill. 172, old gods who carry their shells around with them. Some Teotihuacan deities, especially Tlaloc and the War Serpent, figure prominently on the surfaces of tripod cylinders, while other Maya representations—a bleeding skull at Tikal, for example—have no real precedent. In others, swirling wrap-around designs alternated paired carved workmanship with stucco ornament, and some continued right onto the vessel lid.

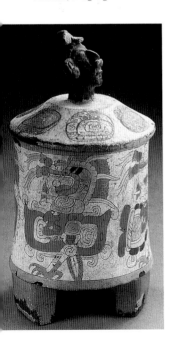

172. At Tikal, Río Azul, and elsewhere, the Maya made local adaptations of the tripod cylinder that called for anthropomorphic or zoomorphic knobs to be used on the lids. Some heads were mass produced, like ancient coinage. Postfire stucco paint retains brilliant blues, greens, and shades of pink. The sides of this vessel, possibly from Río Azul, feature representations of Pawatun, an aged god.

172

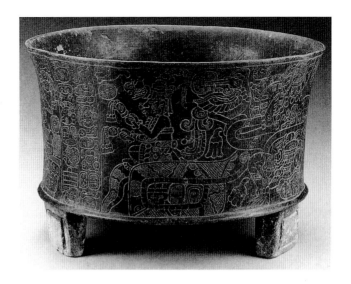

173. A journey through the
Underworld wraps around this
large and low tripod vessel,
beginning with the playing of
music just to the right of the text.

Previously, no single surface of the basal flange bowl was
sufficient for any sort of narrative. But with the advent of the 173
relatively tall and straight wall of the cylinder, the Maya narrative
took off. On some tripod cylinders, extremely complex stories are
spelled out visually, requiring repeated turnings in order to grasp
the unfolding tale. A vessel in Brussels shows a lord's transforma-
tion after death, with a trip through the Underworld, past the
dormant sun and to the turtleshell, the surface of the earth,
through which new life is channeled in the form of the Maize God.

The impulse to narration

How can one explain this impulse to tell stories that indicated
protagonists, their deeds, and the places these deeds took place?
No other society in the New World managed to encode this
impulse in art. What made the Maya so different?

One way to think of how this all happened is to think of the
medium and its message as if they were computer hardware and
software. A stela is hardware. A pot is hardware. A building is
hardware. Software programs these media. Software is the system
of iconography. Maya hieroglyphic writing is software. Software
can wreak havoc on hardware, and the desire to use new software
drives the invention or acquisition of new, improved hardware.

Certainly throughout the Early Classic period, the principal
software for conveying the message of Maya religion and histo-
ry—the writing system—improved. As the writing system
became more phonetic and less logographic, it more easily

handled temporal statements moving both backward and forward through time; it included expansive lateral statements regarding the gods and their activity. Even though there is some evidence of early sophisticated phonetic spellings, the preference (perhaps by readers, rather than writers) for logographs proved limiting. When what had been short notations in the third century were replaced by the fifth century with longer, discursive texts, writing reproduced not only facts, but also nuance and detail. In other words, the software for representing language and speech improved, thus putting pressure on the software for visual representation to improve as well. Apparently it did improve, as ill. 173 attests. One particular type of hardware—the basal flange bowl—could not run this new software system and quickly became outmoded. The new form, the tripod cylinder, successfully did handle it, securing the vessel shape's survival for more than a century.

But the tripod cylinder had elements that did not support visual narrative. The vessel knob lent itself to sculptural forms, most of which were iconic and not narrative; the vessel lid offered a space for visual continuity but not narrative continuity. The three slab feet themselves simply kept the body of the vessel off the ground. What had been universally appealing about the tripod cylinder—including its strong associations of Teotihuacan power—no longer held true by AD 600, and the form was replaced by the simple cylinder, with neither lid nor feet.

Late Classic ceramic traditions

In the ceramic art of the Late Classic period, the Maya artist began to portray himself and his role at court: right-hand man to the king, keeper of accounts, and of course, maker of art and writer of records. Reed pens tucked into his hair or headdress, the artist depicted himself as ready for any job that might come his way. And just as the artist began to include himself in the visual record, so he did in the written record, and Maya scribes began to sign their work.

Depictions of scribes often feature them in groups, and it may well be that Maya artists worked collaboratively, as did, for example, the artists who carved the portrait of the last Aztec ruler, Motecuhzoma, an event recalled long after the fact in a mid-sixteenth-century watercolor. Maya sculptures that bear signatures also often bear several of them, so the notion of working in groups, probably of kinsmen, was probably pan-Mesoamerican. The best-known Maya ceramic traditions provide independent evidence of many artists working together. In almost all cases, a single artist

174. Without regard to their place of origin, most Late Classic vessels include a primary standard sequence; here, this elegant red-on-cream cup from the Naranjo region begins with two very standard expressions, the "initial sign" and Pawatun. The initial sign need not necessarily appear at the start of a narrative scene. The head of K'awil on an angle below creates a sense of motion.

175. Using a strong—if nevertheless somewhat unremarkable—line, the artist has carved the pot at the leather-hard stage, burnished and fired it, and then finished the vessel with postfire blue paint. The characteristic primary standard sequence begins with the "initial sign" and continues on to name the vessel form, in this case, a cylinder vase.

painted an entire pot, from background to details to text, but sitting right beside him may have been another painter, who mixed nearly identical slips from shared pigments, and whose style is very similar. Yet a third person—perhaps a woman, since almost all Maya ceramic facture today is by women—may have made the thin-walled cylinders themselves.

Some Early Classic Maya pots bear dedication texts, but during the Late Classic period, the rim texts became highly standardized. For much of this century, scholars thought that the painters of Maya ceramics were illiterate scribes. After all, they reasoned, if the inscriptions painted around the rims of Maya vessels repeated the same text through time and across geography, regardless of the scene painted below, wasn't that proof enough of their mindless quality?

What, of course, such reasoning failed to consider was that the text might not be directly related to the scene, and when that liberating thought dawned on Mayanists, a new period of understanding of Maya artists and art-making was ushered in. Michael Coe's first hypothesis, that this "primary standard" might represent a funerary chant, did not hold, but his attack on received wisdom opened the door to waves of challenges. Individual decipherments of glyph after glyph in the primary standard have made it clear that this text is about the business of making art itself. As most scholars now interpret the rim texts of Maya cylinders, an inscription reads something like this: "It came into being, it was blessed, the writing on his drinking vessel for cacao [or atole]." The text may go on to say just to whom the drinking vessel—or plate, another common vessel shape—belongs. Additionally, in a handful of cases, the name of the artist himself appears. In other words, the long-mysterious text talks about function, patronage, and authorship, rather than referring directly to imagery, although that may sometimes be implied.

174

175

Regional styles

Such unbridled variation is found among the thousands of known Maya ceramics that one would be hard pressed to define the ultimate limits of Maya ceramic painting style. But the best-known styles now encompass dozens of very fine wares, and Dorie Reents-Budet has juxtaposed clay analysis against stylistic considerations, and then aligned those investigations with studies of the hieroglyphic texts, to identify ceramic workshops and their locations.

The names of the sites where these workshops flourished do not sing out as the most prominent of Maya sites, and it may turn out to be the case that these assignments are preliminary. Yet strangely enough, many of the most powerful Maya states, as known from their public art and writing, provide little evidence of high-quality ceramic workshops. Despite years of excavations, neither Palenque nor Yaxchilán has ever yielded a polychrome vessel of fine quality; many of the Late Classic wares from Tikal are workmanlike, particularly when compared with the extraordinary vessels from the Early Classic. Furthermore, some of the most exciting centers for ceramic painting may have had little—or in some cases no—monumental sculpture.

Nevertheless, some clear regional associations of ceramic painting styles can be made, and the principal workshops are known either by identification with excavated examples, or through chemical analysis of clay, or by identifying place names written into the texts on the pots. A highland Guatemala style is known for its straight-sided low cylinders, painted primarily in reds and oranges, with a chevron border and red rim, and is anchored to its place by examples excavated at Chamá. A related style probably came from the Motagua River drainage, to the east. A northern Petén/southern Campeche style—probably made throughout the greater Calakmul region—is called the "codex-style" for its characteristic black-on-cream painting of red-rimmed cylinders and plates. The emblem glyph of Motul de San José (the "Ik" emblem glyph) appears in the texts of at least two distinctive styles—the Pink Glyphs and the Altar de Sacrificios styles—both of which display a flamboyant use of color and manipulation of subject. Both red-on-cream and black-background styles of painting center on the Naranjo-Holmul region.

In many of these workshops the continuous surfaces of the cylinder vessels provided artists with new spaces for their work. Uncluttered and uninterrupted, the vessel walls helped artists

achieve new levels of narrative and story-telling. And, just as artists had exploited the interaction between two and three dimensions in the Early Classic, during the Late Classic they explored the potential of seeming seamlessness, with amusing turns that force the viewer to turn the pot time and again. While some workshops specialized in historical narratives—and the highland artists may have filled a need created by the absence of stone sculpture—many artists turned to the religious world for their subject matter. Whereas so much of the Early Classic religious ceramic art focused on encapsulating cosmic settings, the Late Classic vessel frequently provides a window on ancient myth-making, and some religious stories are familiar only from the ceramic medium.

Ah Maxam of Naranjo

The names and genealogy of most Maya artists have vanished, were they ever even recorded. The handful that survive may well be anomalous. But anomalous or not, they offer us key insights into at least some instances of art making. The most important artist to provide his name belonged to one of Maya painting's greatest workshops. He painted three striking Maya pots that belong to Chicago's Art Institute today—and probably worked side-by-side with the author of a tall rectangular vessel that has recently come to light. His personal name is obscure, although he notes that he is "of the painting," and that he is an *itsat*, or "sage," but he also called himself "he of the Maxam place," a toponym of the Naranjo region, and so he will be called Ah Maxam here. One vessel provides parentage that may be his: if this reading holds up, 178 his mother was a princess of Yaxhá, a city near Naranjo, and his father the king of Naranjo, a ruler whose monuments and deeds are well known. So we gain a snippet of a royal artist's life: a member of the court, but not its ruler, the Maxam painter was one of the most literate of Maya artists, and one of its most adept practitioners.

The three Chicago pots may well have come from the same 176 tomb, and they may have been painted within a very short period 177 of time. Although undated, they can be attributed to the last twen- 178 ty years of the eighth century by the rulers they name. These were years of artistic and political ferment: in eastern Chiapas, a troupe of Maya painters made the Bonampak paintings in the same period; at Palenque, the artists may well have fled the city. At Naranjo, a star painter made extraordinary paintings and displayed a range of what has seemed to be an almost unmatched talent.

First of all, and most stunningly, Ah Maxam worked in both styles related to Naranjo, the black-background style and the red-on-cream. His success as a dimorphic painter recalls the achievements of a handful of archaic Greek painters, who painted both black-figure and red-figure vases. Like the Greek examples, these two Naranjo styles are essentially a positive and negative: the red-on-cream created by drawing the figures and painting them in; the black-background requiring that the artist outline the figures with contour line, then fill in the background, letting fired clay function as the color of the anthropomorphic figures and their setting.

The three cylinders all exhibit flamboyant but meticulous calligraphy that, in addition to the identifying tagged name on ill. 178, marks them as the work of an individual painter. Iconographically, Ah Maxam also had great range. In his version of the red-on-cream Naranjo/Holmul region standardized imagery of the dancing Maize God (there must be dozens of known examples of this "Holmul dancer" from the area), he gives the old standard a twist. First of all, all other known examples feature two Maize Gods around the cylinder, but Ah Maxam has painted three. Secondly, his Maize Gods twist their bodies so that they truly seem in motion. And third, Ah Maxam has added highlights in a charcoal slip that painted over the red slip reads as if it were dark navy blue, like few other examples.

176. The Maize God dances with his dwarf or hunchback three times around the surface of this large cylinder vessel. Despite the difference in style from ill. 177, Ah Maxam's handwriting is readily identifiable: the glyphs over the third Maize God are nearly identical to those over God L's head.

176

177. On this tall, elegant vessel known as the Vase of the Seven Gods, God L reigns over six lesser gods from his luxurious palace. Typically, he wears the muwan bird headdress and puffs away on a small cigar.

The related Box of Eleven Gods demonstrates the skill of a painter from the same workshop to work in a third style, using the black background, but with figures fully articulated in shades of red and orange. Judging by the patron of the vessel, the box was probably painted between 755 and 765—and the artist could have been a very young Ah Maxam himself. Far more pots in this style are known than in the black-background style of the Vase of the Seven Gods, and many of them may well have come from the Naranjo sphere. The box probably once had a vaulted lid, judging by the wear along its upper surface, and it probably once took the form of a miniature house or palace: the imagery is set within a

4

177

203

178. What may be the names and titles of the artist rim the base of this cylinder, and the nominal "Ah Maxam" appears just to the right of center. Other texts float like pages across the surface of the vessel.

palace, and so one has the sense of seeing the life *inside* the dwelling, as if the box were turned inside out.

Functionally, such a box may well have held elements important for the personification of God L, and when those elements— say, his jewelry, his belt, or his cigar—were stored once again in the box, the box *became* God L. The ancient god of commerce and tribute, he may well still have a presence in Guatemala today as the cigar-smoking supernatural power known as Maximon, a guarantor of economic well-being (sometimes at the cost of others' losses)—and who is kept in a vaulted or coffered chest when not available for supplication. Works such as the Box of Eleven Gods or the Vase of the Seven Gods may alert us to the power that this god of wealth had within Naranjo and its sphere.

In addition to this corpus of extravagant vessels, painters of the Naranjo school could also work in a spare and stark mode. Ah Maxam painted simple black flowers (perhaps cacao flowers, perhaps vanilla orchid blossoms) that float across the creamy surface of ill. 10, alternating with blocks of text that record details of royal genealogies. Set at an angle, they recall the dynastic histories rendered in a woven mat pattern on the stelae of Copán and Quiriguá. An even more simple vessel by Ah Maxam's hand is in the Yale Art Gallery.

Taken as a whole, there is no other Maya artist known to have the range of this Naranjo prince. His example makes it possible to believe that sharply differing styles could have come from a single hand; his range of patrons also makes it likely that there are other masterpieces by his hand that have yet to come to light.

Other painters near Naranjo

For works that seem to be highly conventionalized, the Maize God pots of the Naranjo/Holmul style nevertheless took some strange turns. At Holmul itself, an example of the style features the Maize God dancing within a square drawn within the circle of a plate, as if a manuscript page had landed on the dish. One very large plate (33 cm or 13 in diameter), which features set-in low cups and might be thought of as an ancient "chip and dip" server, integrates the other common subject matter of this style, simple cormorants, all into a single vessel, the pattern and monotonous color making it difficult to read its imagery. At the site of Buenavista, Belize—still a part of the Naranjo political sphere—Maize Gods on several vessels move in counterclockwise direction, unlike any other corpus.

Archaeologists unearthed one very fine example at Buenavista that can be dated to the first decade of the eighth

179. Excavated by Joe Ball and Jennifer Taschek in Belize, the Jauncy Vase was probably painted in Naranjo c. AD 700 by the best court painter and then shipped to one of its provinces as a valuable gift. Like the later works of Ah Maxam, traces of blue-green stucco still remain on the rim. Two Maize Gods dance against a creamy background.

century, and the circumstances of its location and dedicatory text provide evidence that the Jauncy Vase—named for the mound where it was interred—was a present to local lords there from the Naranjo king, probably to shore up regional support. Painted on a tall tapering cylinder, the two dancing Maize Gods stand out clearly and even calmly against their creamy background, for unlike most examples, these Maize Gods stand quietly, their extended arms the only sign that they dance at all. No frenetic dwarves accompany them, and the feathers of one figure do not overlap the other, nor the text. More meticulously drawn than any other example of this subject, the Buenavista Vase also seems less imbued with life.

After the Buenavista Vase was fired, stucco was added to its lower rim, a custom followed with some other Naranjo-area pots, including the Vase of the Seven Gods. Interestingly enough, the tall, tapering proportions of the two vessels are also nearly identical, despite having been made at least eighty years apart. Painting styles apparently changed more quickly than the styles and shapes of vessels, which may have been a more conservative backdrop.

Both the Buenavista Vase and the Ah Maxam pots may well have been made in the same family workshop, albeit by different generations, working closely with the king, for the Buenavista Painter, like Ah Maxam, worked in various styles. Based on the calligraphy and vessel shape, three other vessels have been attributed to the earlier master, two cormorant pots, and another vessel

180. Like Ah Maxam, his successor at the Naranjo court, the painter of the Bunny Pot worked in more than one painting style, since he is apparently the master of the Jauncy Vase as well. Here he indulges his gift for comedy, ridiculing God L.

referred to as the "Bunny Pot." Here the staid workmanship of the Jauncy Vase gives way to broad comedy on a vessel painted in a range of earth tones. "That rabbit took my belongings!" claims a nearly naked God L in an unusual representation of first-person speech to the enthroned K'inich, or Sun God, the words connected to his mouth by delicate scrolls. But what God L can't see is that K'inich himself may have put the rabbit up to the theft, for the rabbit peeks out from behind the throne; on the opposite side of the pot, the haughty rabbit stands on the throne, flaunting God L's trappings.

The two most important aspects of the Maya economy were maize agriculture and tribute, whose payments were probably invoked as a result of warfare. Just as the Aztecs explicitly juxtaposed agriculture and warfare, so the Maya did less specifically and more subtly. The steady message on elite ceramics of Naranjo praises the Maize God; the more subtle story is that of God L, whose role as the patron of tribute is ridiculed in one generation and then seemingly elevated in the next.

Codex vessels
Particularly in the regions of Calakmul and Nakbé, Maya artists painted ceramic vessels with fine black line on creamy backgrounds, sometimes using a thinned black wash for detail, and rimmed by often quite brilliant red paint in what has come to be

called "codex" style. Centuries later, near the time of the Spanish 181
Conquest, the Maya limned their books with black and red writing 182
on the off-white stuccoed pages, closely resembling some of the 183
all-glyphic pots that make reference to Calakmul. The Aztecs, who
actually painted their books with a wide range of colors, neverthe-
less used what may have been an ancient metaphor—"the black,
the red"—to refer to the concept of writing, as if this Maya writing
were the origin of the expression.

The makers of these vessels may well have had a clear sense of
their own role in the making of art and writing, for the supernatur-
al patrons of art and writing are a common subject in codex-style
vessels. In ill. 181 a supernatural Monkey Scribe in profile sits
behind the Maize God. Now the Maize God only occasionally
appears as a scribe, but it makes sense that he *would* be one, since in
Maya religious narrative, the Maize God is the father of both the
Monkey Scribes and the Hero Twins. His first set of children, the
Monkey Scribes, must have gained their scribal skills somewhere:
where better than in the family business? The idea that writing *is*
the family business also runs through the codex-style pots. The
Moon Goddess, too, is a relative of the Maize God, for she wears
the Maize God's attire, particularly the beaded skirt and belt orna-
ment—attire worn by many women in monumental art as well.
Her most notable progeny is the rabbit. The rabbit then may 182
accompany her, perhaps as a spy, to the court of God L, the nemesis
of the Maize God, as cleverly rendered on the Princeton Vase. It
only makes sense that the Maya would have understood that chil-
dren follow the family business, one generation to another, the
lives of gods and mortals alike in this respect.

181. Both the Maize God and
Monkey Scribes frequently
appear on codex-style vessels,
often with laconic texts. Here the
Maize God is also scribe, perhaps
offering instruction in the family
business to one of his sons, a
Monkey Scribe.

182. From within his lavishly appointed chamber, an aged God L distracts himself with five beautiful young women while an execution transpires on the other side of the Princeton Vase. One of the great masters of codex-style painting, the artist of this vessel uses a light wash to create subtle visual effects. The rabbit scribe in the foreground may be a spy in God L's court.

On the Princeton Vase, a distracted old God L dallies with five beautiful young women in his palace, adorning them with jade jewels, perhaps stripped from the Maize God, since he also seems to have hidden the Maize God's belt ornament in his lap. At the same time, a rabbit scribe busily takes down notations for the palace. Meanwhile, on the other side of the pot, two oddly disguised characters decapitate the Maize God. They might also be the Hero Twins, in disguise, in a mythic episode where they carry out sacrifices in order to convince the Underworld gods to volunteer for their own demise.

Despite some modern restoration, the Princeton Vase is an ancient masterpiece, for the fineness of its line, the effective use of wash, and for its compositional complexity. Although the style relates to the making of Maya books, the composition here is designed to work most effectively on a continuous surface: the woman farthest to the left tickles the feet of the woman who kneels in front of God L, as she tries to draw her attention to the scene of sacrifice on the other side. The result is that the observer of the pot turns it in his or her hands, reading the story around continuously. The artist has drawn the five elegant women as if they were moving through slow motion or even stopped action, caught one frame at a time, the brush or pen lingering over the sensuous curves of their bodies.

The narrative range of codex-style vessels is vast, and many of the stories related on their surfaces occur nowhere else. Common subjects include the Death of the Baby Jaguar, known from a frequently reproduced example at the Metropolitan Museum of Art, and scenes from the life of the Maize God, whose rebirth is vividly

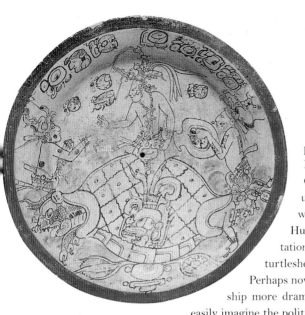

183. Hunahpu and Xbalanque bring their father, the Maize God, back to life from a cracked-open turtleshell on the surface of a codex-style plate.

painted on a plate on view at the 183
Museum of Fine Arts in Boston.
On the plate, one of the supernat-
ural Hero Twins, Xbalanque,
waters his father, while the other,
Hunahpu, extends his hand in invi-
tation, as if to call him up out of the
turtleshell symbolizing the sere earth.
Perhaps nowhere is the pious filial relation-
ship more dramatically rendered, and one can
easily imagine the political utility of such imagery on a
gift to an aged sire.

184. Bound to a scaffold and apparently scalped, a captive prepares for death on a vessel in the Pink Glyphs style. Standing attendants to either side feature thin cutaway masks in front of their faces, a characteristic of this regional style.

The two faces of the Ik emblem pots: Pink Glyphs and the "Altar" style
Only two or three late eighth-century monuments at or near the
site of Motul de San José on the shores of Lake Petén-Itzá feature
an emblem glyph with a main sign of *ik*, meaning breath or wind.
Despite such a limited presence in stone, this emblem glyph com-
monly appears on ceramics, and several ateliers of painters may
have worked at the site, perhaps into the ninth century. At Motul
de San José, the ceramic record may have had as much validity as
stone, for particular rulers and their rites of passage are spelled
out in painted vessels.

The Pink Glyphs vessels are known for the unusual rosy tones
used to paint the hieroglyphic texts, but the mix of these bright
and subtle tones has not always worn well, and many texts have
eroded. A number of different artists worked together on these
pots, sharing pigments and slips, but with different results. Many
rendered scenes of sacrifice unusual in ceramic art— for example,
almost as if they would want to demonstrate to posterity that the
Maya really did perform penis perforation or wear giant jaguar
suits. Most feature a character nicknamed the Fat Cacique, who
usually watches others make sacrifices.

A different hand with the ability to draw a finer line painted a 184
pot from this group at the Art Institute of Chicago. Surely a scene

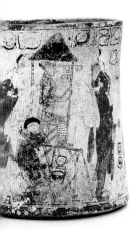

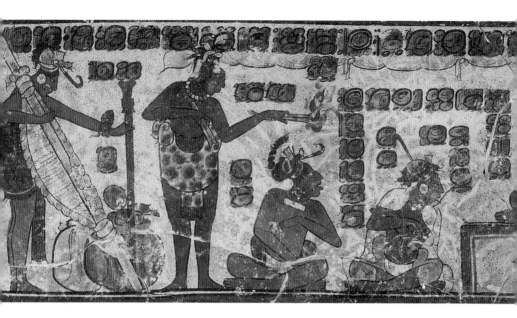

of installation in office, the Fat Cacique descends from a
jaguar-covered sedan chair to face a partly scalped captive who has
been tied to the scaffold where he will be sacrificed. The artist
has rendered all the principal figures with cutaway masks, as if
the viewer had x-ray vision to see through the disguises of the
ceremony.

In 1963 Richard Adams unearthed an extraordinary Maya
vessel at Altar de Sacrificios that bears the Ik emblem—and so it
may have been a gift or payment from a distant Motul de San José
lord. A pot by the same hand provides evidence of such long-dis-
tance exchange, for a pair of translators (who may be scribes as
well) sit between the enthroned lord and heavily laden visitors,
who deliver a tribute payment. The Altar Painter aggressively
engages the figures with the glyphic frames and creates dramatic
settings in part by violating glyphic boundaries. A related painter
at Motul emphasizes architectural scenes, from palace life to the
ballgame, where he manages to suggest the setting with just a few
horizontal lines.

Chamá and Motagua region vessels

Some regions of the Maya highlands, particularly along the
drainage of the Chixoy River, part of the Usumacinta River
system, saw the rise of fine vase-painting traditions, although no
great Maya cities—and no monuments—are found there.

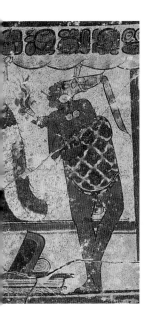

Still, powerful lords lived there and when they died, they took finely painted ceramics with them to the tomb. Many simple subjects were painted time and again on straight-sided cylinders, oftentimes low ones, and on gadrooned cups, a shape of vessel rarely occurring in the lowlands.

Brought from Guatemala to Philadelphia many years ago, the Chamá Vase is among the most familiar of Maya pots. White chevrons on black ground trim both the upper rim and lower margin of the cylinder, probably a replication in paint of the feather borders that often edged Maya attire. The subject once again is trade and tribute, as two Maya merchants, dressed in the black body paint of their Underworld patrons, engage one another. Typical of Chamá painting are the exaggerated facial figures and pronounced buttocks and ankles. Other Chamá pots depict supernatural bats, animals playing musical instruments in processions, and scenes of God N, an old Maya god who lived in a shell.

The highland site of Nebaj yielded the exceptional Fenton Vase almost 100 years ago, but the discovery of other vessels in similar style has now led to the determination that the workshop lay near San Agustín Acasaguastlán, in the upper drainage of the Motagua River. The vases in this style all tell of the warfare and tribute payments of the region, and the owner of the Fenton Vase may well have been a tribute-paying lord to distant San Agustín

186

187

186. Chamá-style vessels usually have perfectly straight sides, unlike the tapered cylinders of the Maya lowlands; the chevron border is characteristic of the region.

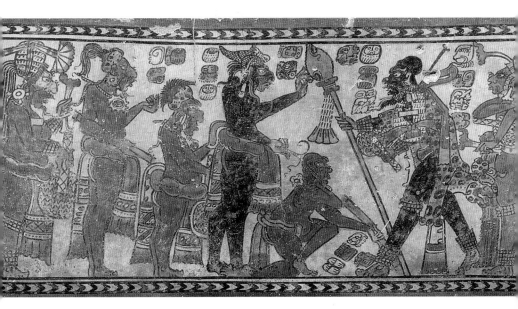

187. One of the best-known Maya vases, the Fenton Vase of the British Museum features the presentation and recording of tribute. Each protagonist has his own caption; the column of larger glyphs is an abbreviated primary standard sequence.

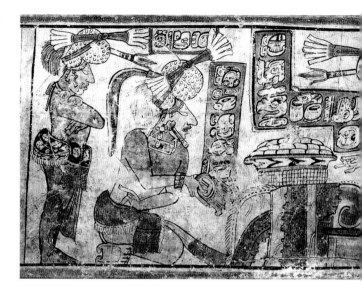

Acasaguastlán. On the Fenton Vase, record keepers tally up the sums, while the lord examines the bolts of cloth and basket of tamales in front of him.

188. In Yucatán, a carved style of pottery—usually called Chocholá—was made near Xcalumkín. On this particularly fine example, K'awil floats up from a waterlily on one side; on the other, batik-like resist patterns run under a primary standard sequence.

Other styles

Maya ceramics of the Late Classic period turn up in too many sizes and styles to categorize them all. Large, heavy plates with stylized muwan birds were painted throughout Campeche. Several styles flourished in Belize, at least one of them with a looser use of line than elsewhere. Copador wares, made to the south of Copán, use only "pseudo" glyphs, as if in imitation of more typical Classic

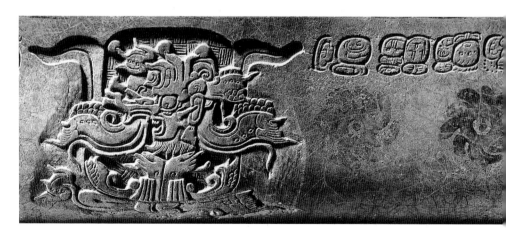

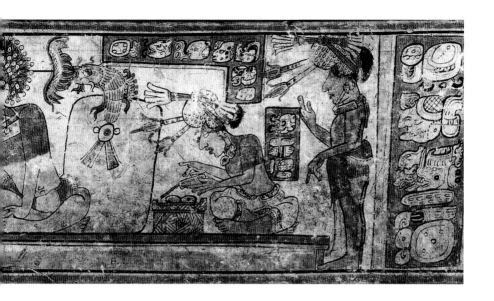

ceramics. Left out of this consideration altogether are the incised alabaster (stone) wares, which were made at Copán and Palenque, as well as other locations.

Northern ceramic traditions

Maya artists of northern Yucatán painted ceramics, but during the Late Classic period a distinctive style of carved wares developed around the city of Xcalumkín, in the Puuc region of northern Campeche, according to Nikolai Grube. Long called Chocholá vessels from the name of a nearby town, vessels in this style are cups, straight cylinders with slightly flaring rims, or cylinders with rounded bottoms. Although their carved surfaces may seem to be the dominant characteristic, a number of other features also pertain. Many show carved imagery only on one side and are paired with text on the other—often in a slanted column; others are paired with resist patterns, or a combination of the two. Yucatán was known for its honey and wax production, and some of the wax was used to produce the resist designs.

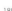

The technique of carving may have put constraints on the ability of the artist to render action, and although there are lively images of two or three figures, more typically a single figure is rendered. The K'awil of ill. 188 has been reduced to key iconographic elements; he is seemingly disembodied but reversed right and left hands emerge from the water scrolls below. Carved

188

into the background is elaborate cross-hatching, perhaps shorthand for agricultural fields. The reverse is marked by both text and seemingly evanescent patterns.

Plumbate and the ceramics of the Postclassic
New ceramics appeared late in the ninth century across the entire Maya region. In Guatemala and Chiapas, mass-produced Fine Orange pottery from Tabasco began to appear, with uniform stamped-in designs turning up at disparate locations, from Veracruz to the Petén. New vessel shapes also took hold: small

189. About AD 900, fine-orange ring-stand vessels became common in Yucatán, but actual manufacture may have taken place in Veracruz or Tabasco. Much rougher than the carved ceramics of just a generation or two earlier, the imagery nevertheless features K'awil.

190. Despite their shiny surfaces, plumbate vessels used no glaze but only the technology of oxygen reduction during firing. Found from Tula to Chichen Itzá and at a host of other locations, the pottery is a characteristic of the Toltec period. Here, the form clearly depicts the Maya god Pawatun, aged and wrinkled, inside his shell.

cups and low bowls became common, as did ring-stand vessels of various shapes, some bases supporting straight-sided cylinders, others with tapering or bulbous containers.

This effort at mass production may have accompanied new rituals: at Chichen Itzá, for example, feasting may have taken on new value, and thousands of ring-stand vessels may have been needed for public use. An example at the Yale University Art Gallery may have come from Chichen Itzá or environs. K'awil is featured on both sides of the pot, carefully incised prior to firing.

189

With the rise of Toltec civilization in Central Mexico, a new ceramic style, probably manufactured somewhere in Chiapas, came into widespread production. Called plumbate, the ware's shiny surfaces develop when oxygen is cut off from the firing process. Many plumbate vessels are zoomorphic or anthropomorphic effigies. Single figures, they cannot provide narration for religious ceremony in the way that cylinder vessels can. Nevertheless, some plumbate vessels feature Maya gods; one, for example, is God N or Pawatun, of the Maya Underworld, and, like an Early Classic example, features the craggy, lined face of the old god who stands within a shell.

190

Chapter 10: A World of Hand-held Objects

Of all the works of the Maya world that have vanished, small-scale objects probably fared worse than monumental ones, since many of the latter were made with the idea of endurance in mind. Although the Maya invested time and energy to construct art on a grand scale, they also relished the miniature and the hand-held object, including delicate and ephemeral things. Wealthy lords commissioned small-scale works for private use in their palaces, and ultimately many of them would find their way to the tomb, whence come almost all such works that survive today. Ceramic objects form such a coherent body that they are discussed in Chapter 9, rather than collected here with the other sorts of gifts and royal paraphernalia that accompanied the dead on their journey.

Surely wood was a principal medium for both monumental and small-scale works of art, but little could last for more than a generation or two in the rainforest. Lintels carved of hewn beams of iron-hard sapodilla survived at the peaks of temples at Tikal and elsewhere, legible a thousand years after they were set in place, but few other works of wood fared so well. Staffs and scepters from the Postclassic survived in a waterlogged state in the Sacred Cenote at Chichen Itzá, providing a taste of the wooden banquet once at hand. When archaeologists opened Tikal Burial 195, they realized that the sepulcher had been flooded with mud in antiquity, eventually leaving behind hollows where wooden objects had rotted away. Injecting these earthen molds with stucco, quick-thinking archaeologists captured ancient forms of the god K'awil, just 40 cm (16 in) high, right down to the stucco surface. The scale of these Tikal objects would seem to be that of dozens of hand-held images of gods depicted commonly on Maya monuments. Most gods were probably carved of wood, small enough to be held in the hand, and ultimately lost to time. The large stone vessels in the shapes of miniature houses at Copán bear self-description as "god houses" and are the right scale for the Tikal K'awils: when not in active use, Maya gods were kept in such sacred vessels, and they, too, like the coffered chests that hold sacred vestments of Maya

lords today, were probably made of wood that could not survive—
or were stored in such a manner as to invite decay.

But to imagine that the Maya carved only their *gods* of wood
would probably be a mistake. A wooden figure in the Metropolitan
Museum of Art of similar scale (38 cm or 15 in) features a kneeling
lord, very likely a portrait. His arms boldly cross his chest, and it
may be this confident—if not aggressive—posture that Early
Classic stelae often seek to replicate. Because Maya artists had not
yet developed the ability to foreshorten the body, they could not
effectively translate the posture into two dimensions. During the
Late Classic, when the Maya artists had indeed mastered
foreshortening, they may have carved few such wooden portrait
sculptures, although it may simply be that they do not survive.

The Maya mastered many other materials that could only be
rendered into small-scale forms—and, perhaps because of their
own knowledge of the decay of rain, termites, and time, they
sought out hard and durable ones. A readily available raw material
was bone, both human and animal. Some recent work suggests
that bodies may have been boiled in order to eliminate decaying
flesh from the tomb—making the taking and keeping of relics
easier, of course. Maya imagery is filled with bones to a degree

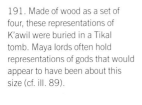

191. Made of wood as a set of
four, these representations of
K'awil were buried in a Tikal
tomb. Maya lords often hold
representations of gods that would
appear to have been about this
size (cf. ill. 89).

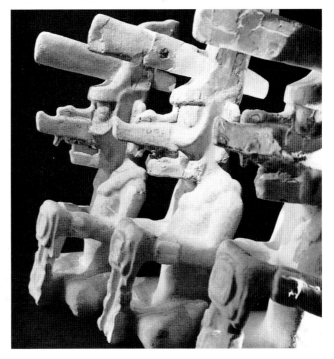

192. Worshipers hurled many perishable objects into Chichen Itzá's Sacred Cenote during the very Late Classic and Postclassic periods. This wooden staff features the Maize God in a "diving" position; its turquoise mosaic is remarkably intact.

uncommon in other world art forms, and even what we think of as the European version, the skulls and crossed bones of the pirates of the Caribbean, may well have been adapted by those roving thieves from Maya imagery of Yucatán.

As a final offering, attendants of Tikal King Hasaw Chan K'awil put a remarkable collection of ninety carved bones into his tomb, probably in a now-lost cotton bag. Among the last objects to be recovered by archaeologists from the burial, the trove included matched pairs, perhaps once to have been used together as tweezers, as well as unique objects. The story of the death of the Maize God continues from one carved bone onto another, with the protagonists' bodies being cut right off by rising waters!—although the ancient Maya observer, as well as the modern one, understands they plunge into the Underworld. Into the delicate incision, made by tools modern man has never recovered or does not recognize, the artist rubbed cinnabar or hematite, revealing the powerful calligraphic line. An elegant but naked captive stares at his bound wrists on one bone whose text proclaims, "his bone, a relation of the king of Calakmul." Is this that lord's very bone, recycled from the flesh to an object of lasting power?

193
194

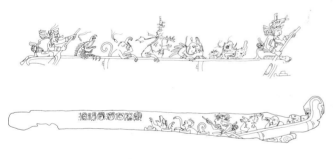

193. (above) A pair of carved bones from Burial 116 at Tikal would seem to feature a narrative sequence. First, on the bone at top, aged gods (the "Paddlers") escort the Maize God, in the company of howling animals, across treacherous waters in a canoe. Remarkably, on the second bone the canoe seemingly plunges into the water and vanishes from the carved surface.

194. (right) Some bones from the Burial 116 offering may have been relics: with its reference to a kinsman of the king of Calakmul, might this bone be from his very body?

A carved human femur at the Yale University Art Gallery would suggest that relics *were* collected from victims, for in this example the text notes that the protagonist "witnessed" the event. The carved bone of a victim would have been a potent souvenir to bring home from a visit, particularly from a visit to a more powerful city, whose lords intended to impress upon their vassals their power. With the bone's heavy, knobby ends, the ancient viewer would probably have taken note that it is upside-down when seen, as if its bearer were holding a victim upside-down as well.

The Maya also cut and carved shell, making headdress spangles (a Piedras Negras tomb yielded over 200 cut tesserae) and personal adornments, including elegant matched pairs that may have once belonged to earflares. Some of the most extraordinary shell jewelry was designed to be suspended as plaques around the neck. The cut interior of the conch provided a satin-smooth and often iridescent surface for fine incision. An example at the Cleveland Museum of Art depicts a Maya lord in a position of relaxation and repose, quietly smoking a thin cigar. Other conch shells were left whole and cut only to make them into functional trumpets. Some bear texts identifying their wealthy owners.

195. Though somewhat eroded, a carved bone at the Yale University Art Gallery clearly features a victorious warrior.

196. One of a matched pair, this Early Classic shell depicts a human—with vivid breath—inside a great skeletal mask.

197. Rendered on a pearly slice of conch shell, an elegant smoking Maya lord beckons toward a serpent in a conch. Barely visible is delicate cross-hatching across the lord's chest.

Takeshi Inomata's excavation in a burned palace at Aguateca has provided good evidence that finished shell, bone, and even jade might all have been produced in a single workshop, probably by a single extended family. Jade's intrinsic value meant that even its scraps were cut into tiny beads and mosaic pieces, probably from the Early Classic onward. Some of the tiniest jades were inlaid into the cut and filed teeth of Maya lords. Some highland Guatemalan sites may have been particular locales of jade production, for not only have large, carved objects been recovered at sites with little other ceremonial presence, such as Nebaj, but most ancient jade-working tools and large, unworked or partially worked jade boulders have come from the highlands, especially Kaminaljuyú, where the raw material from the Motagua River region was perhaps hoarded.

Other greenstones were also valued, particularly in early times, when jade supplies may have been less plentiful. A Late

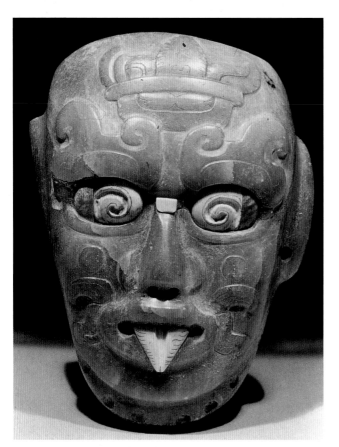

198. Precious materials formed an Early Classic mask of the rain god Chaak, including conch, spondylus, and greenstone. He carries the glyph for sun in a closed bowl on his forehead.

199, 200. (right) Like a miniature stela, the Leiden Plaque features a triumphant ruler on one side and a text relating an early Maya date, 8.14.3.1.12 (in AD 320), on its reverse. Originally worn as one of three plaques at the waist, like the adornment worn by the plaque's protagonist, the object was later drilled to be worn sideways.

Preclassic head of fuchsite was found at Tikal in a first-century BC context. Worked in three dimensions, the head probably represents an early king, as indicated by his foliated headband, insignia of royal status. Fuchsite was also used during the Early Classic at Río Azul, where an extraordinary representation of Chaak, the rain god, masked a dead king early in the fifth century. Confidently worked with both deep modeling and light incision, the face of Chaak is brought to life with inlay of shell, further suggesting that several obdurate materials might have been worked side-by-side in a workshop.

Usually by sawing with a string and abrasives, Maya artisans cut jade stones and boulders into several distinct shapes, some of which could be mass-produced for jewelry. Common in Olmec times, celts—or ceremonial axeheads—persisted during the Early Classic, often receiving only incised decoration, like the Leiden Plaque. From AD 400 to 900, the Maya generally made thin

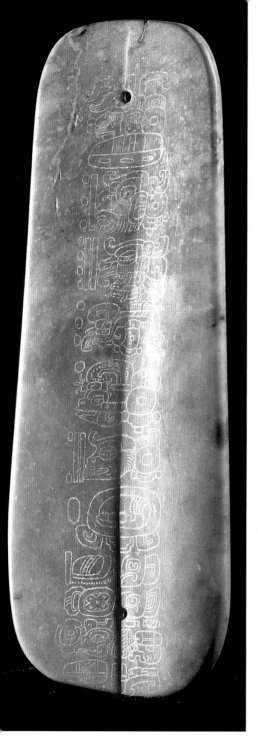
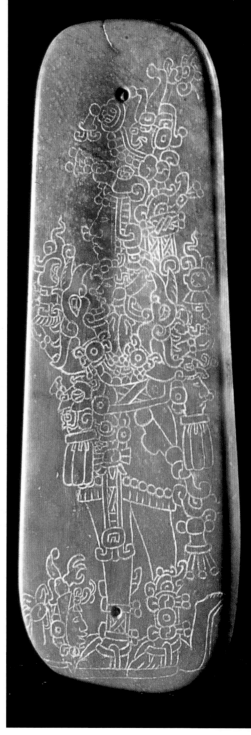

plaques, which they then carved in very low relief, using tubular drills more commonly as time went on. Many of the early jades, like the Leiden Plaque, bear a dated inscription, but once incision gave way to the more standard low relief of Classic Maya jades, few received any writing.

The Early Classic Maya had collected Olmec jades, often adding an inscription or a statement of ownership to the early works—and for a while, they had emulated some Olmec shapes for jade, especially celts. Later, in turn, the Maya at Chichen Itzá from AD 800 onward sought any and all earlier treasures to offer to the Sacred Cenote, and the types of offerings read like an inventory of Maya jades. A rare dated jade from the cenote bears an inscription celebrating a Piedras Negras king of the eighth century, and the 201 sensitive—indeed, for jade, unusually so—head may be a portrait. Such a jade may have made its way to Chichen Itzá's sacred well as treasure or tribute, or perhaps as booty looted from Piedras Negras at the time of its ninth-century abandonment.

Maya pilgrims hurled dozens of necklaces, bracelets, and tiaras of jade into the Sacred Cenote as well. They probably once

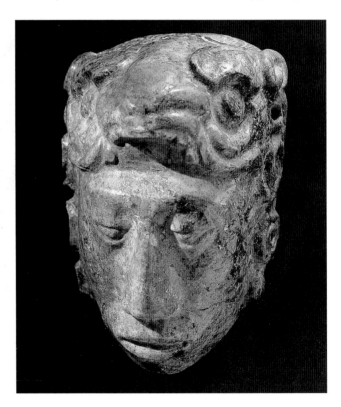

201. The text on the back of the head names the early eighth-century king of Piedras Negras, whose meditative portrait in jadeite this is.

formed the costumes of the Maize God, and it was probably in his guise that most young victims met their watery death, cast there literally into the "black hole" where the Maize God is often featured at his moment of death and resurrection. Interestingly enough, little turquoise was recovered from the cenote, although ill. 192 has what is probably turquoise inlay. Nevertheless, despite the clear Maya appreciation for the material in the era of Chichen, they may have recognized that iconographically, it did not belong in the "black hole" because the material, unlike jade, did not represent maize.

Many plaques may have been costume pieces as well. The 202 finest were shaped carefully with abrasives, but many Late Classic examples retain the clear evidence of less finished drill work. Aesthetically, the low relief of jade plaques offers less visual satisfaction than incision or more vigorous modeling, in large part because low relief fails to exploit many of the intrinsic qualities of jade—its translucence, its color, even its obduracy. On a large jade plaque perhaps once designed to be worn on the chest, an enthroned Maize God receives his attending dwarf.

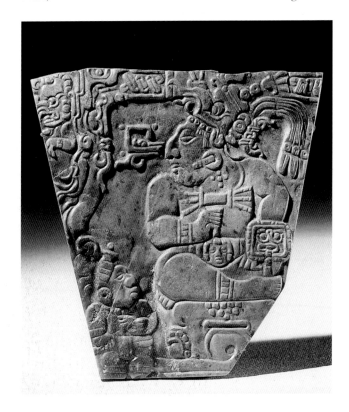

202. Many Late Classic jade plaques feature the Maize God, here attended by his dwarf, probably a reference to the stunted ear that often accompanies the principal cob.

Such representations commonly occur on painted Maya pottery and on monumental Maya stone sculpture, but the imagery is harder to read and the results less successful when translated to intractable jade. This plaque, too, was a treasure, although not one from the Sacred Cenote: found at Teotihuacan in Central Mexico, whence it probably had been spirited in the seventh or eighth century, it was taken to the British Museum by Thomas Gann early in this century. Jades, then, were among the most portable of all ancient treasures. Small, resistant to breakage and intrinsically valuable as a precious material, they moved through the Precolumbian world.

203. Rendered in jadeite, shell, and obsidian, the mask of Palenque's King Hanab Pakal portrayed him as ever young, suspended in time like a young Maize God.

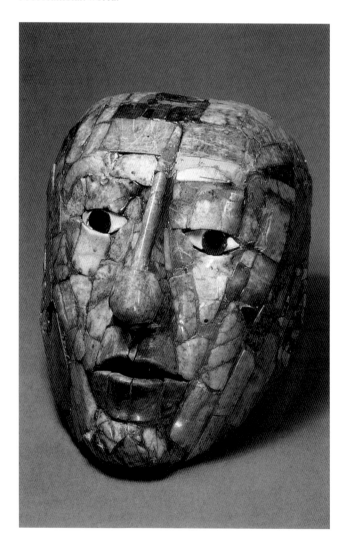

Almost all known jade mosaics of Mesoamerica were made by the Maya, although this specialty may have begun in Oaxaca. Skilled Maya artists shaped dazzling assemblages of tiny tesserae, forming compelling portrait masks to place over the faces of dead kings. Over the course of the Classic period, tesserae grew smaller and thinner. In Yucatán after 900, fine-grained turquoise mosaic masks were made.

At Palenque, at the end of the seventh century, a jade mosaic mask transformed the face of the dead, aged King Hanab Pakal into a permanent image of youth, segmented like so many kernels of green maize. Unlike other masks, this one had no armature of wood or stone but was formed instead directly onto the face of the dead king, perhaps after a trial assembly over a stucco head of the king. A light coat of stucco kept the mosaic in place on the king's face, but the mask must have fallen apart as soon as his flesh began to decay. The larger pieces that are specific to Hanab Pakal's portrait cluster at the center of the face; small tesserae fill in at the ears and chin.

Around the year 900, Toltec traders began to make available turquoise from what is now New Mexico and Arizona to the lords of Chichen Itzá. Some turquoise was probably worked locally, but other finished works may have been imported. Several *tezcacuitlapilli*—round mirrored back ornaments—depicted as having been worn ceremonially on the backs of Toltec lords were found at the site. Archaeologists found one example intact and set into the seat of the Red Jaguar Throne of the interior Castillo. Before that building was sealed and abandoned, Chichen lords placed three large Maya jade beads on top of the mosaic of Central Mexican fire serpents. Each fire serpent head points to a cardinal direction, radiating from the center, itself the direction of "up and down" along a central axis. In placing the three jade beads atop the mosaic, the Maya lords set out the three stones of their creation hearth, perhaps initiating a new era.

Although the Maya used most of the flint and obsidian they quarried for tools and weapons, they also came to cut these stones into precious objects called "eccentrics." Their sharp edges give them the aspect of tools, but these flints and obsidians were purely ceremonial, and most were never used as tools, although some of them may have been worn as ornaments.

The best flint sources lie in Belize, and much of it was apparently worked nearby. From the site of Altun Ha, archaeologists recovered dozens of caches and burial offerings—frequently

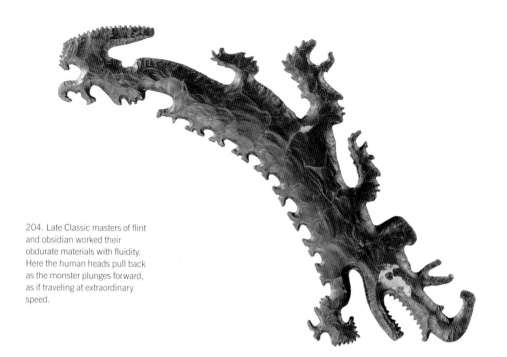

204. Late Classic masters of flint and obsidian worked their obdurate materials with fluidity. Here the human heads pull back as the monster plunges forward, as if traveling at extraordinary speed.

placed under the tomb floor—consisting of great numbers of eccentric flints in the shapes of weapons and animals, as if the former had brought the latter down. Some of them also resemble agricultural tools. But truly extraordinary eccentric flints have been found elsewhere, although never in quantity, and recently several very fine ones were revealed in caches set into the Hieroglyphic Stairs of Copán and also in the Rosalila structure, where they were still wrapped in cloth.

In making an eccentric flint like the one of ill. 204, the Maya artist reduces the human face to its simplest outline, emphasizing the long, sloping forehead of the elite Maya head and the pouty mouth with just the slightest bit of flint. The eye reads the result in the same way that it reads the quick brushstrokes of calligraphy, filling in what is not rendered and accommodating the strange working-out of the human form that characterizes every flint. Yet of course where the calligraphic line is speedy, the flint outline can only have been made under the most intensive concentration and at great investment of time, the artist having carefully struck the stone to chip flakes so precisely. So the artist who rendered the earth monster bearing his earthly charges into the Underworld has such control of his material

that even today, we can see that the monster's maw plunges downward.

Gold was never common in the Maya area, but the lords of Chichen Itzá, by 900 or so, imported semi-finished round disks, probably from lower Central America. Local craftsmen then finished the disks, probably at Chichen Itzá itself. All Maya gold to survive the Spanish invasion served as one sort of costume element or another and provides evidence that the four main types of goldworking known among the Mixtecs and Aztecs in 1500 were familiar to the Maya as well. Artisans cast bells, using the lost-wax method; they also hammered repoussé designs, cut thin sheets of gold, and twisted gold filigree into rings and other ornaments.

The imagery of the gold disks has no obvious source that survives, although general parallels can be drawn between the imagery of sacrifice common to the disks and to particular images in the painting at Chichen Itzá. But what is extraordinary is the deft handling of the human forms and the compositional

205. One of several gold and alloy disks retrieved from the muck at the bottom of Chichen Itzá's Sacred Cenote, this example offers a chilling scene: a victorious warrior withdraws his knife from the chest of a hapless captive while the next victim watches on. The workers of Maya gold disks may have been familiar with the compositional solutions achieved by painters of plates and bowls, the only other round forms known today. Despite iconographic details that relate to Central Mexico, the composition is purely Maya.

205

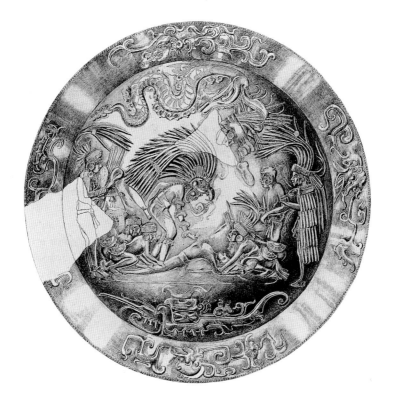

strength of the scenes rendered on the gold disks. Each one of the multifigural compositions provides a separate dramatic moment; each one focuses on the climax itself, rather than the "pregnant moment" so typical of Maya art in Chiapas or the Petén. Ill. 205 shows a victorious warrior who thrusts his right hand into the open chest cavity of the slain captive to rip out the heart. The kneeling attendant in front of him looks up, as if to engage him; the two *tezcacuitlapilli*-clad attendants behind clasp the legs of the captive as if to help, and the artist has worked them in right behind the sacrificing warrior's calves, so that a press of bodies surrounds the void over the captive's chest. One of these two rear attendants turns, his face rendered frontally, and he makes eye contact directly with the viewer, as if both to acknowledge the artificiality of the rendering and to bring the viewer into the scene, to make him complicit in the sacrifice.

Other scenes are also dramatic: sea battles, armed combat all captured in a sort of breathless narrative, as if dashed off with a brush, despite the meticulous and slow craft necessary in goldworking. Although Chichen Itzá is a painted and carved city, the passion and excitement of the imagery worked on these disks is anomalous, and more typical of Classic vase painting than Maya sculpture.

The costumes depicted on the gold disks feature what have long been considered evidence of foreigners trampling local Maya, particularly the long tresses, facial hair, and trimmed feathers of the victorious warriors, but these characteristics can all be identified as normal Maya representations of warfare of the seventh and eighth centuries, with a dose of Central Mexican influence. In fact, executed on a new luxury material, the imported sheet gold, much of the imagery might well have been conservative, and even old-fashioned, much as luxury ivories in late Rome preserved a Hellenistic tradition. The occasional work of gold that converges explicitly with Chichen Itzá painting is far more surprising: remarkably, early twentieth-century divers retrieved all three pieces of a cut-out gold mask, perhaps once affixed to some sort of armature, nearly identical to imagery worn by a figure in both the Upper Temple of the Jaguar paintings and the Lower Temple of the Jaguar carving. These rare pieces of Maya gold link the works to the production of the tenth century, when Chichen Itzá was a leader in introducing new materials and techniques across Mesoamerica.

206. Three pieces of a single mask were retrieved from Chichen Itzá's Sacred Cenote, remarkably, each formed by both cutting the gold foil and hammering details.

Chronological Table

Middle Preclassic (900/800–250 BC)	500 BC	Village life at Tikal El Mirador, Nakbé begin growth and development
Late Preclassic (250 BC–AD 250)	50 BC AD 150 250	Tikal Burial 85 in North Acropolis Main pyramids at Teotihuacan built El Mirador, Nakbé collapse EVII in use at Uaxactún
Early Classic (AD 250–550)	292 320 378 451	Earliest date on a Maya stela found in archaeological context Date of Leiden Plaque Arrival of Teotihuacanos at Tikal, Uaxactún, and elsewhere Siyah Chan K'awil dedicates Stela 31 at Tikal
Late Classic (AD 550–900)	562 615 650 onward 680–720 683 692 711 731 736 738 770– 792 800 869 900	Caracol defeats Tikal in war Hanab Pakal becomes king at Palenque Teotihuacan enters decline Greatest number of female representations on Maya monuments Death of Hanab Pakal at Palenque Completion of thirteen katuns (9.13.0.0.0 celebrated) Toniná defeats Palenque Gold object interred at Copán under Stela H Dos Pilas celebrates victory over Seibal; Seibal king sacrificed Quiriguá takes Waxaklahun Ubah K'awil of Copán captive Ah Maxam paints at Naranjo in multiple styles Paintings at Bonampak, Cacaxtla, Mulchic Chichen Itzá dominates Yucatán Tikal Stela 11 erected Toltec trading routes extend from Yucatán to U.S. Southwest; centered at Tula, Hidalgo Gold disks at Chichen Itzá
Early Postclassic (AD 900–1200)	1000 12th c	Chichen Itzá falls into decline; founding of Mayapán Mayapán
Late Postclassic (AD 1200–1530)	1345 1400– 1400– 1518 1519 1521 1524 1542	Aztecs found their capital city, Tenochtitlan Surviving Maya books painted Quiché and Cakchiquel Maya thrive in highland Guatemala Tulum Juan de Grijalva explores coast of Yucatán; sights Tulum Cortés arrives, first in Yucatán and then Mexico Cortés defeats Aztecs with aid of Tlaxcaltecan allies Pedro Alvarado defeats the Maya of Guatemala Francisco Montejo founds Mérida on site of T'ho

Select Bibliography

General

The best archaeological surveys of the Maya are surely Michael Coe, *The Maya* (6th ed., Thames and Hudson, 1999) and Robert Sharer, *The Ancient Maya* (5th ed., Stanford University Press, 1994). Others worth reading are Norman Hammond, *Ancient Maya Civilization* (Rutgers, 1982), along with the picture drawn of the Maya within larger Mesoamerican surveys, including Muriel Porter Weaver, *The Aztecs, Maya, and their Predecessors* (3rd ed., Academic Press, 1993) and R.E.W. Adams, *Prehistoric Mesoamerica* (University of Oklahoma Press, 1991). Also to be consulted is Gene and George Stuart, *Lost Kingdoms of the Maya* (National Geographic Society, 1993). George Kubler, *Art and Architecture of the Ancient Americas* (1st ed., 1962; 3rd ed., Pelican, 1984) provided a pioneering art historical treatment of the arts of both Mesoamerica and the Andes. I limit discussion of the Maya to two chapters in *The Art of Mesoamerica* (2nd ed., Thames and Hudson, 1997).

Maya religion is considered in Karl Taube, *The Major Gods of Ancient Yucatan* (Dumbarton Oaks, 1992), Mary Miller and Karl Taube, *The Gods and Symbols of Ancient Mexico and the Maya* (Thames and Hudson, 1992), and in David Carrasco, *Religions of Mesoamerica* (Harper, 1990). The reader should also consult Bishop Diego de Landa's account of sixteenth-century Yucatán; the least cumbersome translation remains that of William Gates, *Yucatan Before and After the Conquest* (Dover reprint, 1980). The principal Maya religious narrative to survive has been re-translated by Dennis Tedlock, *The Popol Vuh: The Mayan Book of the Dawn of Life* (Simon and Schuster, 1985).

Several important museum and exhibition catalogues have advanced the study of the Maya, among them Clemency Coggins and Orrin Shane, *The Cenote of Sacrifice: Maya Treasures from the Sacred Well at Chichen Itzá* (University of Texas Press, 1984); Charles Gallenkamp, ed., *Maya: Treasures of an Ancient Civilization*, (Abrams, 1985), Eva and Arne Eggebrecht and Nikolai Grube, eds., *Die Welt der Maya* (von Zabern, 1992), and Peter Schmidt, Mercedes de la Garza and Enrique Nalda, eds., *Maya Civilization* (Thames and Hudson, London, 1998; Rizzoli, New York, 1998), but the most important writing on Maya art in recent years is Linda Schele and Mary Miller, *The Blood of Kings: Dynasty and Ritual in Maya Art* (G. Braziller, New York, 1986; Thames and Hudson, London, 1992), the catalogue for a major exhibition.

Linda Schele went on to write three other major interpretive works that focus on Maya history and religion: Schele and David Freidel, *A Forest of Kings* (Morrow, 1990); Freidel, Schele, and Joy Parker, *Maya Cosmos* (Morrow, 1993); and Schele and Peter Mathews, *The Code of Kings* (Scribners, 1998).

Every reader can benefit by reading the four volumes of John Lloyd Stephens: *Incidents of Travel in Central America, Chiapas, and Yucatan* (Harper Brothers, 1839) and *Incidents of Travel in Yucatan* (Harper Brothers, 1841). Claude Baudez and Sydney Picasso have written a delightful history of discovery, *Lost Cities of the Maya* (Thames and Hudson, London, 1992; Abrams, New York, 1992). The decipherment of Maya writing is best told by Michael Coe in *Breaking the Maya Code* (2nd ed., Thames and Hudson, 1999).

Architecture

A major conference at Dumbarton Oaks in 1994 treated Maya architecture, resulting in the most important study of the built environment to date, with major contributions from and edited by Stephen Houston, *Function and Meaning in Classic Maya Architecture* (Dumbarton Oaks, 1998). A recent volume on Mesoamerican architecture also gives consideration to some Maya cities: Jeff Kowalski, ed., *Mesoamerican Architecture* (Oxford University Press, 1999). Elizabeth Benson, ed., *City-States of the Maya: Art and Architecture*, (Denver, 1986), provides a look at the architectural programs of five Maya cities. Tatiana Proskouriakoff drew reconstructions of Maya architecture that have been more persuasive than written descriptions: *Album of Maya Architecture* (Carnegie Institution of Washington, 1946); her sequenced Uaxactun reconstructions are based on the excavations there (A.L. Smith, *Uaxactun, Guatemala: Excavations 1931-37*, Carnegie Institution of Washington, 1950). Most cities are best looked at in focused studies that treat art, writing, architecture, and archaeology of a given site. Among those to consider: William Fash, *Scribes, Warriors and Kings: the City of Copan and the Ancient Maya* (Thames and Hudson, 1991); Peter Harrison, *The Lords of Tikal: Rulers of an Ancient Maya City* (Thames and Hudson, 1999); Stephen Houston, *Hieroglyphs and History at Dos Pilas: Dynastic Politics of the Classic Maya* (University of Texas Press, 1993); and Jeff Kowalski, *The*

House of the Governor: A Maya Palace at Uxmal, Yucatán, Mexico (University of Oklahoma Press, 1987). Although Harry Pollock provided a masterful review in The Puuc: An Architectural Survey of the Hill Country of Yucatán and northern Campeche, Mexico (Peabody Museum, 1980), the reader must return to Karl Ruppert for the architecture of Chichen Itzá: The Caracol (Carnegie Institution of Washington, 1935); The Mercado (Carnegie Institution of Washington, 1943); and Chichen Itzá (Carnegie Institution of Washington, 1952) and to Charles Lincoln's unpublished 1990 Harvard doctoral dissertation, Ethnicity and Social Organization at Chichen Itzá, Yucatán, Mexico.

Sculpture
Some of the most important sources for the study of Maya sculpture remain the early publications that simply document the works. Among these: Alfred P. Maudslay, Biologia Centrali-Americana: Archaeology (4 vols., London, 1889-1902); Teobert Maler, Researches in the Central Portion of the Usumatsintla Valley (Peabody Museum, 1901-03); Researches in the Upper Usumatsintla and Adjacent Region (Peabody Museum, 1908); Explorations in the Department of Peten, Guatemala, and Adjacent Region (Peabody Museum, 1908); Explorations in the Department of Peten, Guatemala (Peabody Museum, 1911); and A.M. Tozzer, A Preliminary Study of the Prehistoric Ruins of Tikal, Guatemala (Peabody Museum, 1911). Focusing on text but usually presenting figural sculpture as well are the major contributions of Sylvanus Morley, Inscriptions at Copan (Carnegie Institution of Washington, 1920) and Inscriptions of Petén (5 vols., Carnegie Institution of Washington, 1937-38). In recent years, comprehensive publication of Maya sculpture has been led by Ian Graham in the Corpus of Maya Hieroglyphic Inscriptions, with seven volumes now released (Peabody Museum, 1975-).

Herbert J. Spinden, A Study of Maya Art (1913; Dover reprint, 1975) was among the first to chart the development of Maya art, followed eventually by Tatiana Proskouriakoff, Classic Maya Sculpture (Carnegie Institution of Washington, 1950). The sculptural styles of only a few Maya cities have received comprehensive study in recent years: Carolyn Tate, Yaxchilán: Design of a Maya Ceremonial City (University of Texas Press, 1992). Adam Herring's unpublished 1999

doctoral dissertation at Yale treats the sculpture of Palenque: A Critical Study of Maya Stone Sculpture, AD 250-800. Claude Baudez looks at religious meaning in Maya Sculpture of Copan: the Iconography (University of Oklahoma Press, 1994).

Maya Painting
Río Azul has featured in National Geographic Magazine (April 1986), as have Cacaxtla (September 1992 and March 1990) and Bonampak (February 1995), where the reader will find excellent color photographs of their paintings. The Proyecto de Pintura Mural in Mexico has begun systematic publication of all Precolumbian paintings in Mexico. The two volumes on Bonampak, edited by Beatriz de la Fuente, came out in 1999; Cacaxtla is scheduled for the near future. For Bonampak, also see J.E.S. Thompson, Karl Ruppert, and Tatiana Proskouriakoff, Bonampak, Chiapas, Mexico (Carnegie Institution of Washington, 1955) and Mary Miller, The Murals of Bonampak (Princeton, 1986). Uaxactun's paintings lasted less than a year after being uncovered; a color copy exists in Guatemala City. For Tulum and Tancah, see Arthur Miller, On the Edge of the Sea: Mural Painting at Tancah-Tulum, Mexico (Dumbarton Oaks, 1982). For Naj Tunich, see Andrea Stone, Images from the Underworld: Naj Tunich and the Tradition of Maya Cave Painting (University of Texas Press, 1995). Both Clemency Coggins (above, 1984) and Linda Schele and Peter Mathews (above, 1998) have provided fresh publication of the Upper Temple of the Jaguar Paintings at Chichen Itzá; see also Earl Morris, Jean Charlot, and Ann Axtell Morris, The Temple of the Warriors at Chichen Itzá, Yucatán (Carnegie Institution of Washington, 1931).

Michael Coe and Justin Kerr have offered fresh insights into Maya books in The Art of the Maya Scribe (Thames and Hudson, London, 1997; Abrams, New York, 1998).

Ceramics and Small Sculpture
Dorie Reents-Budet's traveling exhibition, Painting the Maya Universe, brought Maya ceramics to international attention (Duke University Press, 1994). Coe and Kerr (above, 1998) have written an insightful book about how these works of art were made and the stories they tell. No study of Maya ceramics can begin without Justin and Barbara Kerr, eds., The Maya Vase Book, now in five volumes (New York, 1988-),

each volume with a clutch of essential articles on the art and writing of Maya vases.

For Jaina figurines, see Linda Schele, Hidden Faces of the Maya (Mexico City, 1997), Christopher Corson, Maya Anthropomorphic Figurines from Jaina Island, Campeche (Ballena 1976), and Mary Miller, Jaina Figurines (Princeton University Art Museum, 1975). A.V. Kidder, J.D. Jennings, and E.M. Shook, in Excavations at Kaminaljuyú, Guatemala (Carnegie Institution of Washington, 1946), provided thoughtful analysis of jade, shell, and other materials used by the Maya to make works of art; Kidder studied jades again in Excavations at Nebaj, Guatemala (Carnegie Institution of Washington, 1951). See also Tatiana Proskouriakoff, Jades from the Cenote of Sacrifice, Chichen Itzá, Mexico (Peabody Museum, 1974), and Adrian Digby, Maya Jades (British Museum, 1972). Clemency Coggins analyzed wood, textiles, bone and other materials in Artifacts from the Cenote of Sacrifice, Chichen Itzá, Yucatán (Peabody Museum, 1992). Samuel K. Lothrop studied the gold disks of Chichen, Metals from the Cenote of Sacrifice, Chichen Itzá, Yucatán (Peabody Museum, 1952).

List of Illustrations

Chip Clark.
59. Nebaj jade plaque, Museo Nacional, Guatemala City, Guatemala. Photo: JK 4889.
60. Head of the Sun God, Guatemala. Indiana University Art Museum, Raymond and Laura Wielgus Collection. Photo: Michael Cavanagh, Kevin Montague.
61. Incised bone from Hasaw Chan K'awil's tomb, Tikal. Drawing: after A. Trik.
62. Human skull censer/cup with wooden plug, Chichen Itzá, PMHU. Photo: Hillel Burger.
63. Altar 3, Yaxchilán. Drawing: from Morley, Inscriptions of Peten (Carnegie Institute, Washington, 1937-38).
64. Ballgame panel, Art Institute of Chicago, The Ada Turnbull Hertle Fund. Photo: JK 2882.
65. Detail, Stela D, Copán. Photo: MEM.
66. Eccentric flint, Metropolitan Museum of Art, New York, NY. Photo: JK 2841.
67. Stucco glyph, Toniná. Photo: RD.
68. Dancing couples vase. Kimbell Art Museum, Fort Worth, Texas. Photo: JK 0554.
69. Greenstone head from Burial 85, Tikal, UM, Neg. # 62-4-972.
70. Hauberg Stela. Private Collection. Photo: JK 0152.
71. Stela 29, Tikal. Drawing: William R. Coe.
72. Seated wooden figure, Metropolitan Museum of Art, New York, NY. Photo: Charles Uht.
73. Tzitzmitl from the Codex Magliabecchiano. From Nuttall, The Book of the Life of the Ancient Mexicans. (Berkeley), 1903.
74. Stela 5, Uaxactún. Drawing: IG.
75. Stela 4, Tikal. Photo: MEM.
76. Stela 31, Tikal. Drawings: after Jones & Satterthwaite 1982.
77. Stela 27, Yaxchilán. Photo: MDC.
78. Wall Panel 12, Piedras Negras. Photo: MEM.
79. Stela 26, Quiriguá. Drawing: C.P. Beetz, Quiriguá Project, courtesy of R.J. Sharer.
80. Incensarios, Petén. Photo: Peter David Joralemon.
81. Stela 16, Dos Pilas. Photo: MDC.
82. Kimbell Stela, Kimbell Art Museum, Fort Worth, Texas.
83. Cleveland Stela, Cleveland Museum of Art, Cleveland, Ohio. Purchase from the J.H. Wade Fund, 1967.29.
84. Oval Palace Tablet. Drawing: LS.
85. Detail, sarcophagus lid, Temple of Inscriptions, Palenque.. Photo: Eugen Kusch.
86. Sarcophagus lid, Temple of

Inscriptions, Palenque. Drawing: Merle Greene Robertson.
87. Reconstruction of the interior of Temple of the Cross; TP.
88. Tablet of the Cross, Palenque. Drawing: LS.
89. Tablet of the Sun, Palenque. Drawing: LS.
90. Stela 1, Palenque. Photo: MDC.
91. Palace Tablet, Palenque. Drawing: LS.
92. Group 16, fragment, Palenque. Photo: Michel Zabé.
93. Creation tablet, Palenque, detail. Photo: MDC.
94. Detail, Tablet of the 96 Glyphs. Photo: MDC.
95. Toniná stela. Photo: MEM.
96. Monument 122, Toniná. Photo: RD.
97. Wall Panel 2, Piedras Negras, PMHU. Photo: Hillel Burger.
98. Wall Panel 3, Piedras Negras. Museo Nacional, Guatemala City. Photo: JK 4892.
99. Stela 14, Piedras Negras, UM. Photo: T. Maler.
100. Stela 8, Piedras Negras, PMHU. Photo: T. Maler.
101. Stela 1, Piedras Negras, PMHU. Photo: T. Maler.
102. Stela 12, Piedras Negras, PMHU. Photo: T. Maler.
103. Lintel 25, Yaxchilán, BM.
104. Lintel 15, Yaxchilán, BM. Photo: JK 2884.
105. Lintel 16, Yaxchilán, BM. Photo: JK 2885.
106. Lintel 8, Yaxchilán. Drawing: CMHI/IG.
107. Lintel 10, Yaxchilán. Drawing: CMHI/IG.
108. Stela 30, Tikal. Drawing: after Jones & Satterthwaite 1982.
109. Stela 16, Tikal, UM, Neg. # 69-5-55
110. Altar 8, Tikal. From Tatiana Proskouriakoff, A Study of Classic Maya Sculpture (Publication 593, Carnegie Institution of Washington) 1950.
111. Lintel 3, Temple IV, Tikal, Museum der Kulturen, Basel, Switzerland.
112. Stela 11, Tikal. Photo: Visual Resources Collection, Yale University.
113. Stela A, Copán. Photo: MEM.
114. Stela D, Quiriguá. Photo: A.P. Maudslay, courtesy of the American Museum of Natural History.
115. Zoomorph P, Quiriguá. Photo: A.P. Maudslay, courtesy of the BM.
116. Stela 14, Uxmal. Drawing: from Taube, The Major Gods of Ancient Yucatan (Dumbarton Oaks Research Library and Collection), 1992.
117. Stela 1, Tzum, Yucatán. Drawing: CMHI/Eric von Euw.
118. Bonampak Stela 1. Drawing: Peter

Mathews.
119. Sculptured columns building, Xkulok. From Pollock, The Puuc: An Architectural Survey of the Hill country of Yucatan and Northern Campeche, Mexico (PMHU), 1980.
120. Stela 21, Oxkintok. From Tatiana Proskouriakoff, A Study of Classic Maya Sculpture (Publication 593, Carnegie Institution of Washington), 1950.
121. Door jambs, Kabah. From Pollock, The Puuc: An Architectural Survey of the Hill country of Yucatan and Northern Campeche, Mexico (PMHU), 1980.
122. Stone head of tattooed lord, Kabah. Photo: MDC.
123. Champoton column, Campeche. Drawing: Larry Mills.
124. Ballcourt panel, Chichen Itzá. Drawing: LS.
125. Chacmool, Chichen Itzá. Photo: Michel Zabé.
126. Fossil temple shrine with jaguar throne and chacmool. Photo: Massimo Borchi/AWS.
127. Turtle katun. Drawing: from Miller and Taube, The Gods and Symbols of Ancient Mexico and the Maya, 1993.
128. Stela 1, Mayapán. After Proskouriakoff, A Study of Classic Maya Sculpture (Publication 593, Carnegie Institution of Washington), 1950.
129. Monkey Scribes vase. New Orleans Museum of Art, New Orleans, Louisiana. Photo: JK 1225.
130. Hero Twins vase, Private Collection. Photo: JK 732.
131. Stela 1, Tikal. Photo: MEM.
132. Sculptured stone 1, Bonampak, PMHU.
133. Río Azul figurine. Photo: George Mobley/NGS.
134. Kimbell Museum panel. Kimbell Art Museum, Fort Worth. Photo: JK 2823.
135. Vase with full frontal figure, Kimbell Art Museum, Fort Worth Photo: JK 5453.
136. Black Background Vase, Museum of Fine Arts, Boston, MA. Photo: JK 0688.
137. Woman warrior, Chaak Chel, Princeton University Art Museum. Photo: Jorge Perez de Lara.
138. Jaina hunter/warrior with deer headdress. Photo: Hughes Dubois.
139. Jaina couple, Insitute of Fine Art, Detroit. Photo: JK 2881.
140. Maize god, BM. Photo: JK 2889.
141. Monument 27, Toniná. Photo: MEM.
142. God L with rattle staff, possibly from Santa Rosa Xtampak. Drawing: from Taube, The Major Gods of Ancient Yucatan (Dumbarton Oaks Research Library and Collection), 1992.

143. Monkey scribe, Copán. Copán Museum, Copán Ruinas, Honduras. Photo: JK 2870.
144. Stucco head, Temple of Inscriptions, Palenque, National Museum of Anthropology, Mexico. Photo: Irmgard Groth Kimball.
145. K'an Balam head, Temple of Inscriptions, Palenque. Photo: LS.
146. Hanab Pakal head, Temple of Inscriptions, Palenque. Photo: Irmgard Groth Kimball.
147. Burial 48, Tikal. Courtesy Visual Resources Collection, Yale University.
148. Early Classic painting, Uaxactún. Photo: MEM.
149. Room 1, South Wall, Bonampak. Reconstruction: NGS.
150. Room 1, North Wall, Bonampak. Reconstruction: Felipe Dávalos.
151. Room 2, South Wall, Bonampak. Photo: NGS.
152. Room 3, Bonampak. Copy: Antonio Tejeda, Reconstruction: Felipe Dávalos.
153. Room 2, North Wall, Bonampak. Copy: Antonio Tejeda, Reconstruction: Felipe Dávalos.
154. Room 3, detail with ladies on throne, Bonampak. Reconstruction: NGS.
155. Maya God L at base of Red Temple, Cacaxtla. Drawing: D. Kiphuth after photo by MDC.
156. Battle painting, Cacaxtla. Photo: RD.
157, 158. Doorway, Cacaxtla. Photos: RD.
159. Painted capstone celebrating K'awil, Museum Ludwig, Cologne.
160. Drawing 21, Naj Tunich. Photo: Chip Clark.
161,162. Paintings from Upper Temple of the Jaguars, Chichen Itzá. From Coggins, *Cenote of Sacrifice* (PMHU), 1984.
163. Chaak impersonators, Mural 1, Tancah. Reconstruction: Felipe Dávalos. From Miller, *On the Edge of the Sea* (Dumbarton Oaks),1982.
164. Page from the Madrid Codex, Museo de las Americas, Madrid. Photo: Scala.
165. Page from the Madrid Codex, Museo de las Americas, Madrid. Photo: Scala.
166. Venus page, Dresden Codex, Sächsische Landesbibliothek, Dresden.
167. Polychrome, mammiform ceramic. Museo Popol Vuh, Guatemala City.
168. Turtle basal flange bowl with water bird lid, Tikal; Museo Nacional de Arqueologia y Etnologia, Guatemala City. Photo: JK 4876.
169. Dallas tetrapod, with paddler lid, Dallas Museum of Art. Photo: JK 3249.
170, 171. "Screw-top" pot, Private

Collection. Photos: JK 4124.
172. Frescoed tripod cylinder vase with anthropomorphic lid. Photo: Hughes Dubois.
173. Incised tripod bowl. Photo: Gerald Berjonneau.
174. Red on cream, primary standard sequence, Naranjo. Photo: JK 5060.
175. Cylinder, blue-painted vessel with primary standard sequence. Photo: JK 7524.
176. Dancing Maize God vessel, AIC. Photo: JK 0633.
177. Vase of the Seven Gods, AIC. Photo: JK 2796.
178. "Fleur de lis," AIC. Photo: JK 0635.
179. Jauncy vase, Department of Anthropology, Belmopan, Belize. Photo: JK 4464.
180. "Bunny pot," Private Collection. Photo: JK 1398.
181. Codex-style vase, Private Collection. Photo: JK 1185.
182. Princeton pot depicting God L, Princeton Art Museum, Princeton, New Jersey. Photo: JK 0511.
183. MFA plate, codex-style, Museum of Fine Arts, Boston, MA. Photo: JK 1892.
184. "Pink glyphs" vase with victim in scaffold; courtesy of The Art Institute of Chicago, Illinois.
185. Pot painted by the Altar de Sacrificios Painter, Museum of Fine Arts, Boston, MA. Photo: JK 1728.
186. Chamá-style vase, UM. Photo: JK 0593.
187. Fenton vase, BM.
188. Chocholá-style vessel featuring K'awil, Private Collection. Photo: JK 4547.
189. Vase, carved redware, Chichen Itzá. YUAG, Gift of the Olsen Foundation.
190. Effigy vessel, plumbate with Pawatun, YUAG. Gift of Mr. and Mrs. Fred Olsen. Photo: Joseph Szaszfai, Yale Audio Visual Center.
191. Wooden K'awil figures, Tikal. Photo: courtesy of UM.
192. Wooden staff, PMHU. Photo: Hillel Burger.
193. Pair of carved bones, Burial 116, Tikal. Drawings: after A. Trik.
194. Bone with incised captive, Morley Museum, Tikal, Guatemala. Photo: JK 8087.
195. Incised human femur, YUAG. Purchased with a gift from Frederic Mayer, B.A. 1950, and Leonard C. Hanna, Jr. B.A. 1913, Fund.
196. Ear flare, shell (El Peten school), YUAG. Gift of Mr. and Mrs. Allen Wardwell, B.A. 1957. Photo: Michael Agee.
197. Smoking Maya Lord, Cleveland

Museum of Art. Photo: JK 2880.
198. Chaak mask, Río Azul, Private Collection. Photo: JK 6440.
199, 200. Leiden plaque, Rijksmuseum, Leiden, Netherlands. Photos: JK 2909.
201. Jade head, Chichen Itzá, PMHU.
202. Jade Plaque, BM. Photo: JK 2891.
203. Hanab Pakal mosaic mask, Palenque. Photo: Merle Greene Robertson.
204. Eccentric flint, Dallas Museum of Art, The Eugene and Margaret McDermott Fund in honor of Mrs. Alex Spence.
205. Gold disk, Chichen Itzá. Drawing: from Lothrop, 1952, courtesy of PMHU.
206. Embossed gold eyepieces and mouth from Sacred Cenote, Chichen Itzá, PMHU. Photo: Hillel Burger.

Index